P9-DID-144

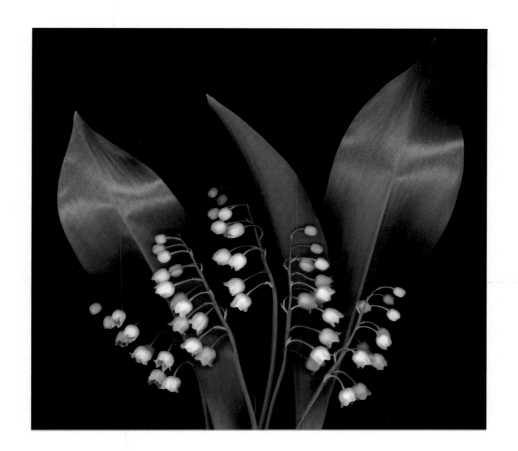

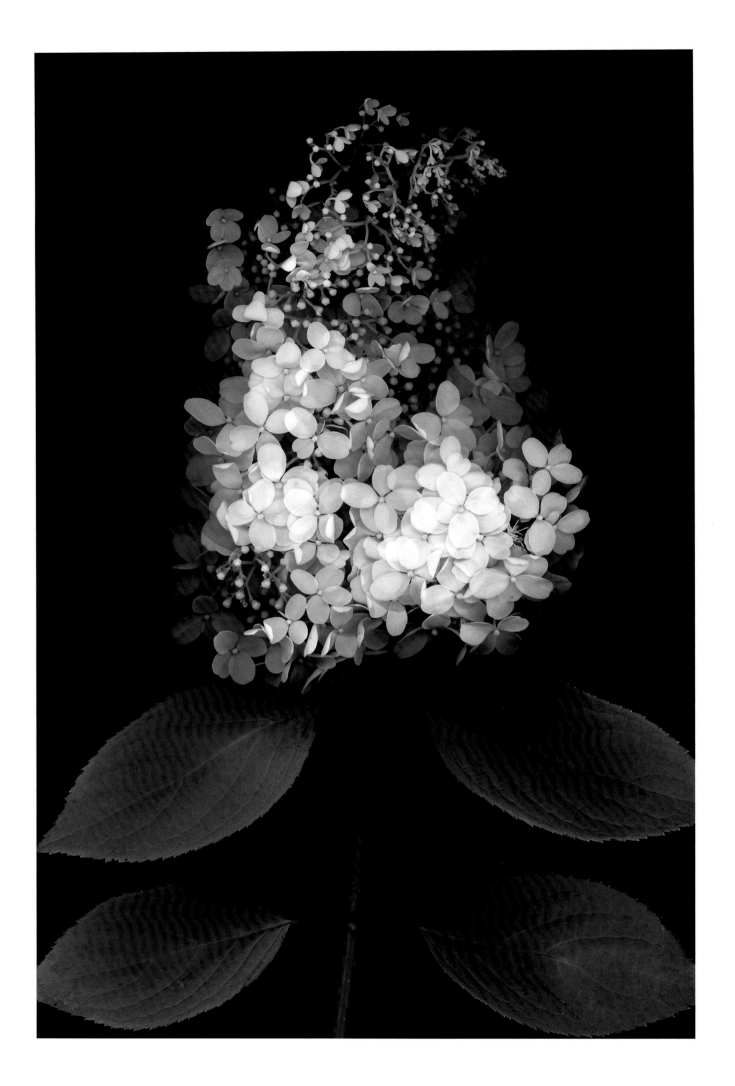

ONE HUNDRED FLOWERS

HAROLD FEINSTEIN

A BEE'S EYE VIEW
SYDNEY EDDISON

"ENGENDERED IS THE FLOWER"
A. D. COLEMAN

BOTANICAL NOTES
GREG PIOTROWSKI

PHOTOGRAPHS SELECTED AND SEQUENCED BY
CONSTANCE SULLIVAN AND LESLIE NOLAN

A BULFINCH PRESS BOOK / LITTLE, BROWN AND COMPANY
BOSTON · NEW YORK · LONDON

Photographs copyright © 2000 by Harold Feinstein

"A Bee's Eye View" copyright © 2000 by Sydney Eddison

"Engendered is the Flower" Harold Feinstein's Floral Photographs copyright © 2000 by A. D. Coleman.

All rights reserved. By permission of the author and Image/World Syndication Services.

Botanical Notes copyright © 2000 by Greg Piotrowski

All rights reserved. No part of this book may be reproduced in any form or by any electronic or mechanical means, including information storage and retrieval systems, without permission in writing from the publisher, except by a reviewer who may quote brief passages in a review.

First Edition

ISBN 0-8212-2665-7

Library of Congress Catalog Card Number 99-76149

Bulfinch Press is an imprint and trademark of Little, Brown and Company (Inc.)

FOR JUDITH, ROBIN AND GJON

THIS BOOK WAS PREPARED AND PRODUCED BY CONSTANCE SULLIVAN

DESIGNED BY KATY HOMANS

Printed and bound by L.E.G.O.

Captions for pages 1 through 14

1. LILY OF THE VALLEY, *Convallaria majalis*

2. PANICLE HYDRANGEA, *Hydrangea paniculata*

5. SPIRAEA, *Spiraea vanhouttei*

6. DELPHINIUM, *Delphinium cultivar*

8. MODERN ROSE, *Rosa cultivar*

14. ANEMONE, *Anemone coronaria cultivar*

PRINTED IN ITALY

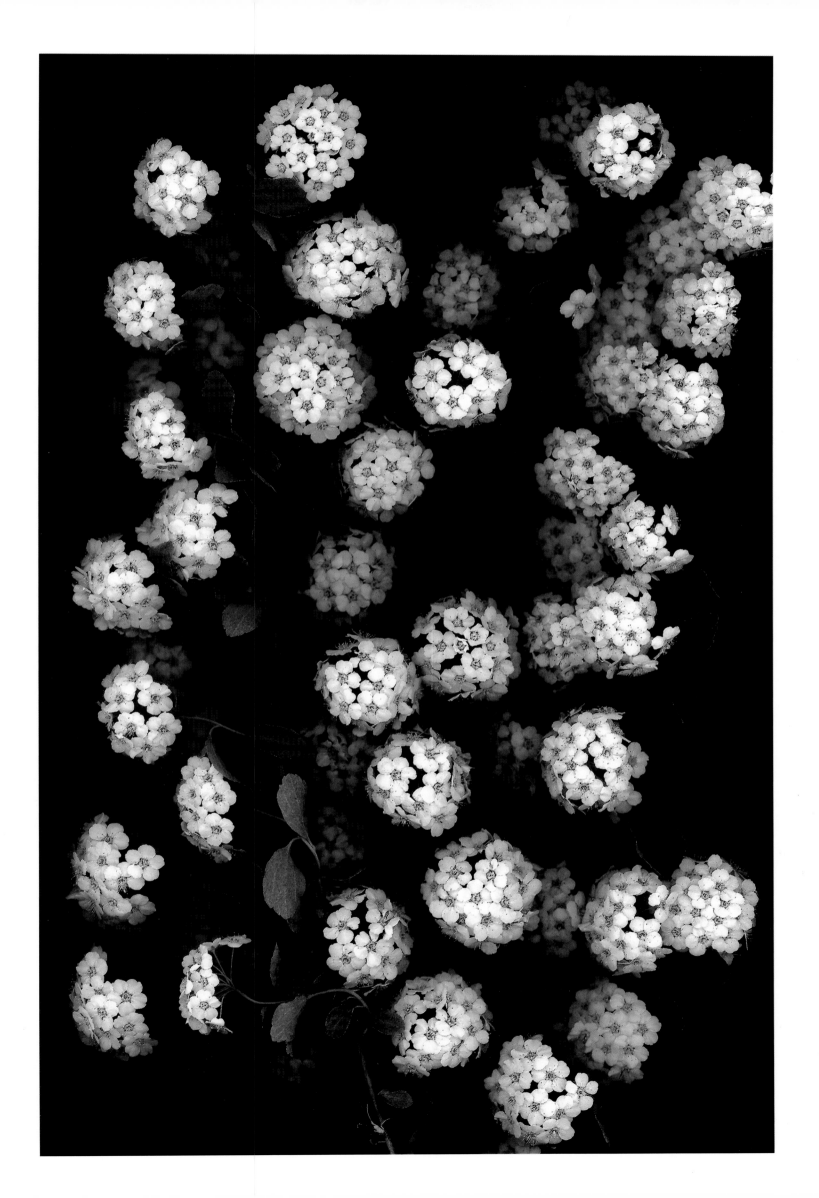

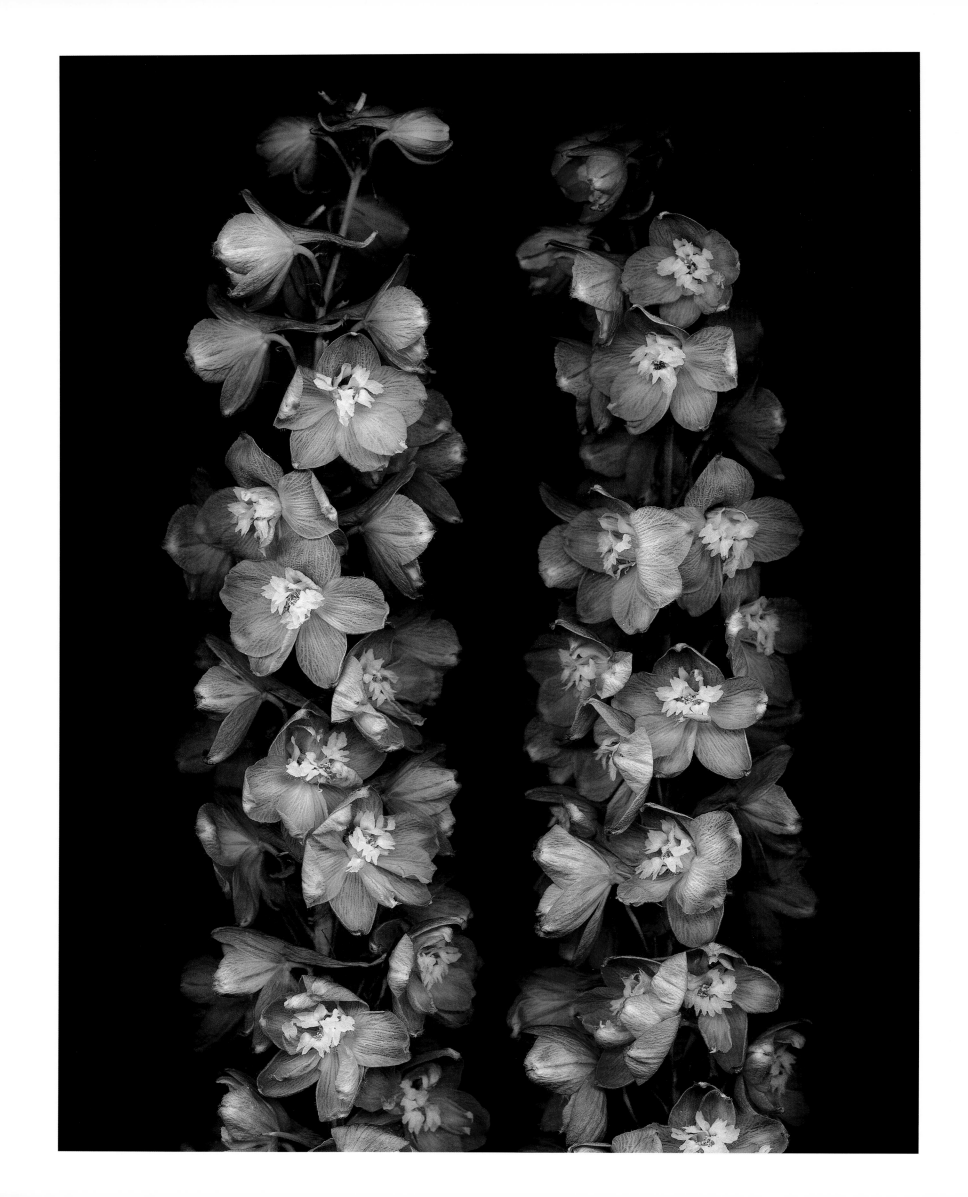

CONTENTS

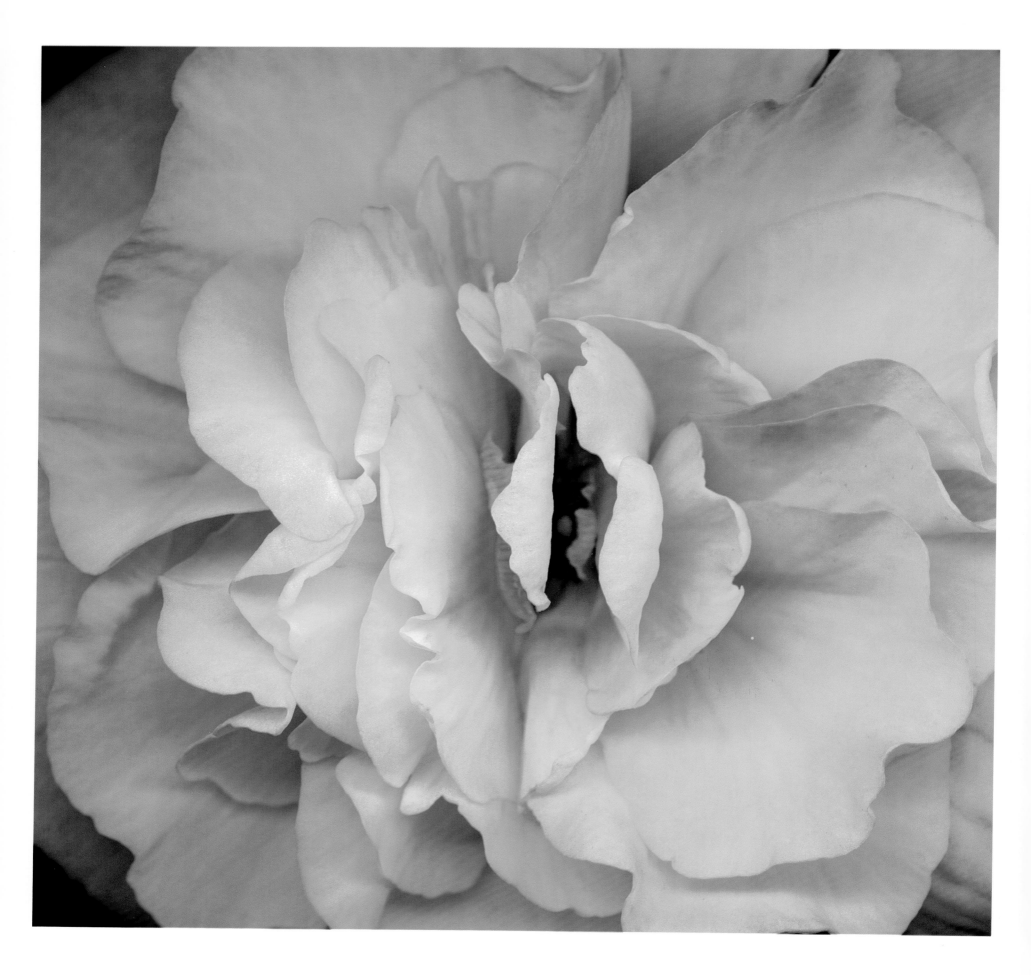

A BEE'S EYE VIEW

SYDNEY EDDISON

In my teens, I fell under the spell of W. H. Hudson's nature writing. Hudson was born in Argentina in 1841 and allowed to run wild in "a wild land." A country girl myself, I responded passionately to his accounts of birds and animals. But it was his descriptions of flowers that I loved most. One in particular has stayed with me. I thought of it immediately upon seeing Harold Feinstein's flower photographs. Hanging poised and flawless in a black void, these blossoms have the haunting, unearthly beauty of Hudson's Hata flower in the romantic fable *Green Mansions*:

> Once, when clambering among the rough rocks, overgrown with forest, among
> the Queneveta mountains, I came on a single white flower, which was new to
> me, which I have never seen since. After I had looked long at it, and passed on,
> the image of that perfect flower remained so persistently in my mind that on
> the following day I went again, in the hope of seeing it still untouched by
> decay. There was no change; and on this occasion I spent a much longer time
> looking at it, admiring the marvelous beauty of its form, which seemed so
> greatly to exceed that of all other flowers. It had thick petals and at first gave
> me the idea of an artificial flower, cut by a divinely inspired artist from some
> unknown precious stone, of the size of a large orange and whiter than milk, and
> yet, in spite of its opacity, with a crystalline luster on the surface.

The hero in the story returns the next day to examine the flower again. It still shows no sign of deterioration. Repeatedly he is drawn back to the spot where the mysterious flower blooms.

> That first impression of its artificial appearance had soon left me; it was, indeed,
> a flower, and like other flowers, had life and growth, only with that transcendent
> beauty it had a different kind of life. Unconscious, but higher; perhaps immortal.

This is what I felt as I looked at photograph after photograph of flowers captured at the height of their perfection by Feinstein's camera. While they obviously are flowers, like other flowers, they have another kind of life, mystical and imperishable.

My fascination with the photographs also lies in the knowledge that the structures revealed in such exquisite detail have an urgent purpose, that of allowing the plants they adorn to reproduce sexually and to set seed. Flowers are always living on the edge. For each blossom, it's now or never. They must attract pollinators before they are damaged by weather or consumed by predators. The continuing health and strength of the species depends on it.

The intricate floral architecture in which we take such pleasure is designed to facilitate reproduction. Flowers rarely pollinate themselves. Because genetic diversity is best served by cross-pollination, the male pollen grains of one flower must be transferred to the female seed-producing pistils of another. With two different parents, the offspring will exhibit characteristics from each and be stronger, better plants. But, being rooted to the spot, plants need help in this endeavor. They need partners.

Gaze into the face of the magnolia blossom. Its partner is the wind. Because wind pollination is a hit-or-miss affair, the magnolia requires many pollen-bearing stamens and an equally large number of pistils. Thus, form follows function. Every part of the flower must contribute to the process of pollination. While wind flowers, like the magnolia and the anemone, are among the most beautiful in the plant world, they are also the most primitive. Their floral parts are arranged in the simplest possible manner: a ring of petals, all the same and of plain design; a ring of stamens surrounding a raised cluster of pistils. At the bottom of each pistil lies the egg-bearing ovary, the receptacle of future seed, and the top, the stigma, which collects the pollen grains. The slender filament that connects the two is called the style.

Because these wind-dependent flowers have laid open their wares, they are infinitely vulnerable. Exposed to the elements and offering up their banquet of pollen to all comers, they do nothing to help themselves. Bees can come and go at will. No guidelines lead them by way of pollen-bearing stamens to the source of nectar. No hood, lip, or spur bars their way and ensures pollination. But more developed flowers use all these devices, and more. Evolutionary changes favor insect pollinators, but they also guarantee that the flowers get their due.

Not just for our delight are the pansy faces with their comic and tragic masks, their frowns and smiles. These lines and grimaces are nectar guides. Along with a myriad of colors and a delicious scent, they attract bees and lead them straight to the heart of the matter. There is no mistaking the entryway. In even the darkest pansy face, a tiny golden halo surrounds the opening. The stigma, a minute green knob inside, blocks the way to the nectar. As the foraging insect moves it aside, pollen sticks to its long, probing tongue. This pollen will be deposited in the next flower the creature visits.

The wonder is that Feinstein's camera has captured an almost bee's eye view. He boldly confronts the mechanics of pollination. Nectar guides and gaping mouths have a utilitarian purpose, but the size of the image invests them with extraordinary power. Thus, the photographer has transformed an appealing but ordinary garden flower into a work of art. Preserved in a pristine state of readiness for a moment that will never arrive, these giant pansies quiver with life.

In contrast to the straightforward tactics of pansies, orchids make life difficult for visiting insects. I have read that some species bombard them with cannonballs of pollen and ply them with drugs. Other species are more pollinator-friendly, but all have blossoms of exotic appearance and complex design. Extravagance is required of tropical plants that have to compete for

pollinators with the rich flora of the jungle. In this no-holds-barred game of survival, orchids pull out all the stops with their fantastic shapes and colors. There is something slightly disturbing, almost sinister about Feinstein's monumental images of these flowers.

While equally elaborate, the blossoms of the bearded iris are as benign as they are beautiful. They treat pollinators with courtesy and reassure us with their familiar fluer-de-lis shape. However, the separate flower parts are specialized in function and unique in name and structure. Irises have three of everything: three "falls," as the downward-hanging sepals are called; three upright petals called "banners"; three artfully hidden pistils disguised as small, crested petals, and on the underside of these, three stamens. A beard of fine, erect hairs rises from the center vein of each fall to guide bees toward the nectar. Often, colored markings are also employed to help show the way.

Everything about the iris is exquisitely crafted, from the pointed buds, wrapped in a thin membrane like tissue paper, to the heavy, satin-textured falls. The petals are of a more delicate substance. Sometimes, petals and falls are different colors; sometimes, they match. Always, the colors are rich, as befits the flower symbol of the French royal family.

Although sunflowers are commoners, they, too, boast highly developed flowers. In the world of plant evolution, the thrust is always toward saving material and energy, and these simple-looking flowers, with their friendly disk faces surrounded by loves-me-loves-me-not rays, are models of efficiency. Instead of squandering effort and resources on large, colorful single blooms, one set of rays serves to lead insects to a central disk composed of hundreds of tiny, upright, tubular flowers.

The petals of these disk flowers are so insignificant that it is hard to distinguish them with the naked eye, but they are there, five in number and fused around the pollen-bearing anthers. The anthers, too, have been welded together and surround the pistil. After shedding their pollen inside the flower tube, the anthers emerge on the outside. Soon the pistil follows, forcing its way upward through the loose pollen. But to prevent self-fertilization, the stigma remains closed. Meanwhile, insects fall upon the fresh pollen. Once they have borne it away, the stigma flings wide its two minute, hairy arms.

These photographs record in mesmerizing detail every stage of the sunflower's life story. You can actually see tiny tufts of pollen that the pistils have recently brought to the surface. Around the edge of the disk, the pollen has already been harvested, making it safe for the stigmas to open. And if you look closely, you will notice a fringe of fully opened stigmas, like short lengths of black yarn. Receptive now, these reach out for imported pollen.

The convenience of this supermarket approach to pollination makes the composite family, to which sunflowers belong, a great favorite with insects. Once my husband and I spent a fascinating lunch hour watching the activities of a bee that came in on a bouquet of sunflowers. Already covered with yellow pollen, the creature continued to dip into every minuscule flower tube. Slowly, methodically, it worked its way around the disk. Finally, sated with nectar and

heavy with pollen, it lost its footing and slid to the table. Having landed on its back, it waved its feet feebly in the air until rescued and released out-of-doors.

The family name "composite" refers, of course, to the clever device of crowding so many small disk flowers together and surrounding them with insect-attracting rays. But it also contains plants with compact heads of florets, all of which look like rays or petals. The jaunty, indestructible dandelion is a composite of this type. Its tousled yellow buttons are made up of thin ribbons with tubular bases that house the reproductive organs. In these greatly enlarged images, open stigmas thrash and wave among the yellow ribbons, like Medusa's snakes.

Many members of the composite family have familiar faces: the sky-blue chicory of roadsides with flowers similar in design to those of the dandelion; goldenrod, a field flower of my youth, its egg-yolk-yellow plumes composed of hundreds of small, closely set daisy flowers complete with proportionally small rays and tubular disk flowers. Numerous much loved garden flowers, like cosmos and zinnias, dahlias and chrysanthemums, also belong to the composite family.

In the case of garden flowers, no matter what their family allegiance, the pollinating partner has usually been a human hand. Enticed by the same wiles that have attracted other pollinators—beautiful shapes, colors, and scents—generations of susceptible men and women have succumbed to the lure of plant breeding. And with striking results. Man-made hybrids are the product of cross-fertilization between two plants carefully selected for their superior qualities.

Hybridizers are the dreamers of dreams. They dream of what does not yet exist, blue lilies and black gladioli. They apply the stage actor's "what if" motivational prod to their breeding programs. Roses naturally blush in shades of pink and yellow, but what if you crossed a pink with a yellow, might it not result in a new shade of tangerine? Tulips already come in a vast color range, but what if they had more blossoms to a stem or were taller or shorter or larger or smaller?

Many of the glorious flower colors in these photographs, both subtle and scintillating, are the result of hybridization. Plant breeders have created hundreds of varieties of roses, chrysanthemums, gladioli, lilacs, irises, and dahlias. There are more than fourteen thousand man-made varieties of dahlia. In the wild, dahlias are nearly always single-flowered. But hybridizers have crossed two or three different wild species to produce doubles in many different configurations: small ball-types with honeycombs of ray florets; huge shaggy plates of twisted or pointed floral rays; peony look-alikes with several tiers of ray flowers.

The mechanics of hybridizing are similar to the pollination techniques employed by insects. Pollen is transferred from the anthers of the male parent to the receptive pistil of the female parent. Sometimes it is as easy as breaking off the anther of one flower and brushing the fresh pollen onto the stigma of the other, and making note of the two plants selected as parents.

Hybridizing wind-pollinated plants requires a different approach, a process that mimics the movement of air. Pollen from the plant chosen as the father is collected in a bag and

inverted over the blossom of the mother plant. A few shakes of the bag cause a miniature wind-storm, and when the dust settles, enough pollen adheres to the stigma to ensure fertilization.

On the whole, hybridizers are humbled by their relationship with the flowers they breed. Although they participate in creation, they are often mystified by the results. These photographs bring us face-to-face with a conundrum. How is it that the more we learn about flowers, the less we know? The more of nature's secrets that are revealed, the greater the mystery that remains. And how did it all start?

It is thought that plants began growing on land about 400 million years ago, and that the first flowering plants appeared about 300 million years later. Paleobotanists on a site in Sweden discovered a cache of fossilized flowers dated at 78 million years old. These flowers, like their modern counterparts, had petals, sepals, pistils, and anthers.

We can learn what function each part performs and, with patient study, read a plant's life history. It is a story told in anatomical structures and forms, in chemical characteristics and inherited traits. Botanists can trace plant life back to the fossilized remains of blue-green algae found in Precambrian rocks 2.5 billion years old.

We know that as the first plants left the sea, they underwent adaptations. They developed specialized tissues for transporting water and nutrients and reproductive systems to ensure the continuation of the species. We know that mosses came after algae, then ferns, and finally flowering plants. But we still cannot fathom the geometry of a daisy's eye, and we can only marvel at the rose window tracery that supports the flowers of Queen Ann's lace.

The enormous scale of the flowers in this book restores them to their rightful place in the scheme of things. In showing us so much, these photographs impress upon us how little we really understand. Flowering plants are the dominant plants of the earth. They are the reason the surface of the planet is not lifeless. They are neither trivial entertainment nor out-door decoration. Flowers are a metaphor for life.

> Our entrance into this life is a mystery.
> Our exit an even greater one . . . We know not whither from
> nor whither bound. We must accept them both, comprehending
> neither the one nor the other.
> There are no answers to the ultimate questions:
> "Who am I? Why am I here? and how? What is my
> place in the Cosmos?" Knowledge cannot help us . . .
> Whether we know it or not, we live by faith.
> Each day is a lifetime. . . . Each day is a miracle.
> —NELL DORR, "OF NIGHT AND DAY"

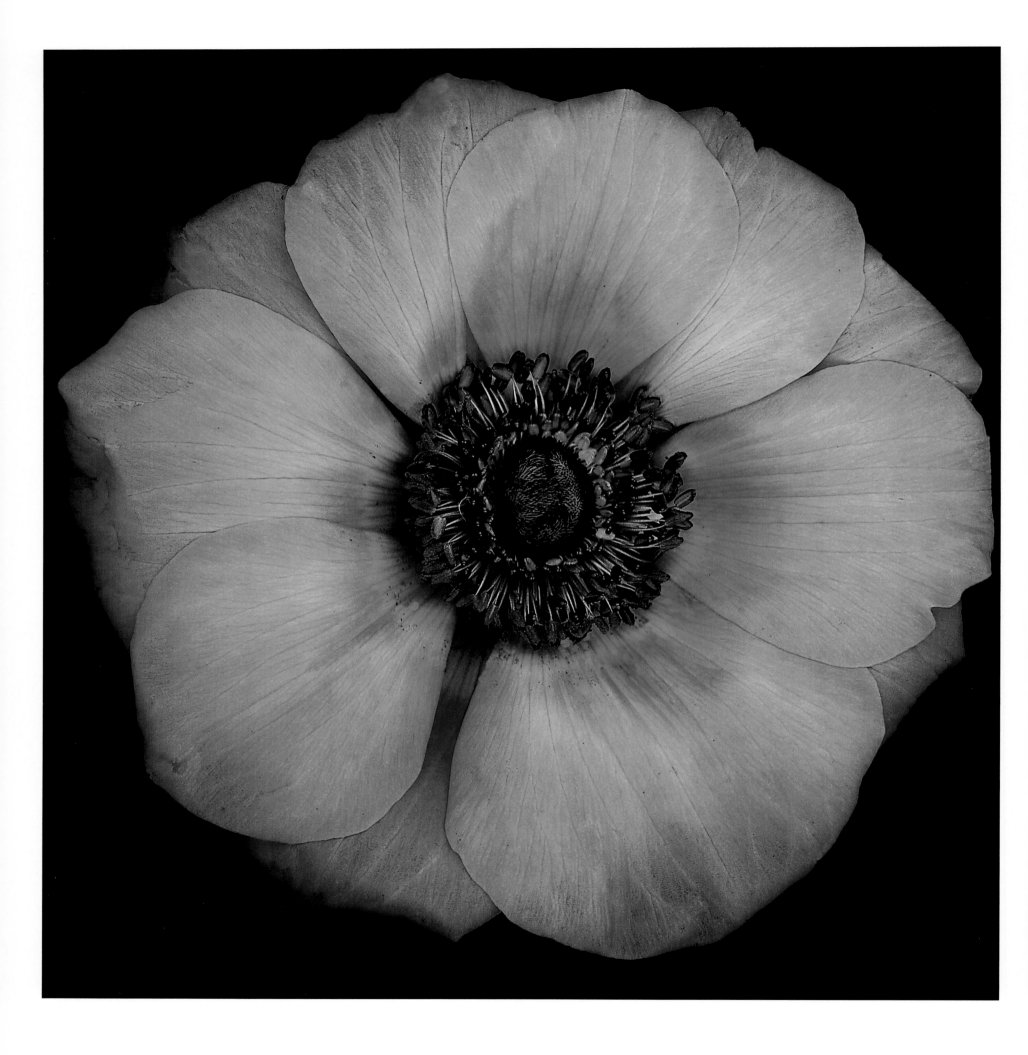

"ENGENDERED IS THE FLOWER"

HAROLD FEINSTEIN'S FLORAL PHOTOGRAPHS

A. D. COLEMAN

"When April with its sweet showers/ the drought of March has pierced to the root/ and bathed every vine in those liquids,/ by virtue of which engendered is the flower . . ." So (albeit in Middle English, rather than my homemade modernization thereof) begins the very first sentence of the first written epic poem in the English language, the "Prologue" to Geoffrey Chaucer's *The Canterbury Tales*. After continuing his paean to spring and renewal for some lines, the poet suggests, as effect from that cause, "Then people long to go on pilgrimages."

Chaucer began his magnum opus sometime circa 1387, and finished it in 1400—exactly six centuries ago. There's a curious symmetry, therefore, in Harold Feinstein finishing this project of his own six hundred years later, because it too uses flowers as a jumping-off point for a pilgrimage—one of a very different sort, at least superficially, though imbued with a delight in life and reverence for the energies of creation not dissimilar from those that set the keynote for Chaucer's tale.

It's a surprising project from this particular photographer. Feinstein is a true photographer's photographer who started taking pictures in 1946 as a teenager, caught the eye of Edward Steichen (then the head of the photography department at the Museum of Modern Art), and by the age of 19 had prints in the museum's permanent collection. Later he'd work with W. Eugene Smith for a spell. Widely and internationally published, exhibited, and collected since then, Feinstein became one of a small handful of master teachers whose legendary private workshops—which he's taught now for more than forty years—have proved instrumental in shaping the vision of hundreds of aspiring photographers.

In regard to his own work, he's known primarily as a small-format devotee, steadily pursuing his own idiosyncratic brand of that mix of the diaristic and the sociological which we associate with what's been tagged the "New York School"—in his case, a photographic form of tough-minded, tender-hearted humanism. If people associate his name with particular images, they're probably extracts from his decades-long engagement with Coney Island as a democratic cultural milieu and a proscenium for the human comedy. And while he's long been known as a master printer, his reputation in that area to date rests on his virtuosic handling of silver—the traditional craft of the photographic print.

Hence the surprise here: an expansive suite of floral still lifes, made in the studio, in color —and, most significantly, the result of what's become a serious engagement with digital imaging as a way of achieving the pictures he feels impelled to make. For many photographers of the old school, anything digital still remains anathema. Yet more and more senior figures, like Feinstein, are making the transition, because (among other things) digital technologies offer an unprecedented degree of control over one's final results.

Feinstein came to digital imaging through the back door, as it were, by using it to catalogue and archive half a century's work, produced primarily in black and white. The resulting familiarity with digital-imaging systems led to various experiments, which in turn opened up the possibility of working in color by eliminating the expenses involved in analog color printing and, even more importantly, allowing him to nuance his color prints as consciously as he does his works in gelatin silver.

According to Feinstein, "The availability of the more precise controls with immediate feedback, plus the simple capability of duplicating images, allowed for a more intuitive and improvisational way of working. One could take more risks," he adds, "and there was a further sense of adventure in the printmaking process."[1] Indeed, he claims that he can not only get a digital color print superior to anything achievable by analog means but can get even better quality out of his black-and-white negatives by rendering them digitally.

For many photographers of Feinstein's generation, the darkroom serves as a meditation chamber, in which the interpretive process of printmaking turns the negative into a communicative expression of its maker's vision. This is achieved through a delicate adjustment of tonal relationships, among other strategies. Yet before the introduction of digital imaging systems those options were largely beyond the reach of photographers working in color. As digital technologies level the playing field for workers in both forms, the dramatic schism between them that prevailed for decades may rapidly come to look archaic, anachronistic, even quaint. After all, if photographers can work as interpretively in color as they can in black and white, both simply become tools in the kit bag, equally handy and viable, the choice depending entirely on the project and the photographer's inclination.

That seems to me the way that Feinstein has treated his decision to work with color here. Beyond that, he's still showing us a world filtered through his own inimitable sensibility. Consequently, once they get over the shock, those who know Feinstein from his more familiar work will see clear relationships between this suite and, say, his Coney Island work. Animated by the same spirit, they actively enrich and amplify each other. Moving between examples of the two of them, as I am here at my desk, I find a profound awe in the presence of living things manifested in all his pictures. A cluster of smiling faces on a beach blanket suddenly becomes a bouquet; a thoughtful scrutiny of an opened blossom suggests a portrait. Part and parcel of the same encompassing worldview, they need no further justification.

Because flowers partake of the sacral in many religions (think of the rose in Christianity, the lotus in Buddhism), because they've fascinated botanists as accessible examples of the process of reproduction in nature, and of course simply because they're beautiful objects in their own right, bound volumes of images of flowers in fact constitute an ancient and widespread form of book. Stopping to smell the roses represents one form of contemplation; sitting down to study pictures of the roses is another.

Like picture-makers in the preceding visual arts, photographers have from their medium's inception been drawn to flowers as subject matter, to such an extent that a recent survey of work in this vein gathered hundreds of examples while by necessity omitting thousands more.[2] And most photographers who have addressed this subject matter have of course encouraged us to look more attentively at flowers.

Feinstein suggests, instead, that we see ourselves in relation to them, look *into* them, and his images enable us to do so. You or I could never get this physically close to a flower and see it in such detail. This combination of proximity and precision of focus, unavailable to the naked eye, is a gift to us from photography. There are pictures in this suite so crisp that you can count the grains of pollen on a stamen, trace tiny filaments and veins.

You'll probably engage with Feinstein's images, as presented in this book, by holding the volume in your lap, or perhaps perusing it as it lies open upon a table. So your experience of these pictures will be one of an illusory hovering over each flower, then a descent into it and a browsing, perhaps even an imaginary landing on this or that surface.

Is this the way that insects experience the entrance into a blossom? Would a bee, a butterfly, an ant perceive it that same way as you or I do? Undoubtedly not. The invitation here is not to speculate anthropomorphically on the perceptual or psychological structures of other species, but rather to imagine how it would feel, with our own intelligence and spirit and sensorium, to exist consciously among, enter into and inhabit these living organisms—as if they were residences, restaurants, homes, sanctuaries, houses of worship. Or to think of them as fellow citizens, inhabitants of a shared ecosystem—or as spirits interacting with our own.

For Feinstein treats these living forms in a variety of ways. In some of his images the flower appears as a fleshed, tactile, sensuous creature, a corporeal being alive and embodied. In others he reveals his subject as a scape, a visual terrain inviting imagined travel. Yet others he renders as architectural spaces, complex constructions through which he encourages the viewer's eye and mind to wander. And still others pulse and radiate like flames, pure energy somehow made visible.

"To reveal the miracle of what I believe to be God's creations," Feinstein wrote recently, "has been my path with the camera, even though I was unaware that this was so until later in my life. . . . [W]e have ceased to see the life in which we live. It is my intent to cause the viewer to revisit the gifts we are surrounded by and see them as if for the first time."[3] Whether one believes in divinity or Darwinism, what Feinstein reminds us of with these images, as he does in all his work, is the astonishment of "the life in which we live." Persuading us to attend closely and reverently to it once more, wherever it manifests itself, is his great gift, opening itself before you in these pages.

1. Quoted in Hunt, Leslie, "An Unobstructed View: Harold Feinstein's Inner Eye Grows Keener With the Passing Seasons," *Photo-Electronic Imaging*, February 1999, p.8.

2. William Ewing, *Flora Photographica: The Flower in Photography from 1835 to the Present* (New York: Simon & Schuster, 1991).

3. Untitled statement, July 13, 1999.

WHITE FLOWERS

Plants with white flowers, or white variegated leaves, announce themselves in the garden by calling out with their brightness. White is a color that attracts attention—it immediately draws the eye. The word "white" is derived from Old English and means "to shine." And white literally does shine, or reflect, all colors off its surface—absorbing none. It is not really a color but represents the absence of color.

The brightness, or luminescence, of a white flower or leaf depends on how light and shadow play off its shape and texture, and additionally, how the eye and brain perceive the purity of its whiteness. Not many white flowers are pure, even though white is a universal symbol of purity; most are blended with hues of green, yellow, pink, or lavender. White blended with another color, even the slightest hint of color, becomes a white less saturated, less intense.

White affects the landscape more vividly than any color. The brightest white will shorten visual distance, making any white object seem closer than it really is: a visual trick of perspective. Placing white in the foreground of a landscape and darker, muted colors in the distance creates a feeling of length and spaciousness. The eye is drawn to the close, white object, making those in the distance seem farther away than they are. And at night, especially with the help of moonlight, white flowers are more visible than others because the eye responds more to illumination than to color.

Everyone visualizes color differently, and like any color, the character of white will appear different to everyone. White can be cool or warm. The quality of the light and the air, the season, the angle of the sun, the amount and color of foliage, all play a part in how white is perceived.

19. GARDEN RANUNCULUS, *Ranunculus asiaticus* cultivar
Originally native to Turkey, the magnificent double-flowered ranunculus blossoms were first grown in European gardens in the late eighteenth century. But because they are difficult to grow outside, they are more often raised in greenhouses as a florist's flower.

20. MAGNOLIA, *Magnolia* cultivar
Georgia O'Keeffe shared these thoughts about why she painted flowers that were larger than life: "Everyone has many associations with a flower—the idea of flowers. You put out your hand to touch the flower, lean forward to smell it, maybe touch it with your lips almost without thinking, or give it to someone to please them. Still, in a way, nobody sees a flower, really; it is so small, we haven't time, and to see takes time like to have a friend takes time."

21. GARDEN DAHLIA, *Dahlia* cultivar
Dahlias are vigorously growing plants that require full sun, rich soil, and heavy fertilization for optimum performance. In warm climates they are perennials, in cold areas, they are treated as annuals. More than twenty thousand named dahlia hybrids exist, in shapes ranging from cactus-flowered to pompon. All originate from species native to Mexico and Central America.

22. HYBRID GARDEN ANEMONE, *Anemone hybrida* cultivar
Hybrid anemones and Japanese anemones are two common names for the same group of perennial plants. Gardeners in England, the United States, France, and Germany raised many hybrids from species native to Japan. They're easy-to-grow garden plants that bloom on long, wiry stems in late summer and autumn.

23. FLORIST'S CHRYSANTHEMUM, *Dendranthema grandiflorum* cultivar
Chrysanthemums, or mums, are common names for these, the most common of all florist's flowers. When grown outdoors, mums bring autumn color to the garden as the shorter days of autumn initiate flower buds to form.

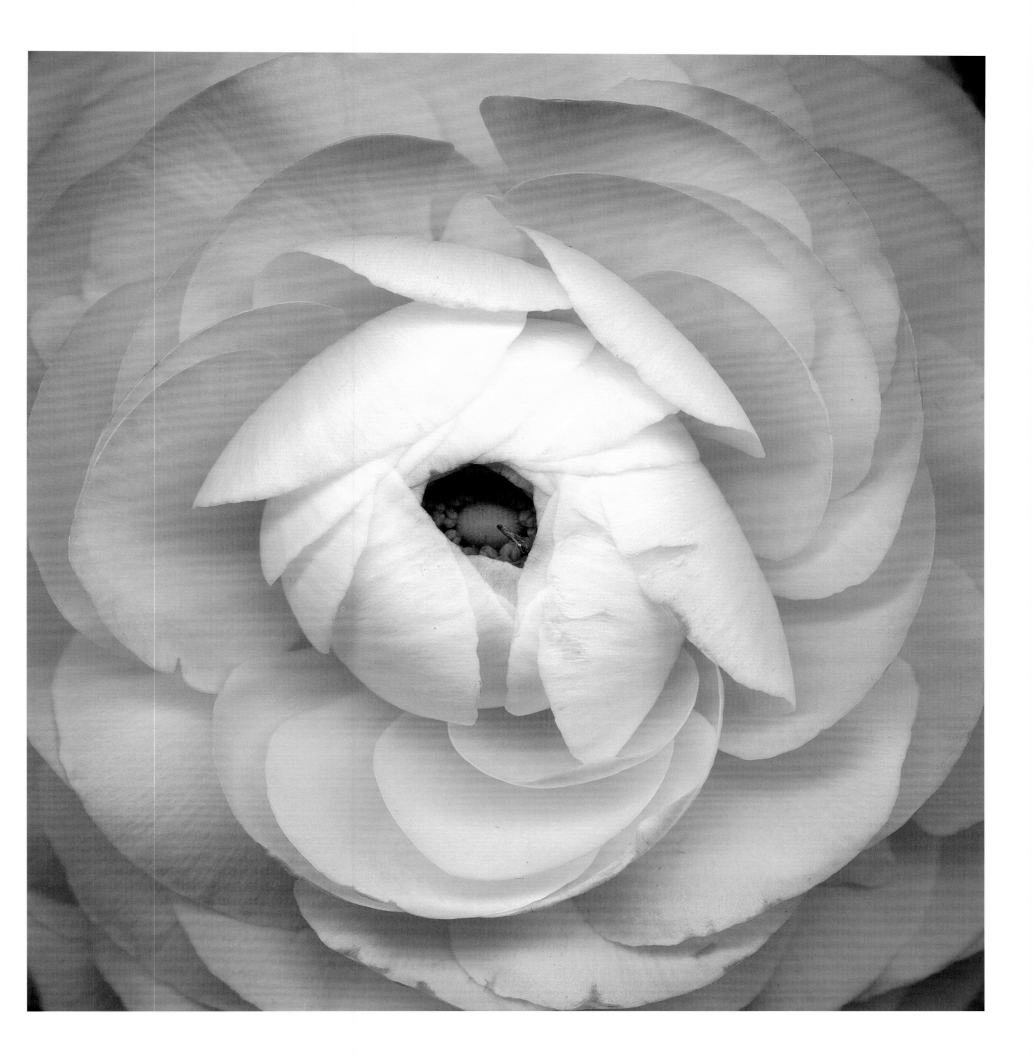

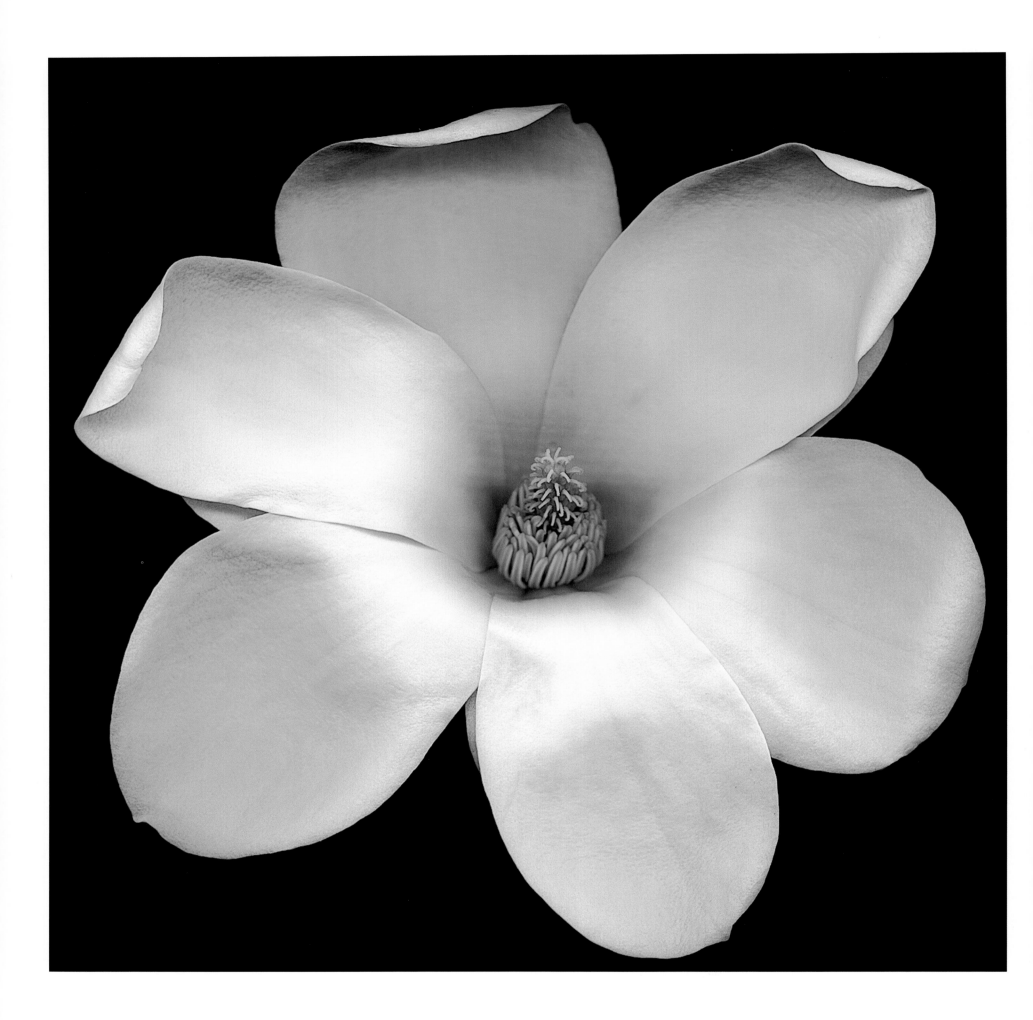

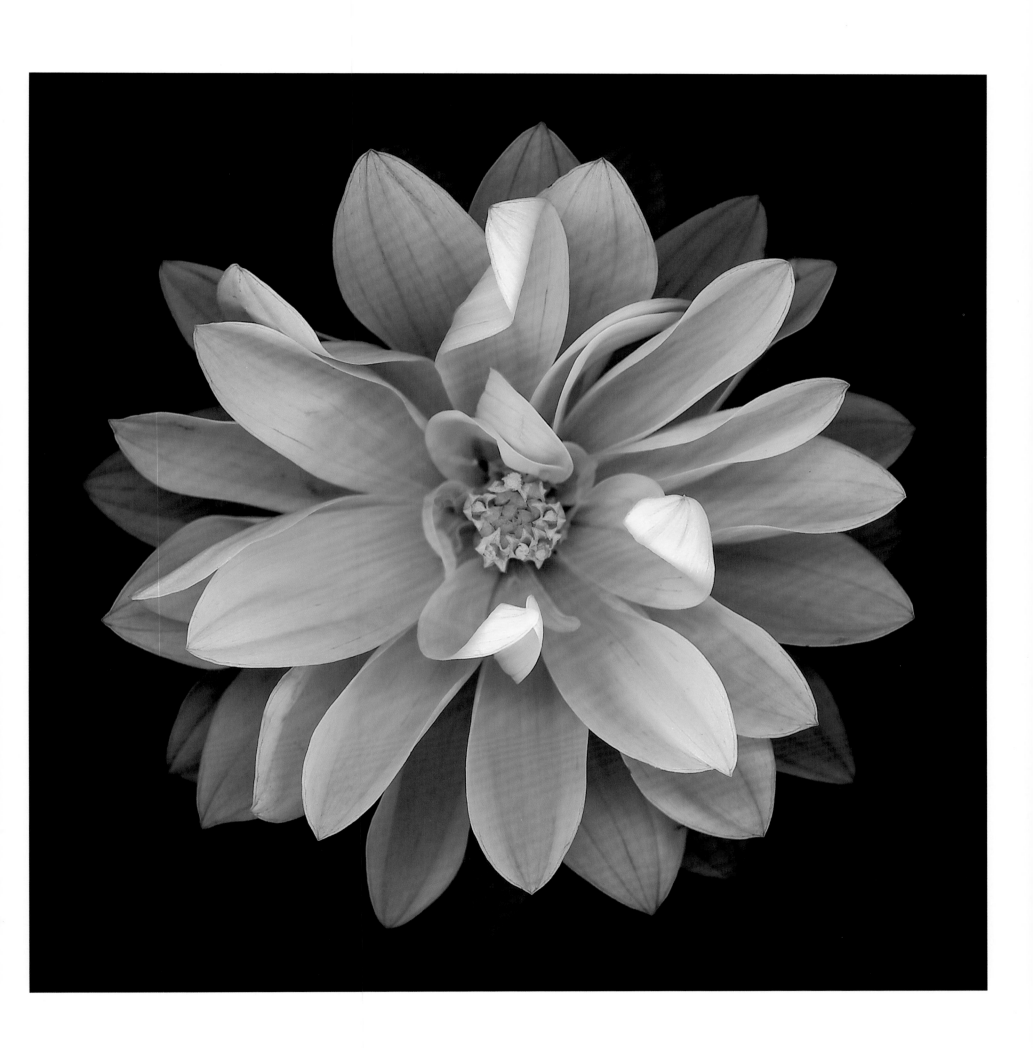

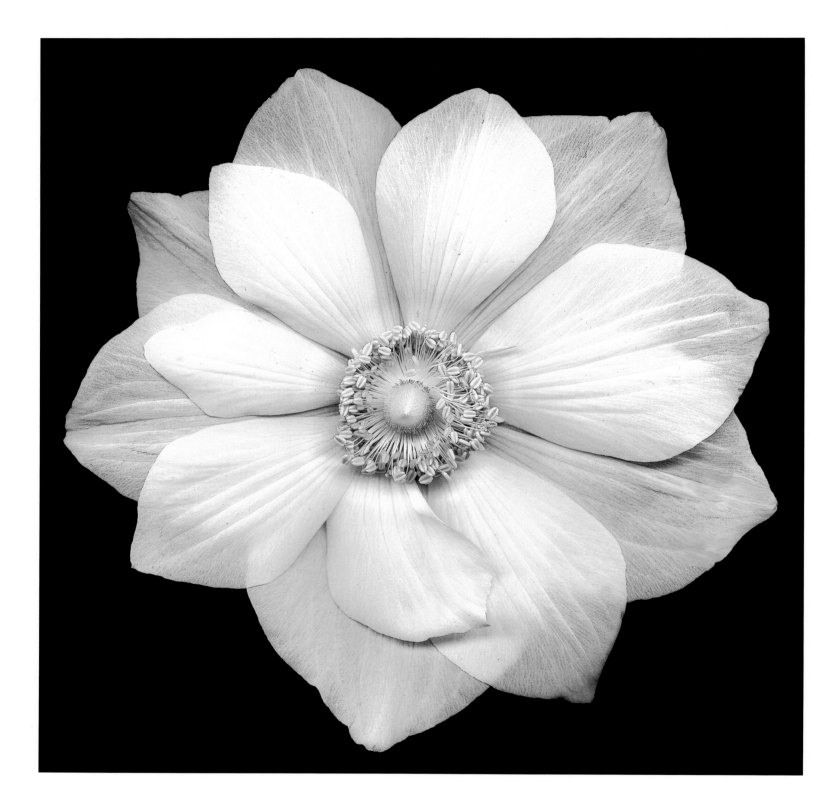

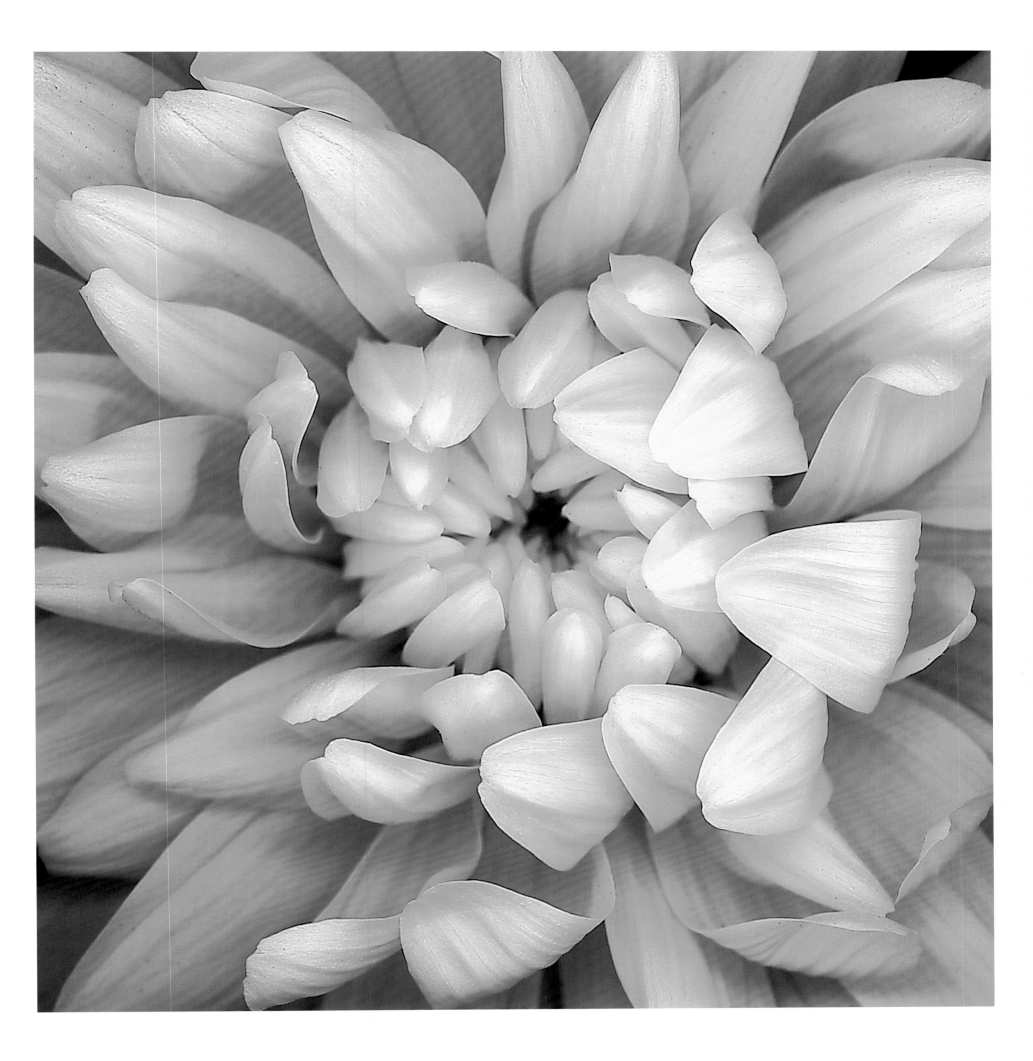

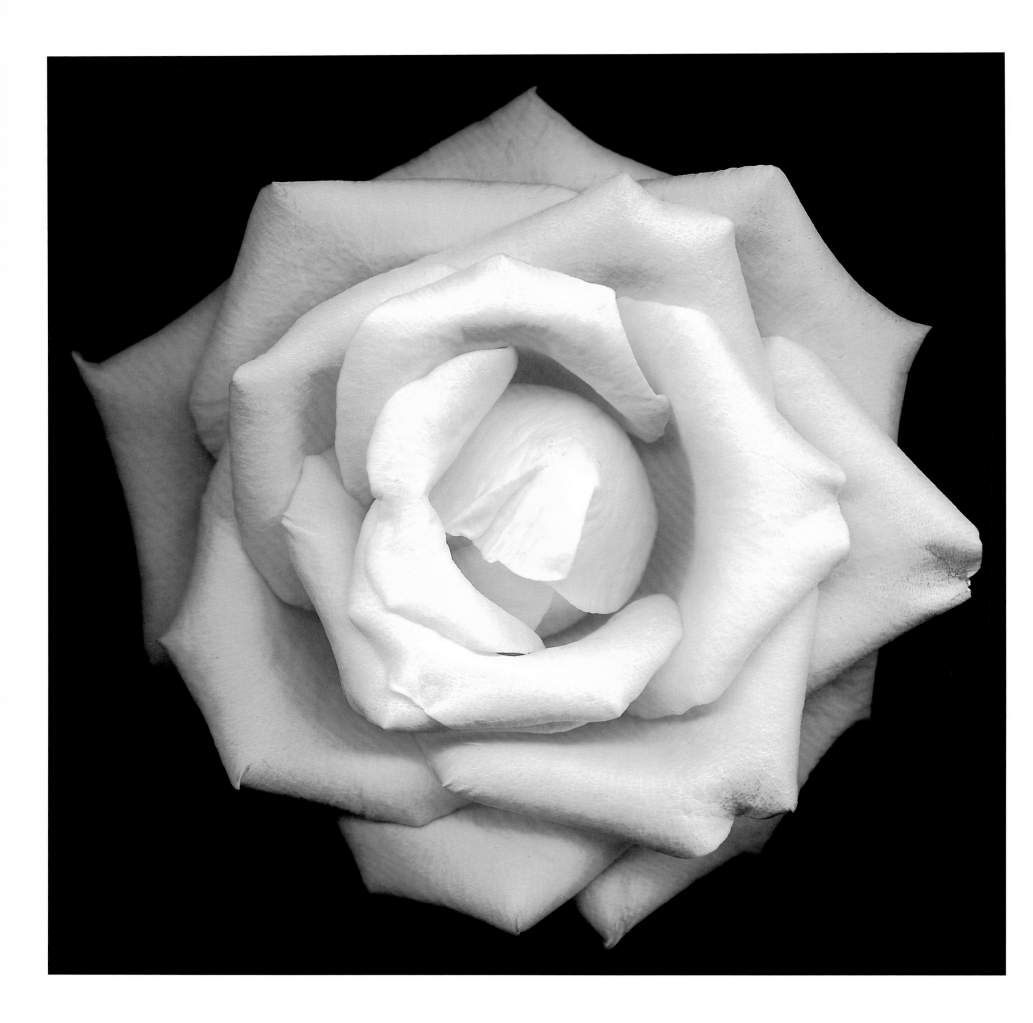

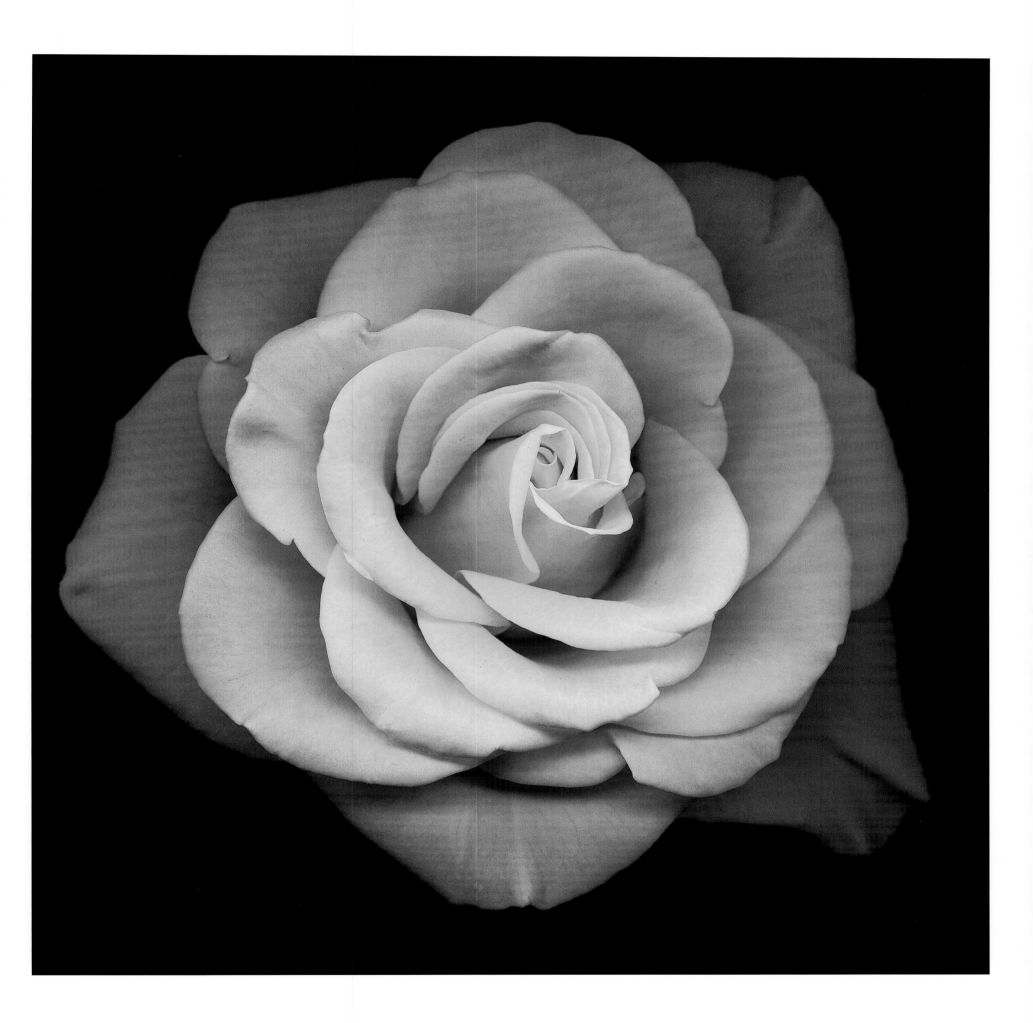

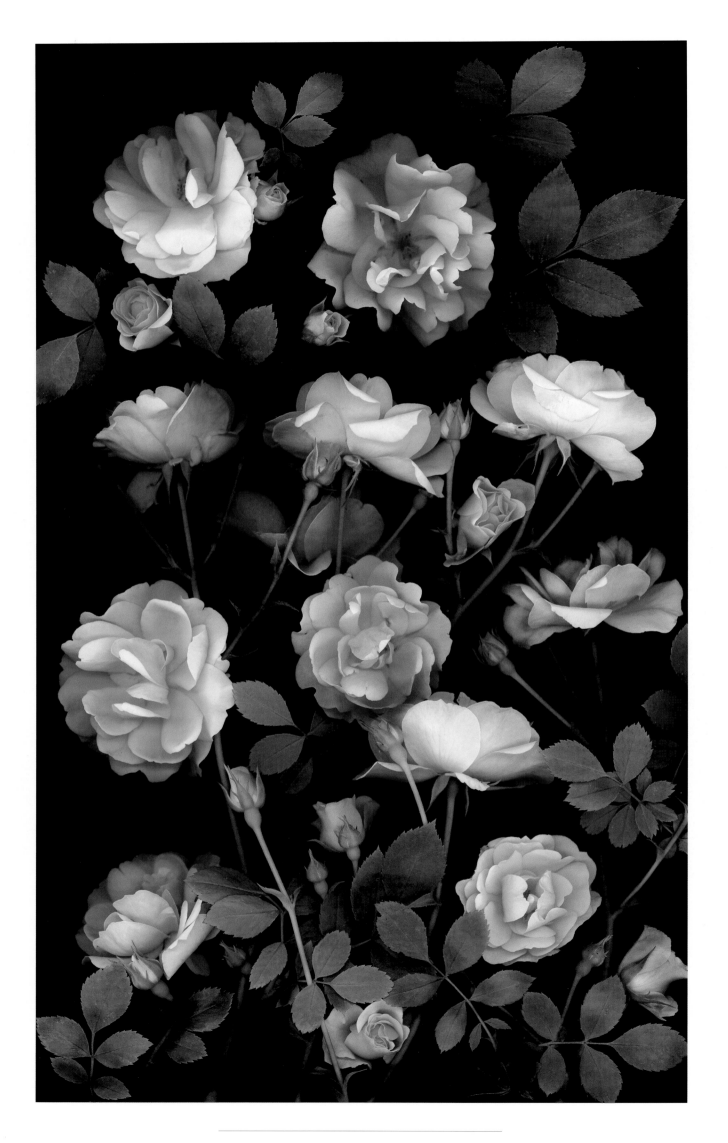

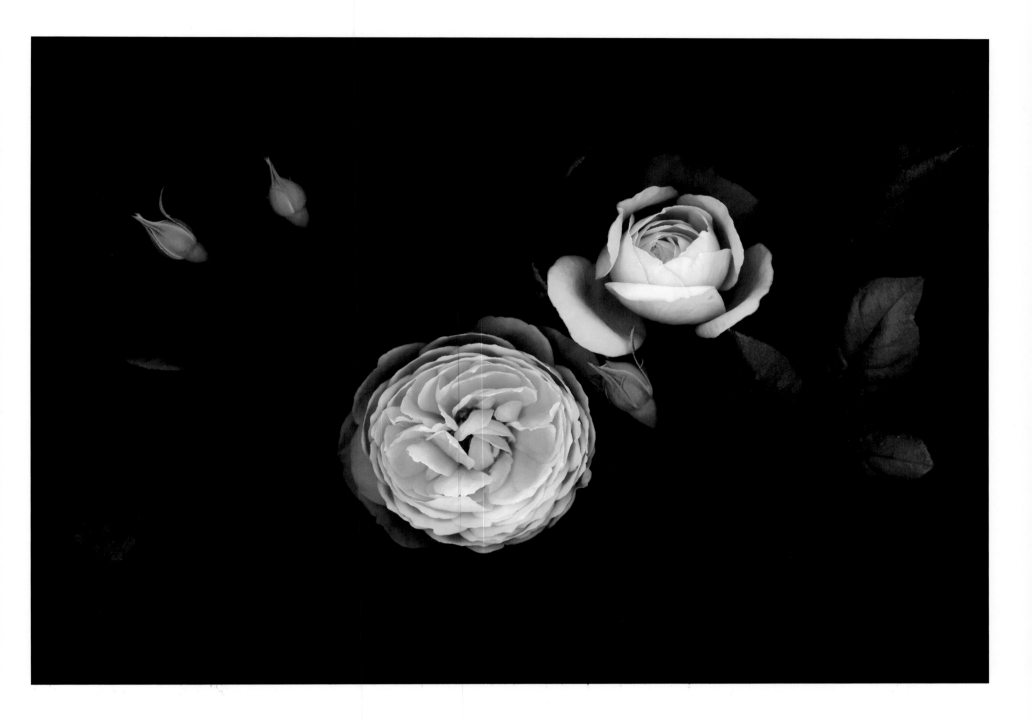

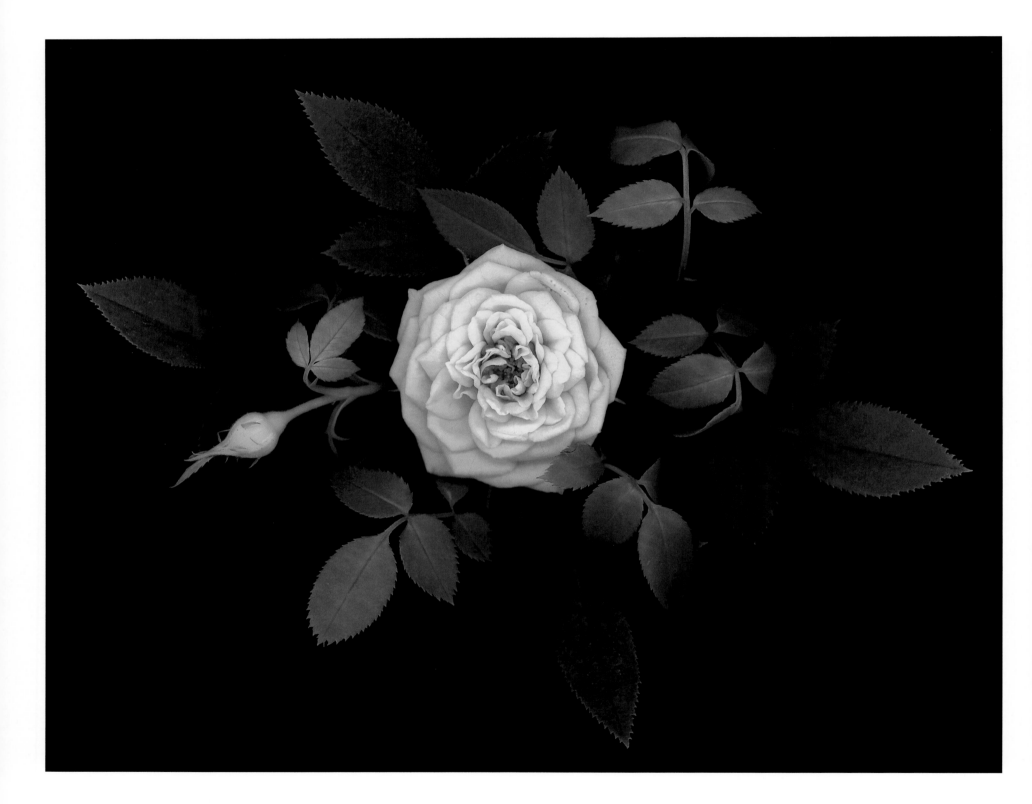

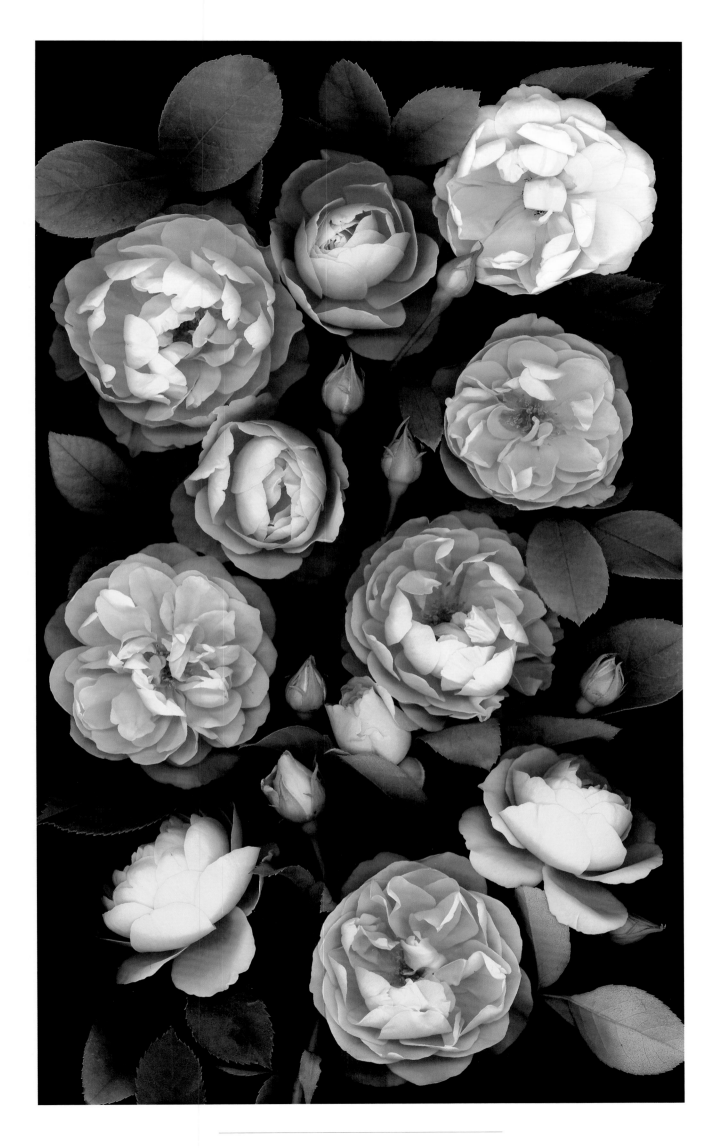

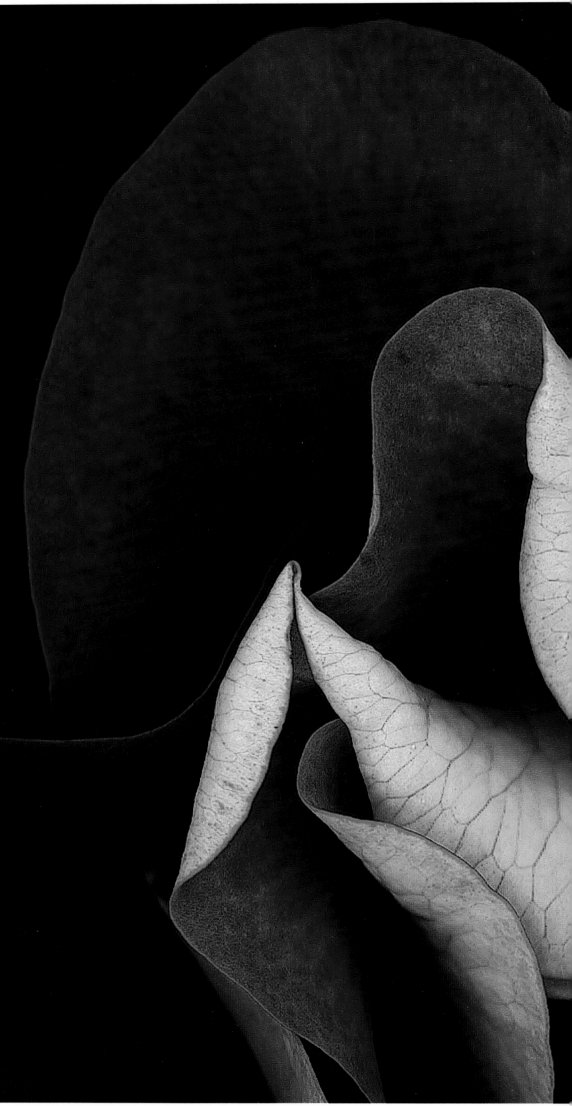

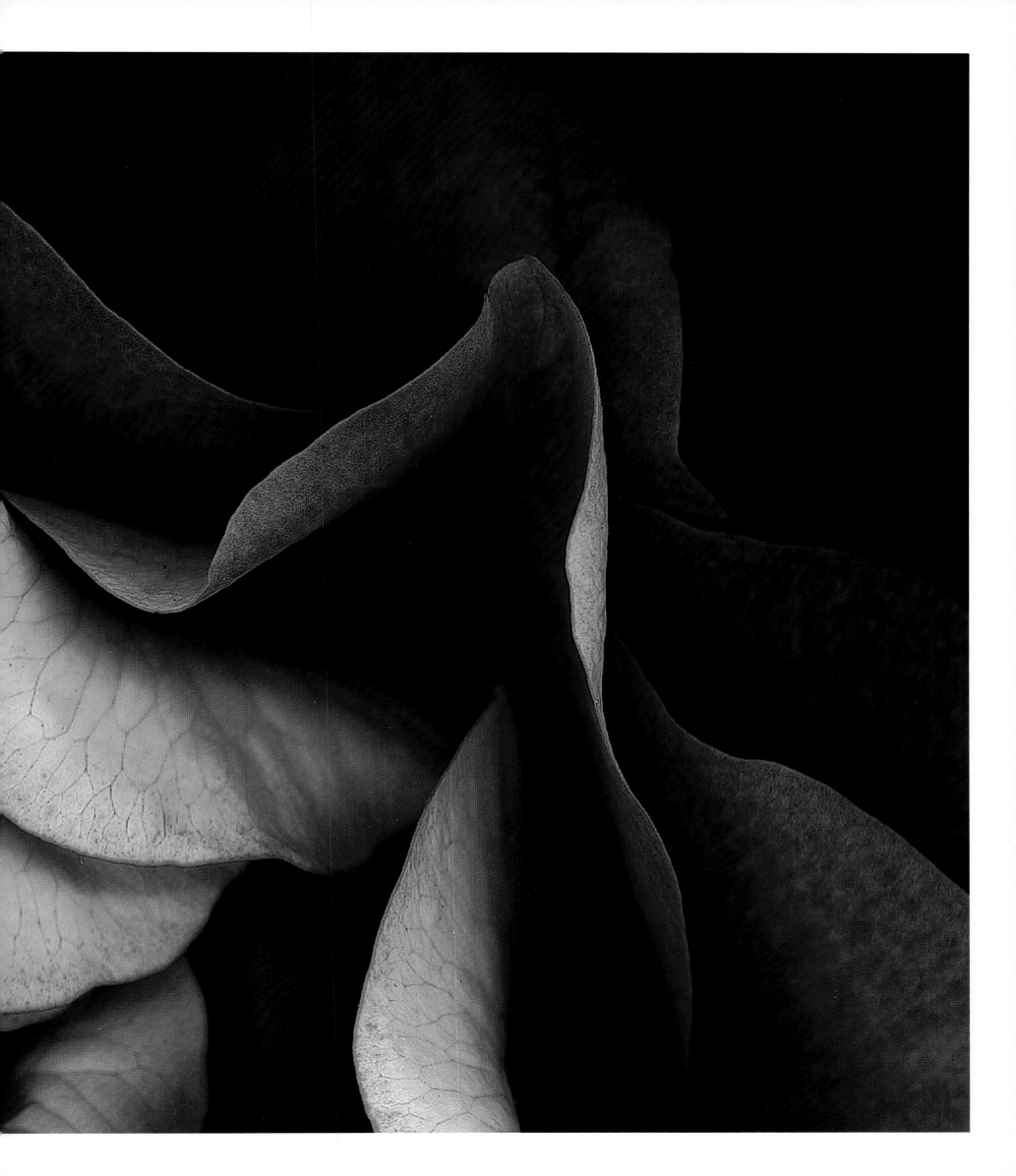

PANSIES

Pansies are cherished by gardeners and non-gardeners alike. They bloom when the weather is cool and are a joy to see, especially at times when other garden flowers are scarce. The English common name, pansy, is derived from the French word *pensée*, meaning to think or to have an idea—to be thoughtful; pensive is an obvious derivation. Four hundred years after the common name came into use, it can be difficult to understand how or why it was applied to this plant. One explanation comes from the idea that the flowers of pansies and violets are thought of as expressive, human faces. Because of the association of the flower with human character, the word *pensée* is a suitable designation. The common name, heartsease, was used for the pansies' smaller kin—the violet. And it's easy to reason that the bright faces of violets could ease the heart. Both pansies and violets share the same botanical name, *Viola*, which is the ancient Latin name for a violet.

Pansies are favorite bedding plants in regions lucky enough to have mild winters or cool summers. Autumn planting is best if your winters are mild and summers hot; the plants will bloom sporadically during the winter and profusely in the spring. Spring planting is best in regions with cool summers for blossoms all summer and autumn, until hard frost occurs. Pansies are treated as cool-season annuals: they will live only for one season or until temperatures become too warm for them to continue growing.

Pansies can truly be called flowers of the modern age. They are endemic to cultivated gardens and are not to be found anywhere in the wild. Developed in the gardens of England during the 1830s, plant breeders used seedlings of *Viola tricolor*, the Johnny jump-up, to establish a strain of flowers with dark centers that have become known as pansies. Since then, many pansies have been introduced by plant breeders with and without dark centers.

35. GARDEN PANSY, *Viola wittrockiana* 'Antique Shades'
Pansies are indispensable because they provide spring color with minimum care.
As the short days of winter lengthen toward spring, pansies bloom profusely with their jewel-colored blossoms. When planted in reasonable soil and in sun or light shade, pansies will unfurl their pointed buds even on bright winter days.

36. GARDEN PANSY, *Viola wittrockiana* cultivars
Katherine Whiteside writes in *Antique Flowers* that the predecessors of modern pansies, violets, have more than two hundred common names. Tickle-my-fancy, love-in-idleness, meet-her-in-the-entry-kiss-her-in-the-buttery are a few of the colorful common names used in England before the nineteenth century.

37. GARDEN PANSY, *Viola wittrockiana* cultivar
Another association the pansy has is with remembrance; this is very much like the idea of thoughtfulness. Shakespeare used this meaning in *Hamlet*: ". . . and there is pansies, that's for thoughts."

38. GARDEN PANSY, *Viola wittrockiana* cultivar
Louise Beebe Wilder writes in *The Fragrant Garden*; "The juice of the pansy in old times was believed to have a wondrous power of increasing the affections."

39. GARDEN PANSY, *Viola wittrockiana* cultivar
In the 1840s, pansies were so popular in England that clubs devoted to the flower organized exhibitions of this highly prized florist's flower. Cut blossoms were judged and awarded prizes. The popularity of "pansy societies" in England led to their organization in France and Belgium.

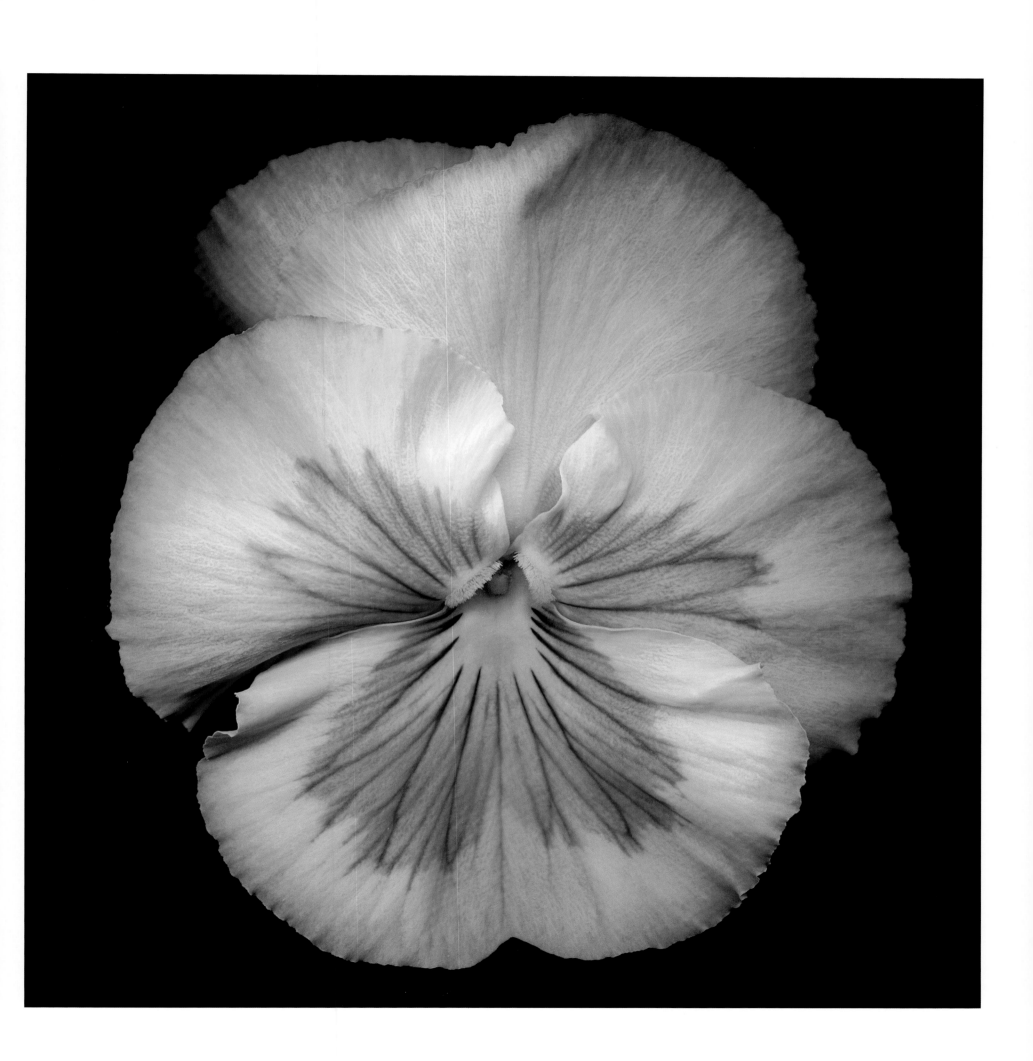

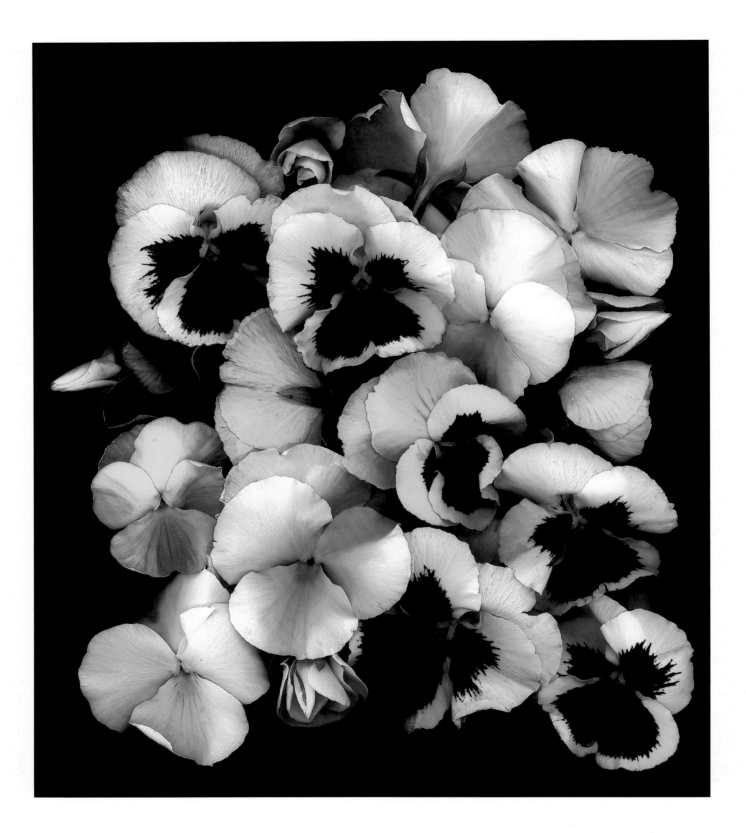

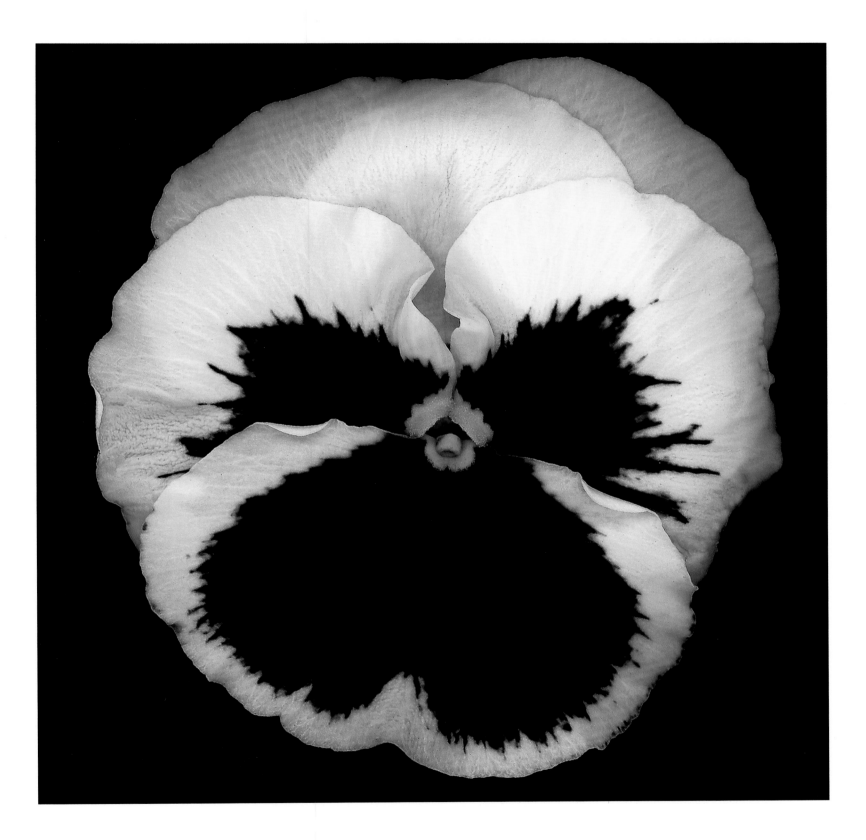

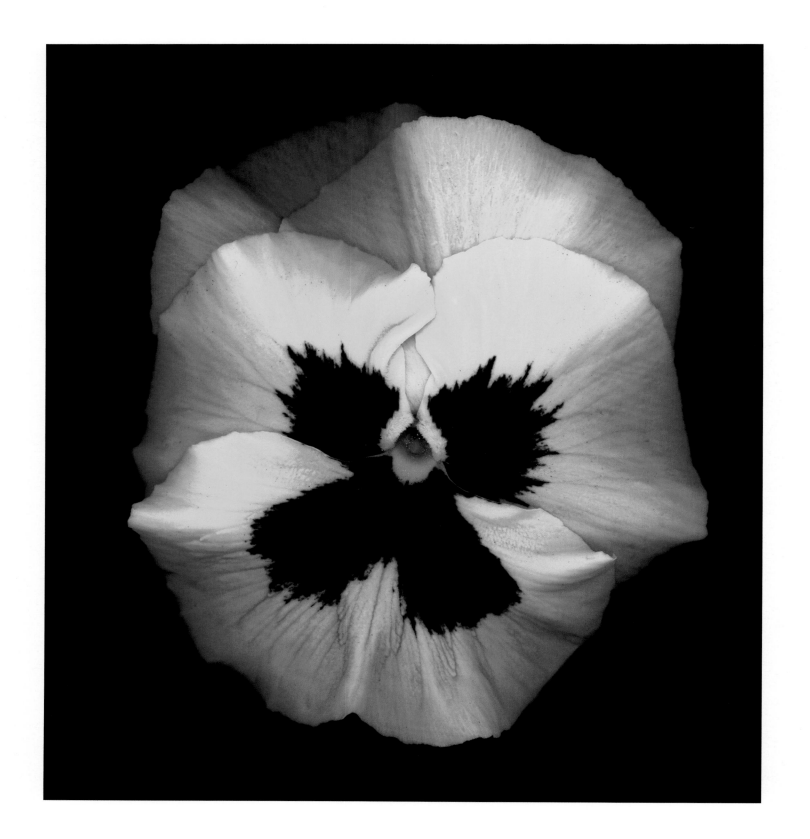

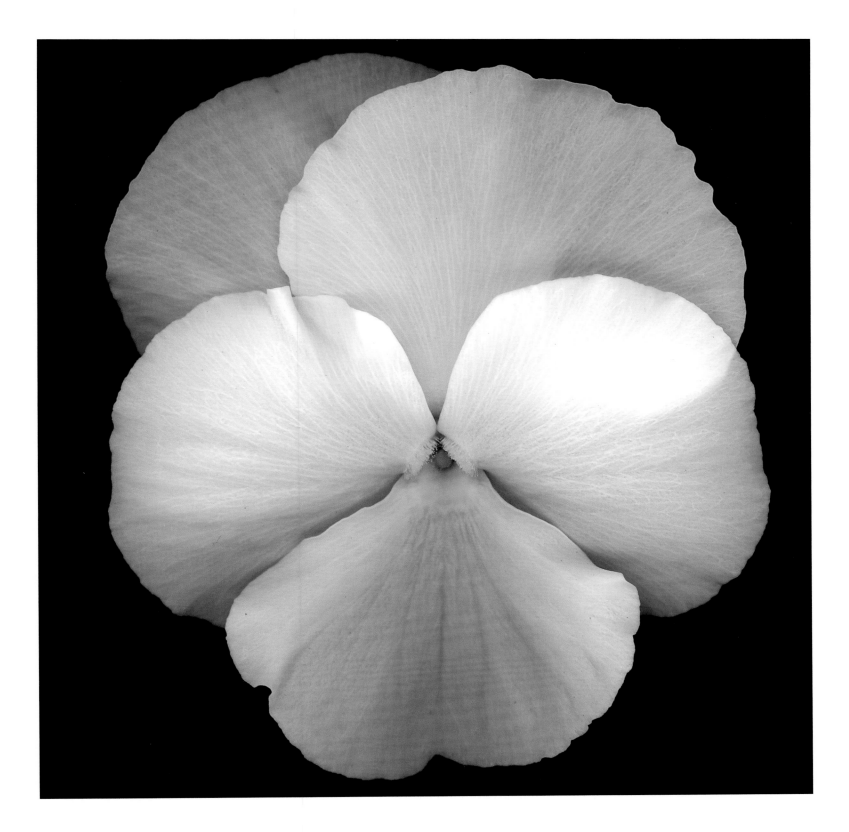

POPPIES

Ancient Greeks believed that sleep was the best medicine, and the sleep-inducing drug morphine honors Morpheus, the god who shaped the images in their dreams. Morphine and other opium derivatives are alkaloids (organic bases that originate from plants) that are produced from the dried milky sap of *Papaver somniferum*, the opium poppy. Only sap from unripe seed capsules contains the alkaloids; no other parts, including the seeds that are used in baking, have narcotic properties. Native to southeastern Europe and adjacent Asia, this poppy varies in color and flower form. Creamy white, mauve, and purple predominate, but pink and salmon colors also exist, especially in the double forms. The opium poppy is an annual but is a prodigious self-seeder and will reappear each year; once it's in your garden, you'll never be without it.

Of the fifty species in the world, the field poppy of Europe (*Papaver rhoeas*), has also been recorded as having narcotic properties. This annual poppy gave rise to the colorful Shirley poppy, a strain selected by Reverend Wilks of England. Like many vicars, he cultivated a garden. In 1880, among the typical scarlet field poppies, Reverend Wilks spotted one plant with unique coloration. Its petals were edged in white—something not seen before. The reverend tagged the plant and saved the seed. Many years and several seed generations later, a new strain of poppies developed that included varying shades of pink and white. Reverend Wilks called them Shirley poppies to commemorate the vicarage.

The Shirley poppy is in a league with other plants that have been transformed by enthusiastic gardeners and florists into creations of exquisite beauty. With many plants—pansies, carnations, irises, primroses, and daylilies to name a few—it's the "backyard" gardener, the amateur botanist, making the big strides in plant breeding. Plants are improved gradually, in small steps, by people who have patience and vision, by people who admit that luck has a lot to do with the outcome, by people who realize there's more to creation than what they put into it. Walt Whitman accurately sums up the creation of a new flower: "As to me, I know of nothing else but miracles."

41. ICELANDIC POPPY, *Papaver nudicaule*
The botanical name *Papaver* is the Latin word for poppy, but some feel the root word *papa* suggests a similarity between the juice of some poppies and breast milk.

42. CALIFORNIA POPPY, *Eschscholzia californica*
These low growing poppy relatives have brightly colored orange flowers and silvery foliage that make a carpet of color when in bloom. They're tender perennials that will reappear each year from seed.

43. POPPY, *Papaver species*
Robert Burns writes in "Tam o' Shanter:" "but pleasures are like poppies spread—You seize the flow'r, its bloom is shed . . ." Poppies do not last long as cut flowers unless they're cut before they open, during the cool of morning. Once cut, dip the ends into boiling water, then submerge them in ice cold water. With this treatment the flowers will look fresh for days before shedding.

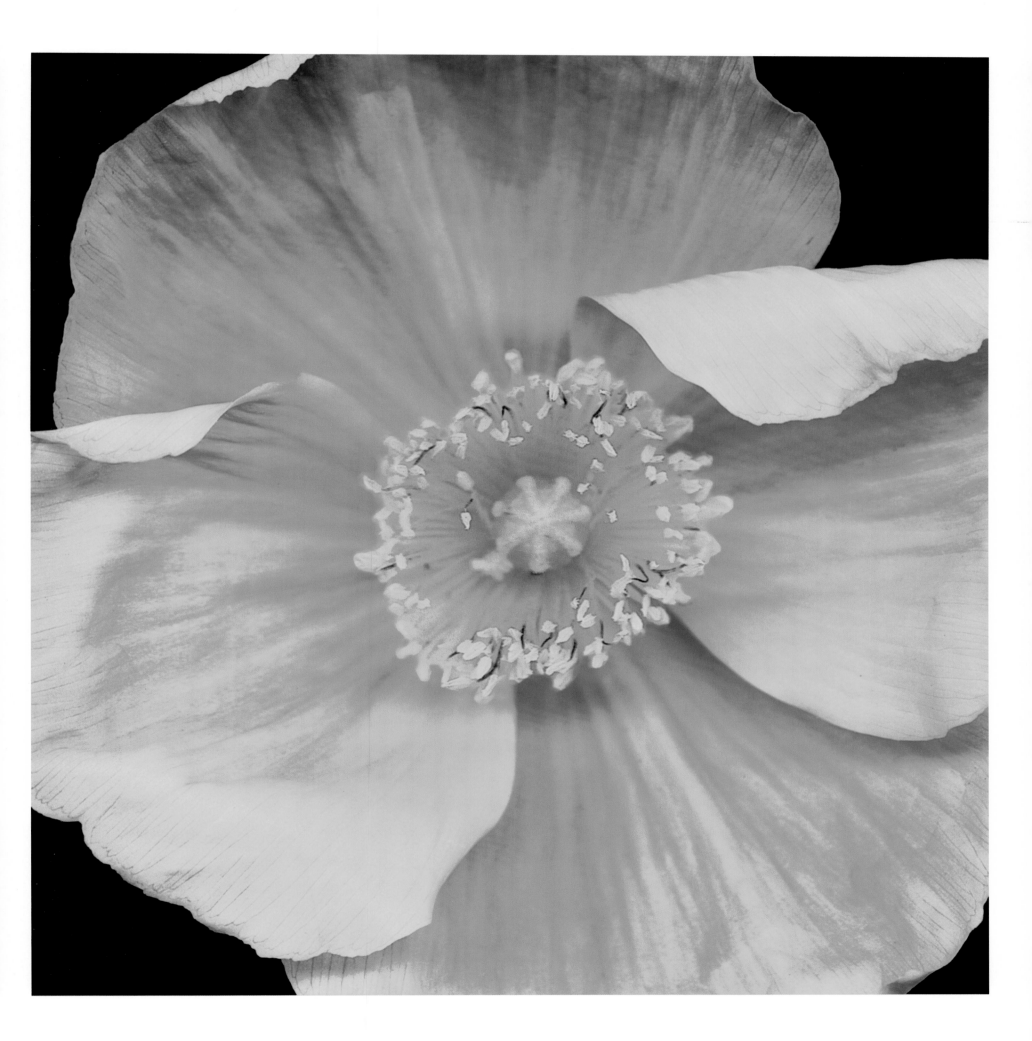

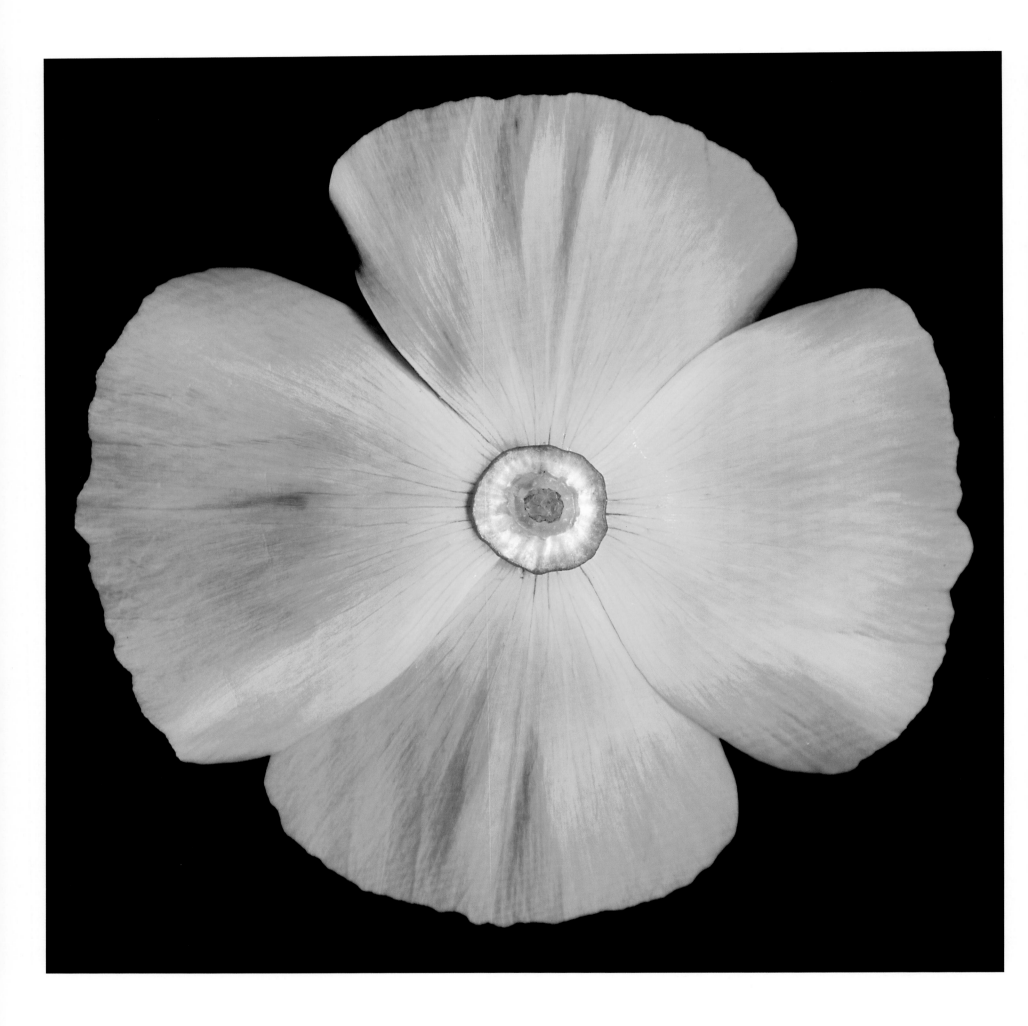

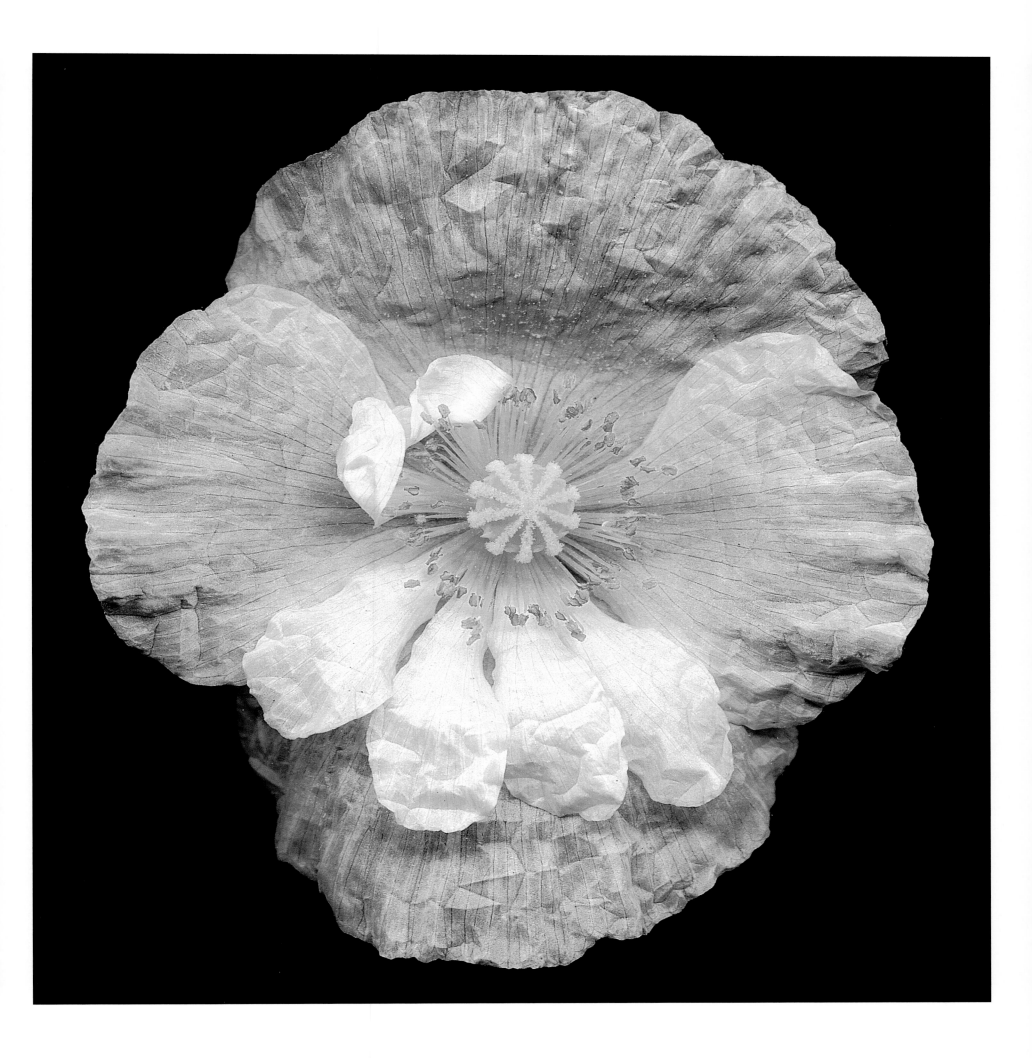

ORCHIDS

Orchids are a large group of flowering plants that contain approximately eighteen thousand species, and the only places they don't grow naturally are in the coldest and driest climates of the world. Because they are common to many habitats, orchids have evolved in many directions. Their flowers are more diverse than most other groups of flowering plants, a diversity that takes advantage of a wide population of pollinators. And this is beneficial because the continuation and evolution of the orchid species through pollination is the purpose of these plants. Bees, wasps, ants, beetles, birds, bats, frogs, and flies of many kinds pollinate the blossoms after being lured to them by scent or visual patterns. Once pollination and fertilization take place, a capsule containing many seeds begins to develop. The seed capsule of one particular orchid, *Vanilla planifolia*, is the source of vanilla flavoring. Although it's not a bean, the seed capsule resembles a long, thin bean pod and is called a vanilla bean.

Although a big group by themselves, orchids belong to an even larger community called angiosperms; these are the flowering plants of the world. "Angiosperm" is a Latin word that means housed seed. The seeds of these plants are enclosed in a protective covering, commonly called a fruit. A smaller group of plants are the gymnosperms. Conifers, such as pine trees, and other related plants belong to this group. They produce seeds that are naked, not enclosed in a fruit, and are not considered flowering plants.

Ferns and fern-like plants are called pteridophytes. This group is primitive; they do not have flowers or fruit and reproduce by spores instead of seeds. The organization of plants into these groups identifies them and classifies them in evolutionary terms—information that helps people understand how plants relate to one another.

Botanists and plant taxonomists consider orchids to be a group of highly evolved plants. Botany and plant taxonomy are two interrelated fields of plant science—botany, the study of plant anatomy, and plant taxonomy, the identification of plants—that help create a sense of the plant kingdom's web of life. Many factors are considered before making an educated decision about the evolutionary status of a plant—chemistry; geography and habitat; form and function of roots, stems, leaves, and flowers; pollen shape and method of pollination. In the end, the decision is more of an educated guess than anything else, since the result cannot be confirmed.

Some of the characteristics that make orchids more advanced than plants such as magnolias, peonies, and roses are the simplification of their leaves; their limited number of floral parts and their fusion to one another; and their success in many habitats. Plants that are more highly evolved than orchids show some of the same features, and additionally, lack flower petals and insect-attracting nectar; they are pollinated by the wind, such as the grasses.

45. TIGER-STRIPED ORCHID, *Oncidium tigrinum*
This small-flowered orchid is named for the "tiger stripes" that appear on the upper petals. Native to Mexico, this epiphytic species is grown for its lovely sprays of small blossoms, often sold as cut flowers.

46. MOTH ORCHID, *Phalaenopsis* cultivar
These are among the easiest orchids to grow indoors, where the blossoms can last for two months. Bright indirect light, good air circulation, and regular watering provide a good beginning toward maintaining a healthy moth orchid.

47. MOTH ORCHID, *Phalaenopsis* cultivar
The unique flower shape of the *Phalaenopsis* orchid is the inspiration behind the common name moth orchid. Although these orchids come in several colors, it is the stark beauty of a white *Phalaenopsis* that conjures the image of a moth in flight.

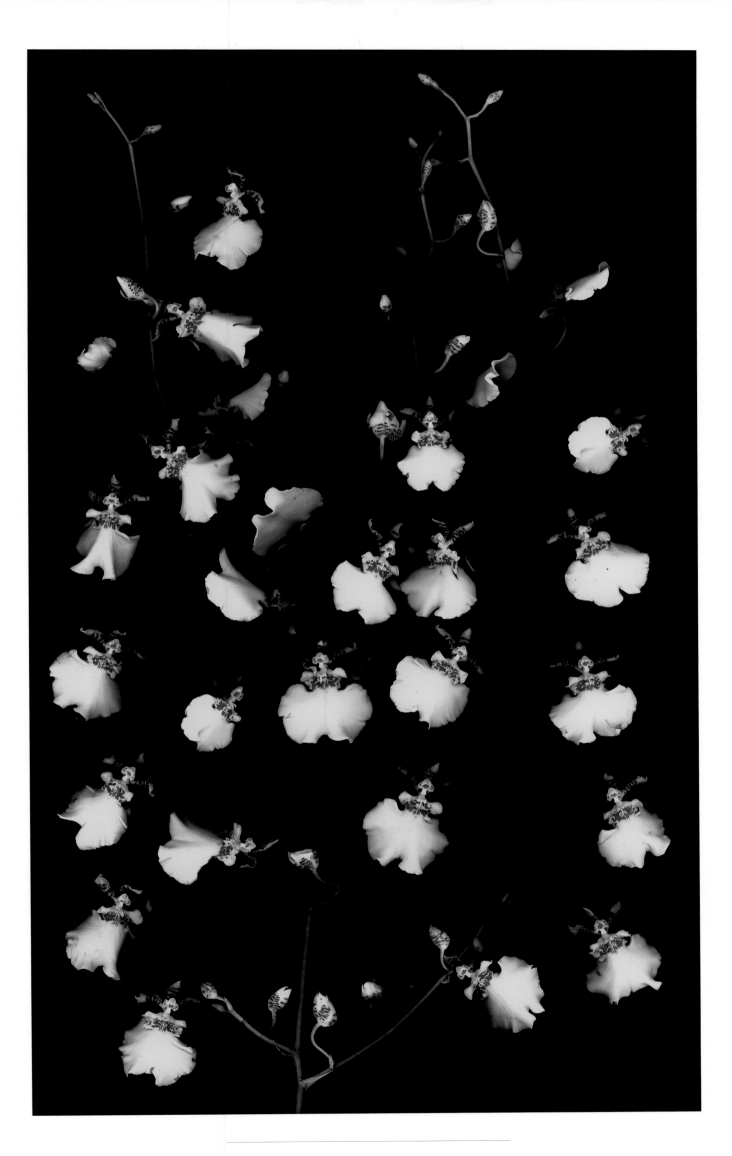

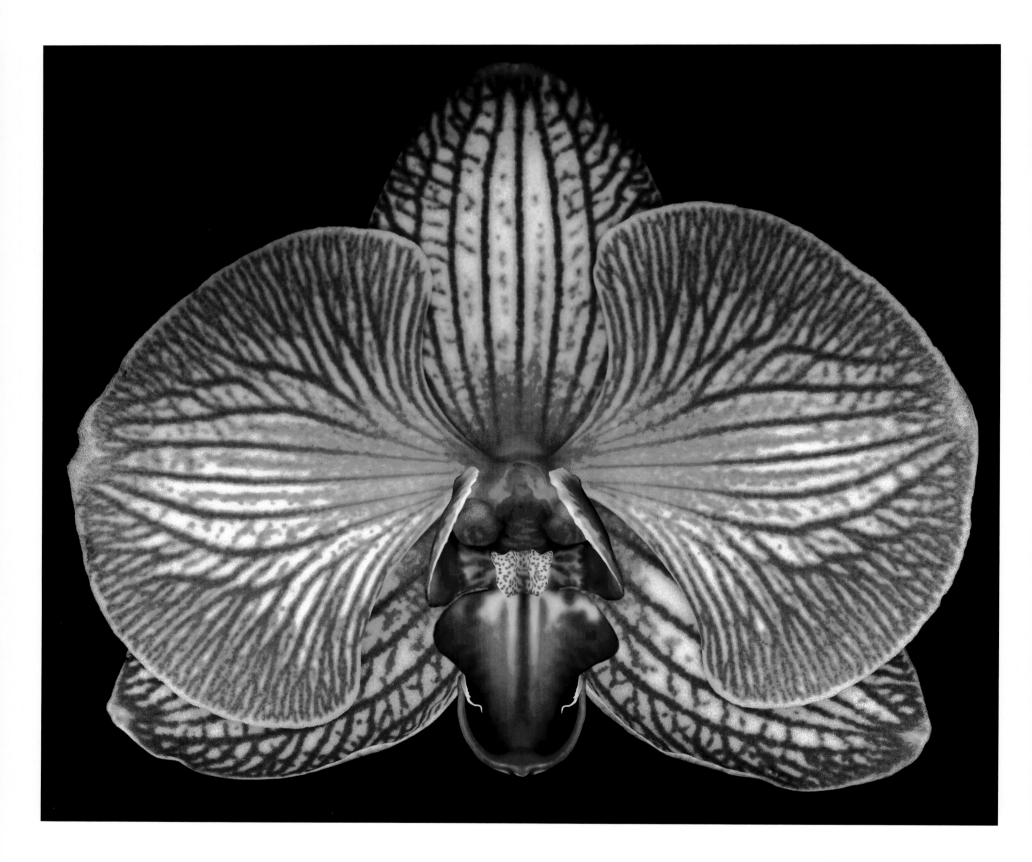

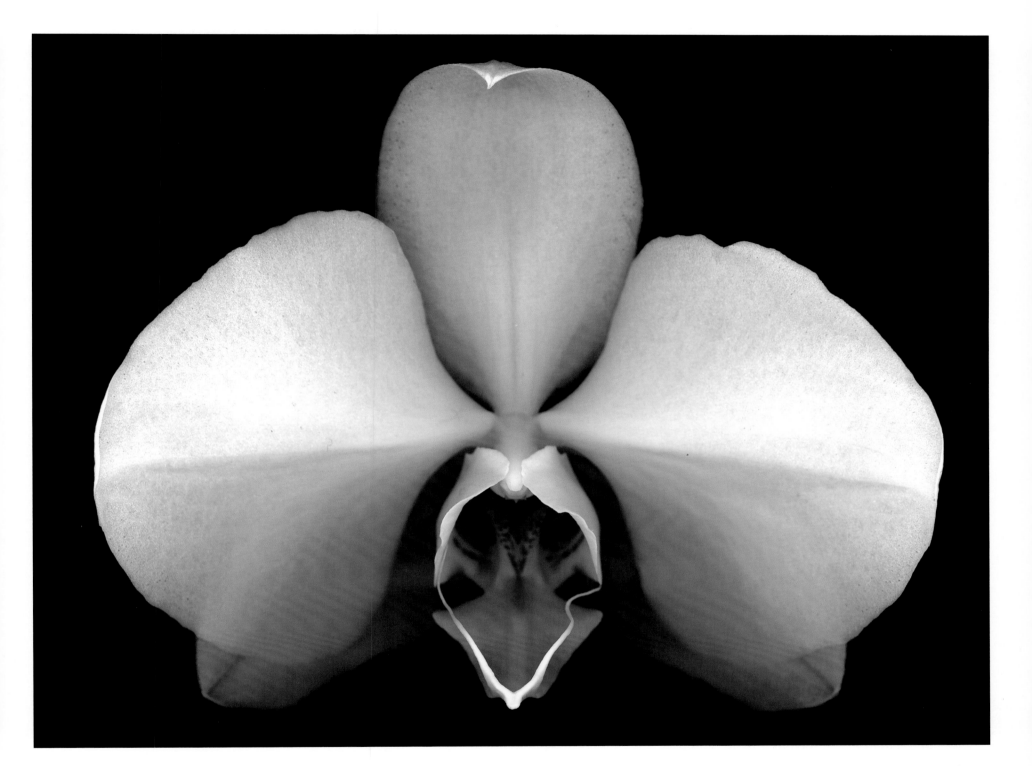

IRISES

The botanical name *Iris* is taken from the mythological Greek goddess of the rainbow—spanning the sky in the form of a rainbow, Iris carries messages from one god to another. And the colors contained within the bands of a rainbow suggest the diversity of colors found among the three hundred species of *Iris* flowers. Most are native to the northern temperate regions of Asia, Europe, and North America.

The tall-bearded irises are the ones most commonly seen in gardens. Sometimes they are mistakenly called German irises, which they resemble. The tall-bearded irises are hybrids that were bred early in the eighteenth century from a handful of species native to Europe. Since then, thousands of these irises have been bred and selected by hybridizers from around the world. In the late spring, the branched flower stems hold many beautifully sculpted and sometimes fragrant blossoms. A "rainbow of colors" does not exaggerate the variety of hues found in the flowers of these easy-to-grow perennials. They have become so popular with gardeners that their breeding and propagation is a large and profitable industry. The vertically growing, sword-shaped leaves of the bearded iris are arranged side by side in the fashion of a collapsible paper fan. They emerge from a thickened stem called a rhizome that grows horizontally along the soil. The rhizome of one specific variety of German iris, *florentina*, is called orrisroot. This fragrant rhizome can be dried and ground into a powder that serves as a base for cosmetics and perfumes.

Another popular garden perennial is the Siberian iris. The leaves of these irises are deciduous; they turn brown in the winter, when gardeners usually cut them back to the ground. Sometimes the tawny clumps of leaves are pleasant enough to leave standing for part of the winter. But when they are cut back, it's an easier job if the foliage is dry, as moist leaves have the tenacity of hemp.

49. BEARDED IRIS, *Iris* cultivar
The fleur-de-lis is a familiar symbol based on the iris. Stylized from the flower, it was used as a heraldic device among French monarchy. The iris was also the flower of chivalry, having "a sword for its leaf and a lily for its heart."

50. BEARDED IRIS, *Iris* cultivar
These beautiful plants are so satisfying because they require such little effort to maintain. They need full sun to flower well, and soil that drains quickly. The thickened stem, or rhizome, should be planted at the surface of the soil or just slightly below. Planting too deep can inhibit flowering or cause the rhizome to rot.

51. BEARDED IRIS, *Iris* cultivar
In *Flowers and Fruit*, the French writer Colétte describes "blue" irises: "The garden iris, at home in all countries . . . passes for blue thanks to the unanimity of a host of people who know nothing about the color blue."

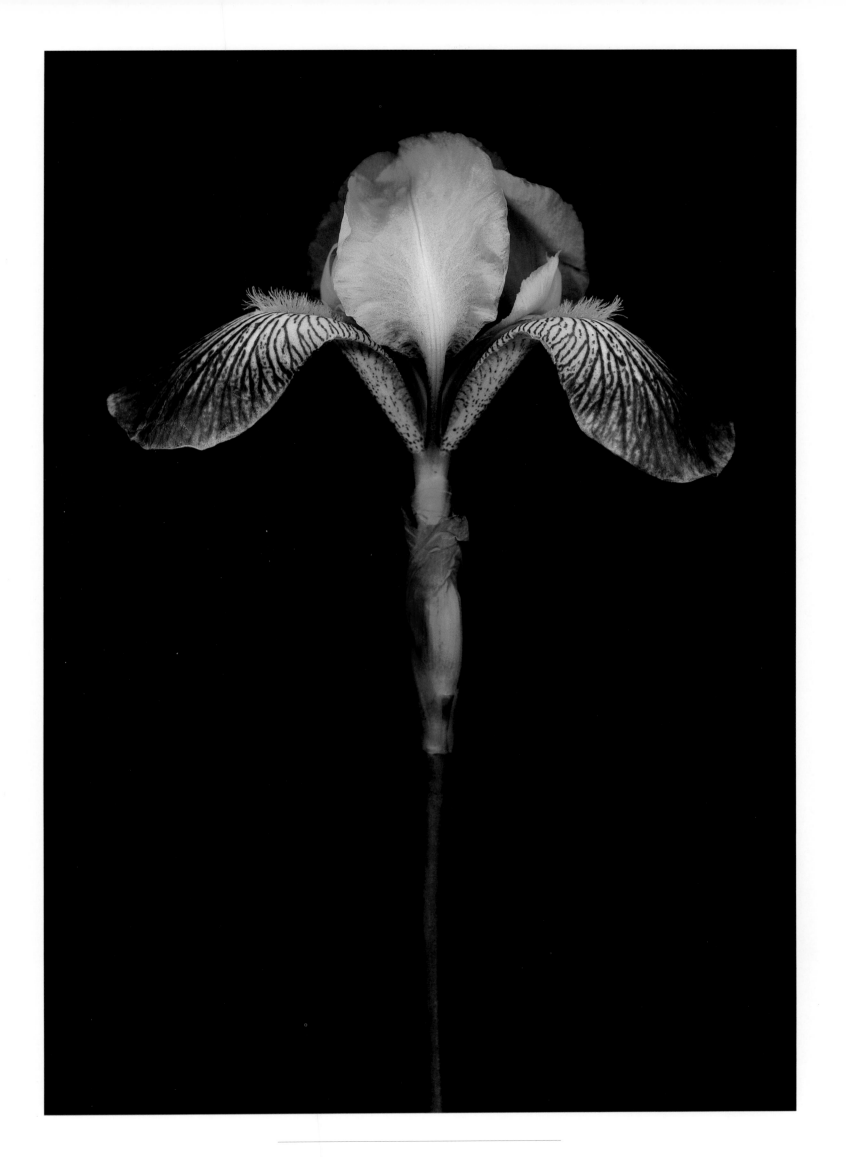

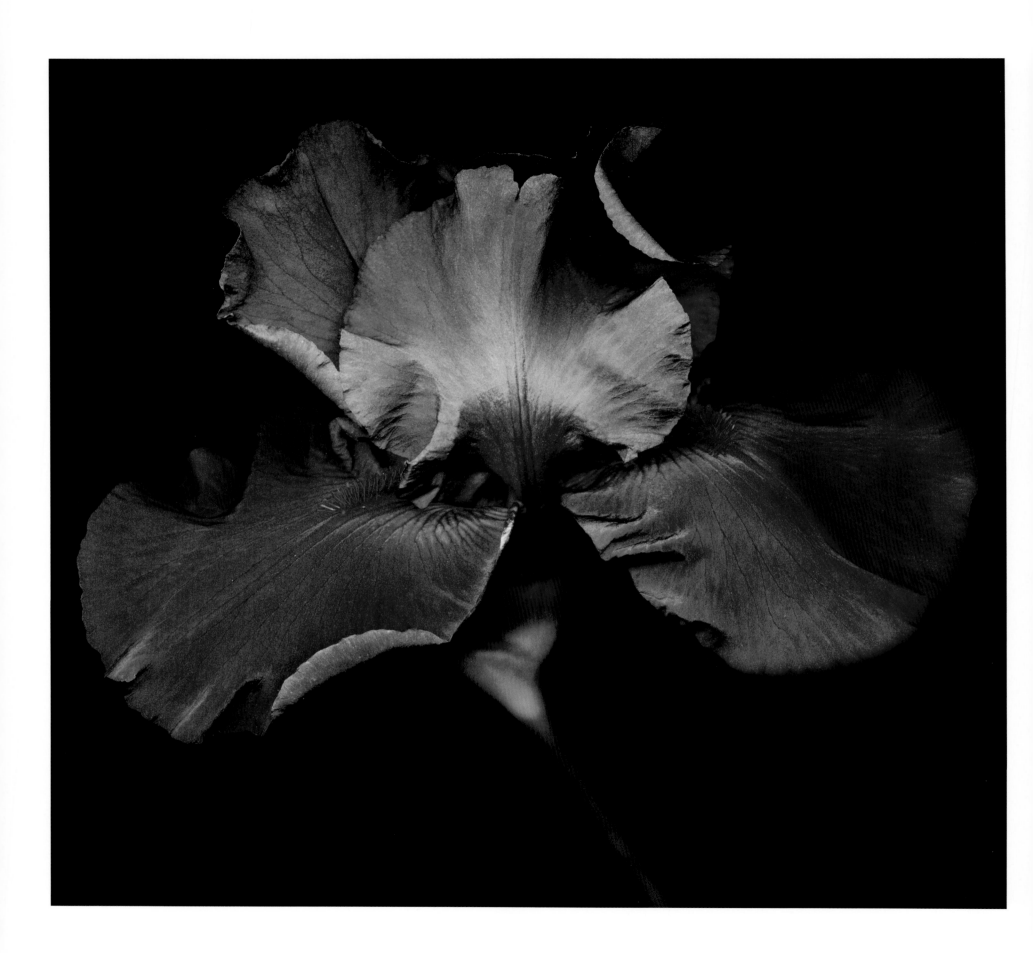

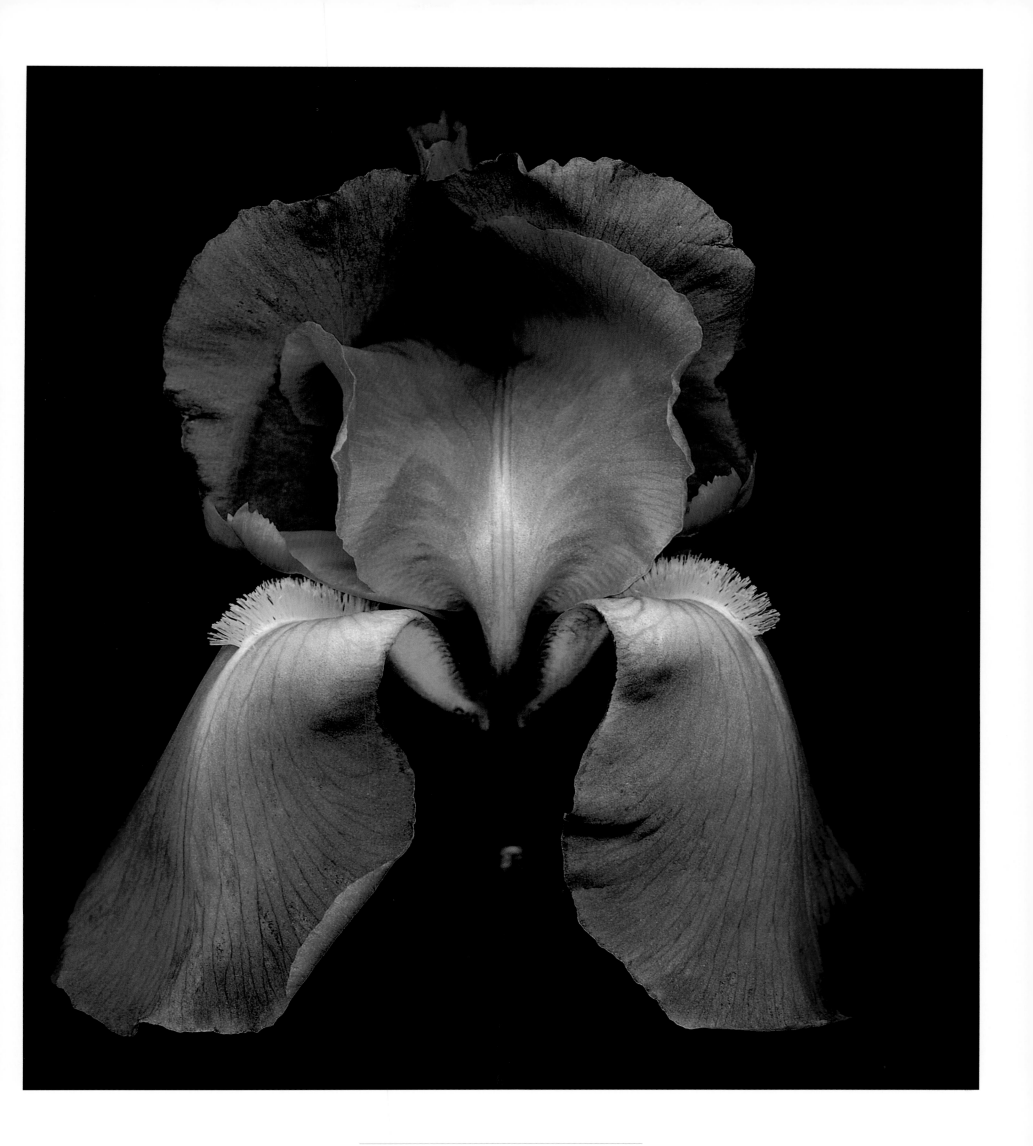

SUNFLOWERS AND DANDELIONS

Sunflowers and dandelions are recognizable to most people. City dwellers know a sunflower when they see one, just as quickly as country folk. And the bright yellow flowers and fluffy powder puffs of seed give away the dandelion's identity in an instant. These two plants are identifiable even to those without the firsthand experience of growing them. Exposure and familiarity come from art, advertisements, movies, television, books, and even fashion; and memory takes care of the rest. In societies that use these resources, images of plants are created that ignore their intricacies and complex survival habits—characteristics common to sunflowers and dandelions.

Sunflowers are native to the prairies of North America. Their yellow flowers and black seeds bear only a basic likeness to the towering, large-seeded garden sunflowers of today. For hundreds of years, beginning with Native Americans, sunflowers have been selected and bred to develop plants that deliver abundant crops of large seeds. The high oil content of the seeds has made sunflowers economically important.

Being an annual, sunflowers complete their life cycle in one season. They begin growing in the spring from seeds, and during the long days of summer the tall, leafy stems and the large, circular flower heads develop. The cycle is completed when the flower heads, which are really many tiny flowers, are pollinated and produce seeds.

Aside from being a unique garden flower and an economically important crop, the sunflower is, surprisingly, also linked to the field of mathematics. The spiral pattern of tiny flowers—and subsequent seeds—on the face of the sunflower reinforces an important mathematical theory called the Fibonacci sequence. The ratio of the number of clockwise spirals to the number of counterclockwise spirals always equals two consecutive numbers in the Fibonacci sequence of numbers. The sequence is a never-ending series of numbers beginning with 1. 1. The next number in the sequence is the sum of the two previous numbers. This sequence was discovered by a medieval Italian mathematician named Leonardo Fibonacci, as a result of studying the numbers associated with the reproduction of rabbits: it could be called a mathematical theory of nature. During the nineteenth century, scientists began discovering this pattern in many other facets of nature. It can be found in the spiral designs of pine cones and snail shells, and in the dichotomous branching of plants. People then began to realize that the ratio of any two consecutive numbers in the sequence, 1.618, is very close to the ratio that creates the pleasing proportions that artists and architects call the Golden Ratio, or the Golden Section of 1.6.

Although closely related to the sunflower, dandelions come from a different part of the world. They're native to Europe and adjacent parts of Asia. But they have been introduced into many parts of the world where, by the power of their persistence, they have become naturalized flora. When plants or seeds are introduced onto foreign soil, they are exposed to a new ecosystem. This is often advantageous for them because the ecological checks and balances that limit the population of a plant species within its native habitat might not exist in the new habitat. This allows the newly introduced species the opportunity to abundantly populate the new ecosystem, appearing to be a part of the native flora. When this happens, the plant has become naturalized. This is how many plants become referred to as weeds; they are usually non-native plants that become invasive in a new habitat.

The dandelion is one of the few plants in the world that produces viable seeds without ever having its flowers pollinated or fertilized. This unique phenomenon is called apomixis. And it's one reason that the dandelion is so invasive—the flowers do not need to rely on pollinating insects to produce lots of seeds. The fluffy seed heads are dispersed by the wind with the hope that each seed will be carried to a location where it won't compete with its parent.

54. SUNFLOWER, *Helianthus annuus* cultivar

In *Crockett's Victory Garden*, James Underwood Crockett advises about harvesting sunflower seeds:
"Wait until the seeds are fully grown and firm, then cut the head
with about a foot of stem attached. Hang it in a dry, airy spot to finish ripening.
Don't stack the heads in a box or they will rot. (The biggest problem with harvesting
sunflower seeds is that the birds often get to them first.)"

55. SUNFLOWER, *Helianthus annuus* cultivar

The common name "sunflower" comes from two Greek words: *helios*, meaning sun,
and *anthos*, which means flower. A false assumption that the face of the flower follows
the path of the sun stems from both the botanical and common names.
A more rational explanation comes from the resemblance of the bright yellow flower petals
to the radiant beams of the sun.

56. SUNFLOWER, *Helianthus annuus* cultivar

Gardeners are very proud of the plants they grow, and sometimes competitive,
a combination that encourages contests. Sunflowers have always made good subjects
for contests at local and state fairs. The tallest sunflower measured 25 feet, 5½ inches;
and the largest flower was 32¼ inches across.

57. SUNFLOWER, *Helianthus annuus* cultivar (back of flower)

Vincent van Gogh wrote to his brother Theo: ". . . I want to make a decoration for the
studio. Nothing but big sunflowers . . .there will be a dozen panels. So the whole thing will
be a symphony in blue and yellow." Imagine the music van Gogh could have composed if
his inspiration was drawn from the backs of flowers.

58. DANDELION, *Taraxacum officinale*

The common name of the dandelion comes from the French term *dents de lion*,
a phrase that plays on the similarity between the jagged edges of the dandelion leaf and
"the teeth of a lion."

59. DANDELION, *Taraxacum officinale*

In *Flowers and Fruit*, Colétte writes of the dandelion: "At your feet, that delicate rosette is a
growing dandelion, and that pearl in its center will one day be its flower."
That delicate rosette of evergreen leaves was first brought to North America in the form of
seed by colonists, who used the various plant parts for food, medicine, and libation.

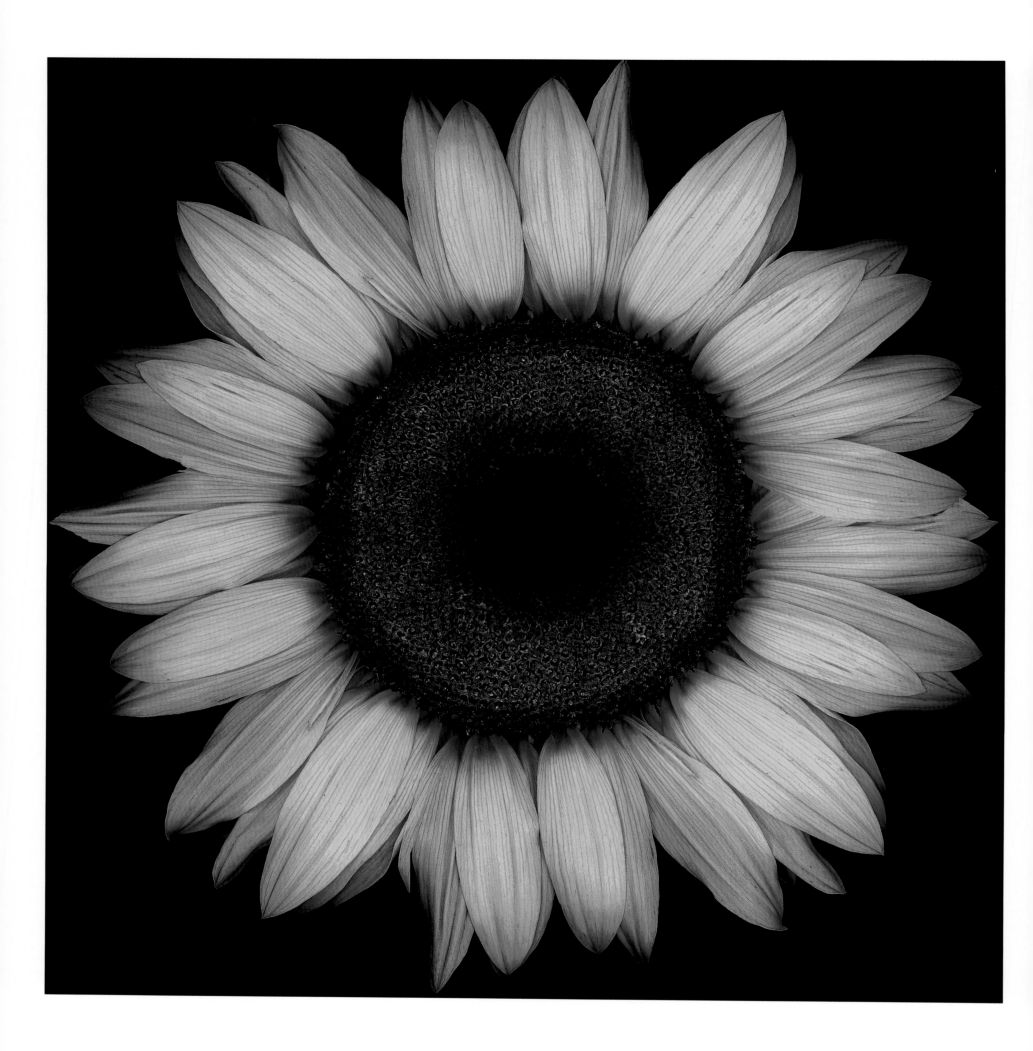

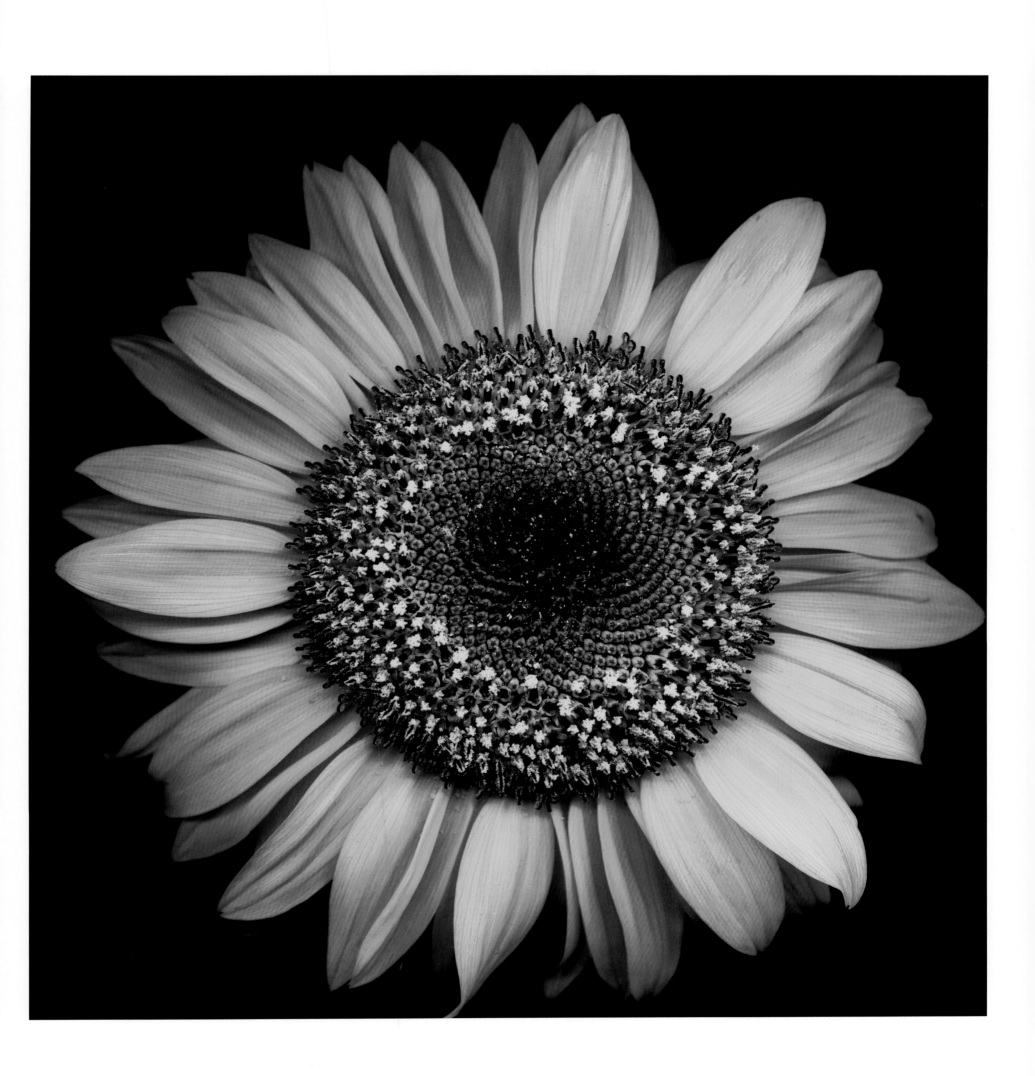

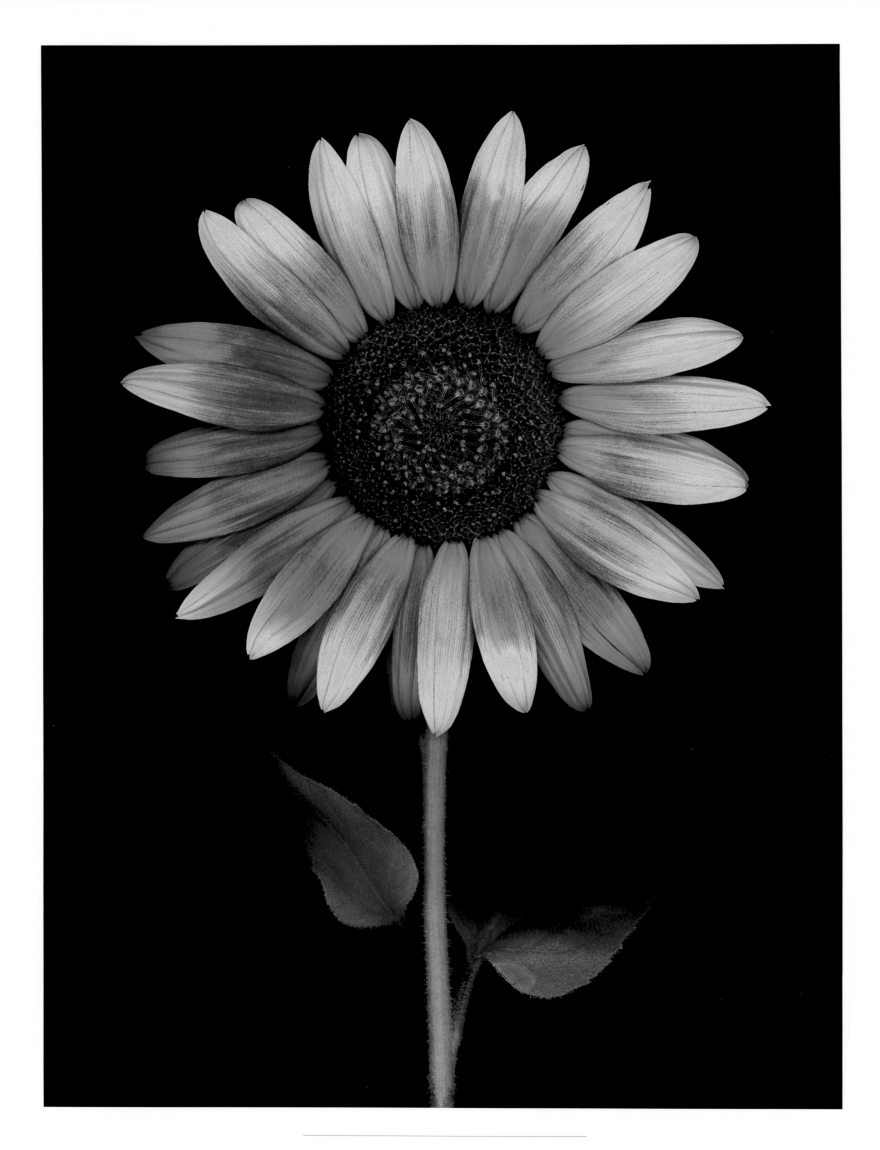

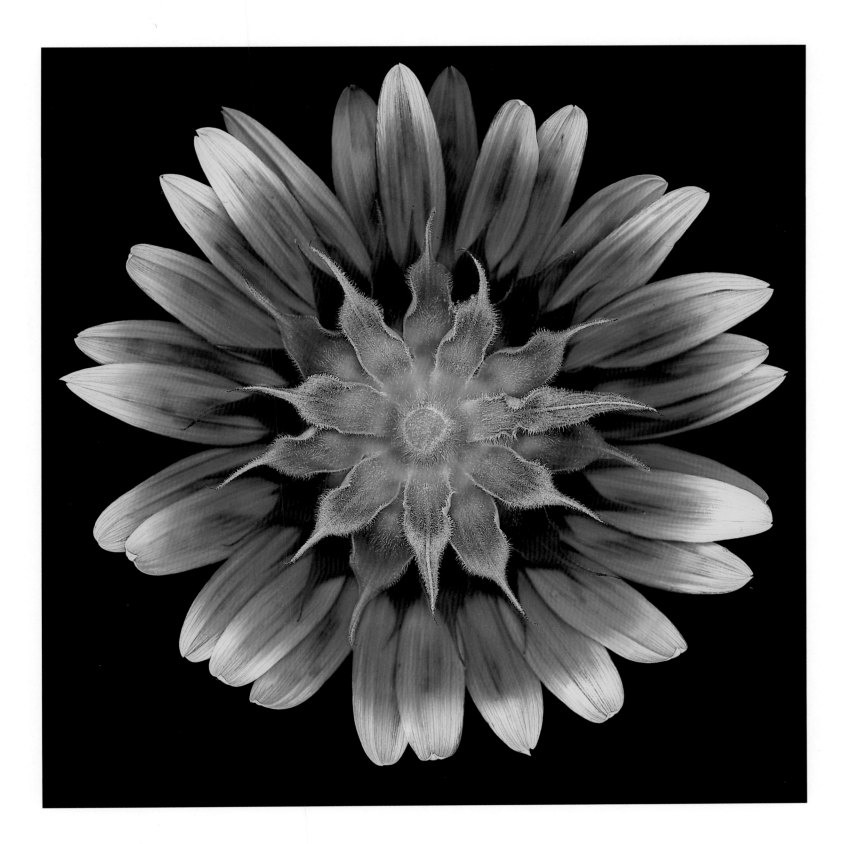

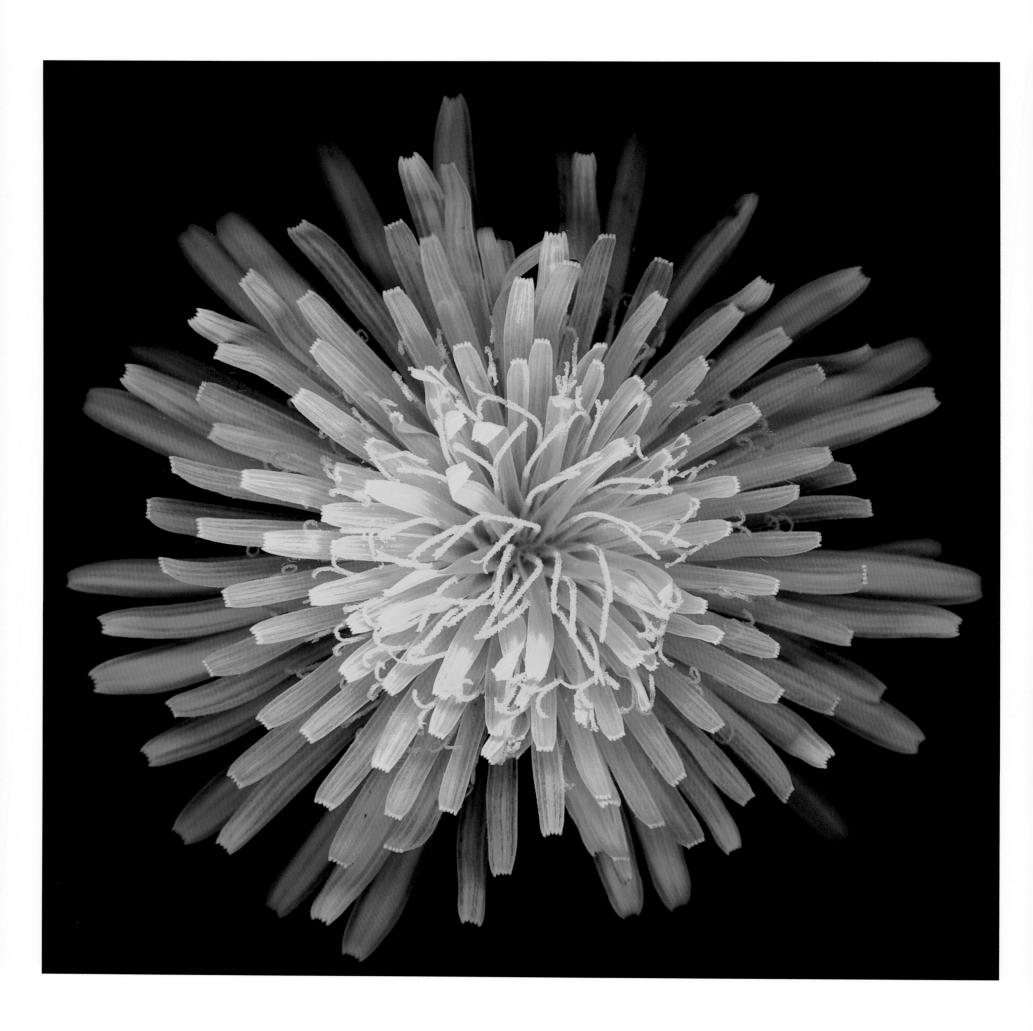

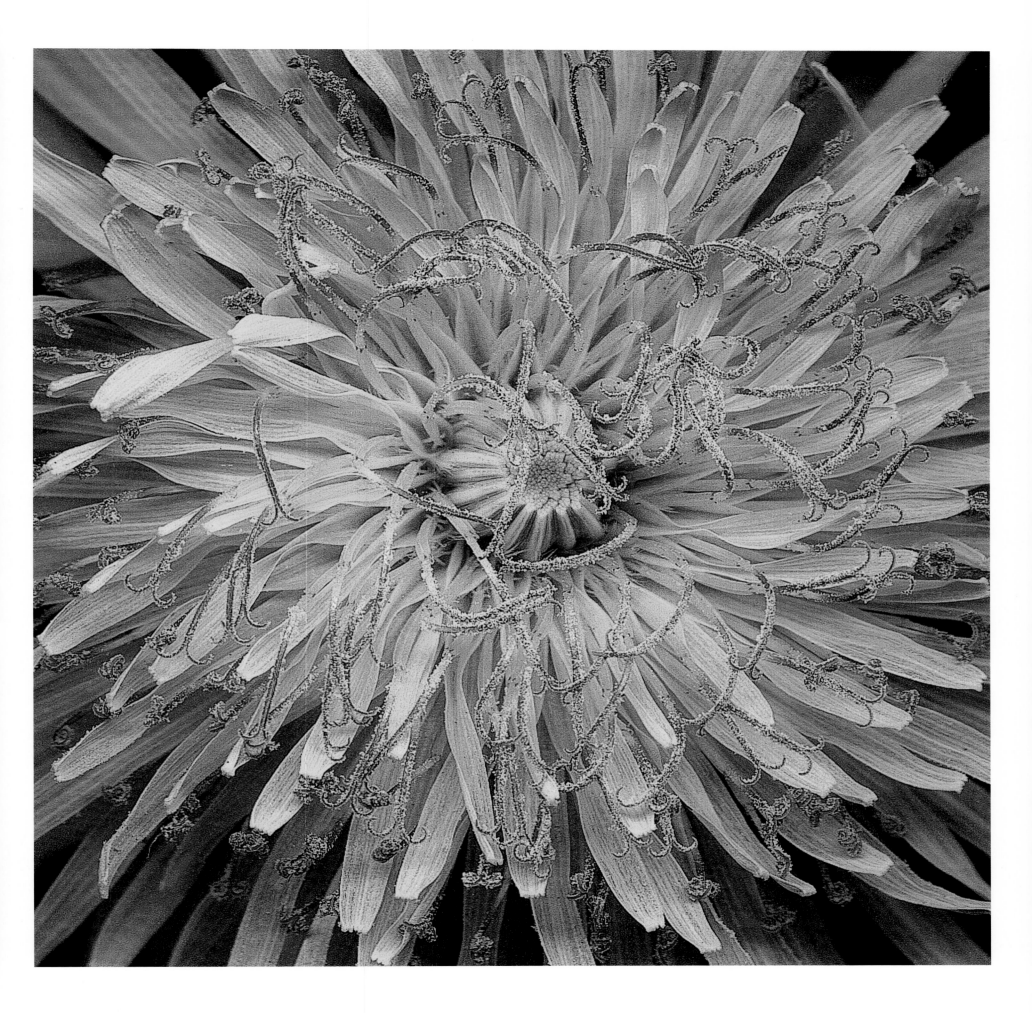

COSMOS AND DAISIES

The common and beloved daisy, inspiration for daisy chains and loves-me, loves-me-not games, is closely related to a very popular vegetable—lettuce. Daisies and lettuce belong to a large family of plants that includes marigold, artichokes, dandelions, asters, goldenrods, chamomile, and tarragon. The twenty-one thousand members of this family grow on all parts of the globe except for the Antarctic mainland.

Gardeners who grow vegetables will sometimes see lettuce flowers when plants "bolt," or go to seed. These flowers don't have the typical daisy pattern of a yellow center surrounded by colorful petals. Lettuce flowers look more like small dandelions; the flowers of artichokes and goldenrods don't look like daisies either. But even though the flowers of these plants are not daisy-like, they all have similar flower parts arranged in the same way—that's why they're all grouped together.

A daisy is really a "false flower": it's not one flower, as it happens, but a composition of many tiny flowers. The center of a daisy is called the disk. This is the yellow, or sometimes dark, center that is an aggregate of small tubular flowers. The "petals" that surround the disk are also individual flowers. Since these flowers emanate from the disk like rays of sunshine from the sun, they are called ray flowers.

The word "daisy" comes from an Old English word meaning "days eye." This phrase was first used to describe a native English flower that has the habit of closing its colored petals in the evening, concealing its glowing center. Since it was visible only during daylight hours, the golden "eye" of the flower, or disk, suggested the sun itself. The expression "fresh as a daisy" takes its inspiration from the same plant. It captures the feeling of being unspoiled. This plant is now commonly called an English daisy, *Bellis perennis*.

62. COSMOS, *Cosmos bipinnatus* cultivar
Cosmos are quick-growing, colorful annuals that reappear in the garden each year from seeds that have fallen to the ground from the previous year's plants. While serendipitous plant combinations happen from self-sown seed, it's not a reliable method of propagation.

63. ZINNIA, *Zinnia elegans* cultivar
In their hybridized forms, these summer blooming annuals from Mexico have more to offer than most other bedding plants. Color alone provides a dozen options; consider long stems for cutting or a dwarf mounding habit; ponder the available flower shapes—dahlia, cactus, decorative, or pompon are just a few to choose from.

64. GERBER DAISY; TRANSVAAL DAISY, *Gerbera* cultivar
During the beginning of the twentieth century, the Gerber daisy was unknown to American gardeners. But in less than one hundred years, with improvements to flower color and flower production, the popularity of Gerber daisies has put them in the most esteemed of positions—supermarket merchandise.

65. GERBER DAISY; TRANSVAAL DAISY, *Gerbera* cultivar
Modern Gerber daisies are tender perennials that have been bred from two African species. They are grown as annuals, or more often as potted plants. Gerbers like sunshine and soil that is well drained. To avoid rot, the rosette of long, lobed leaves should not be planted deeply into the soil.

66. GERBER DAISY; TRANSVAAL DAISY, *Gerbera* cultivar

Gerber daisies are long-lasting cut flowers; they remain fresh-looking for up to three weeks in water. The flowers do not open well once cut, so it is important to cut or purchase only those flowers with fully expanded petals.

67. GAZANIA; TREASURE FLOWER, *Gazania* cultivar

The botanical name for these tender, South African perennials has a double meaning. In Latin, *gaza* means treasure or riches, inferring the brightly colored flowers are similar to sparkling treasure. But others think the name *Gazania* commemorates Theodore of Gaza (1393–1478), who made the botanical writings of Theophrastus available to many by translating them into Latin.

68. GERBER DAISY; TRANSVAAL DAISY, *Gerbera* cultivar

The color of the wild gerber daisy is orange-red and its form is a simple arrangement of one or two rows of petals (ray florets). Flowers with many rows of petals, or tufts of shortened petals, are hybrids that have been cross-pollinated and selected from a cultivated area. (This is a loose definition of a cultivated variety, or cultivar.)

69. GERBER DAISY; TRANSVAAL DAISY, *Gerbera* cultivars

In *Crockett's Indoor Garden*, James Underwood Crockett writes about growing daisies indoors: "These natives of South Africa will blossom year-round, with most of the flowers appearing between midwinter and early summer. The plants live indefinitely and are best divided and reset in fresh soil in [early summer]."

70. SHASTA DAISY, *Leucanthemum superbum* cultivar

The Shasta daisy is one of many hybrid plants bred by Luther Burbank. Named after Mount Shasta in northern California, these daisies are perennials that make good cut flowers and are easy to grow in full sun and almost any soil. They're short-lived plants, but will often self-sow their seeds. Frequent division also promotes their longevity.

71. BLACK-EYED SUSAN; YELLOW CONEFLOWER, *Rudbeckia fulgida* 'Goldsturm'

The botanical name *Rudbeckia* commemorates the Swedish botanist Olof Rudbeck, who was the mentor of Carolus Linnaeus, the naturalist who standardized the nomenclature of the natural sciences. Black-eyed Susans are perennials that often form impressive stands of easy-to-care-for summer color.

72. COSMOS, *Cosmos bipinnatus* cultivar

The botanical name for the cosmos comes from the Greek word for beautiful, *kosmos*. These Mexican natives are beautiful because they are fair, they are visually pleasing in a bright landscape of scarlet, orange, yellow, and white.

73. SUNSCAPE DAISY, *Osteospermum* cultivar

Sunscape daisies are hybrids bred from species native to southern Africa. In climates with hot and humid summers, they flower profusely in spring and autumn and very little during the summer. The botanical name refers to the hard, bone-like fruit.

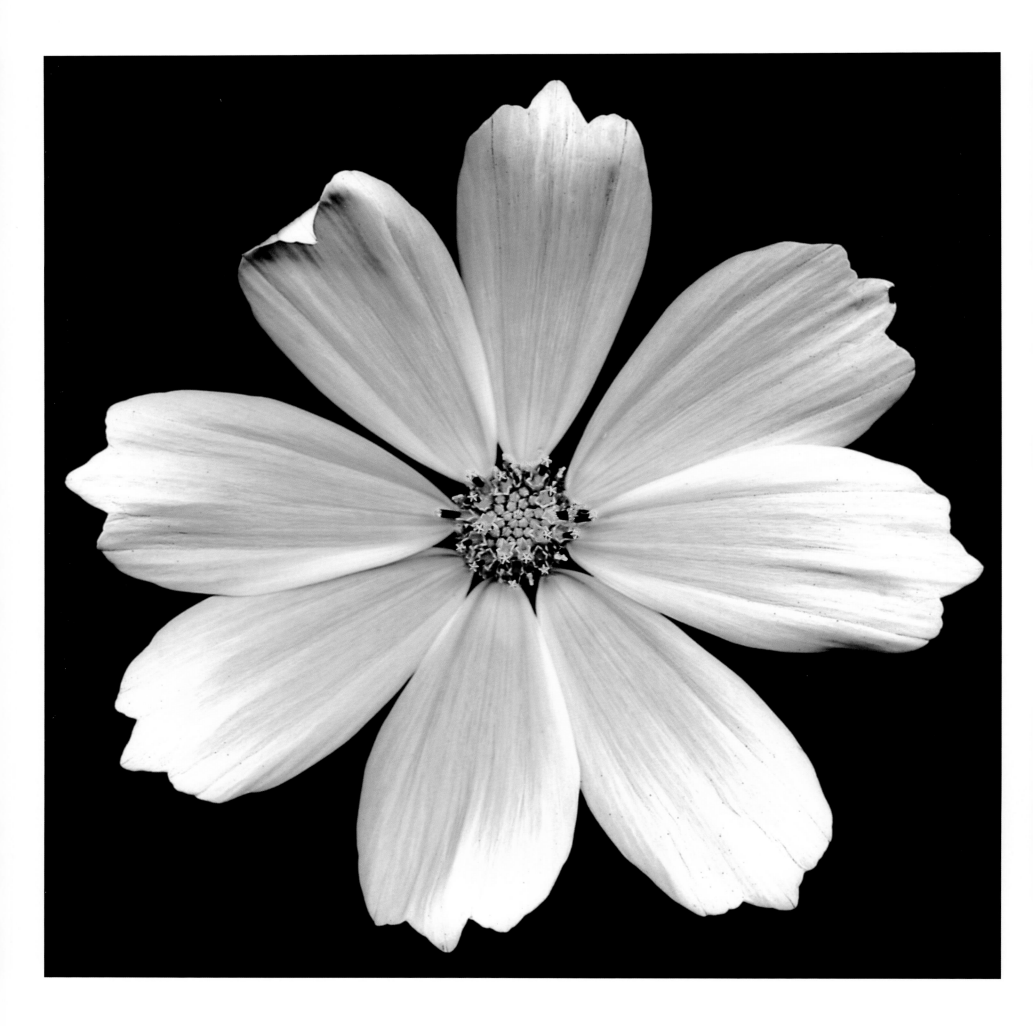

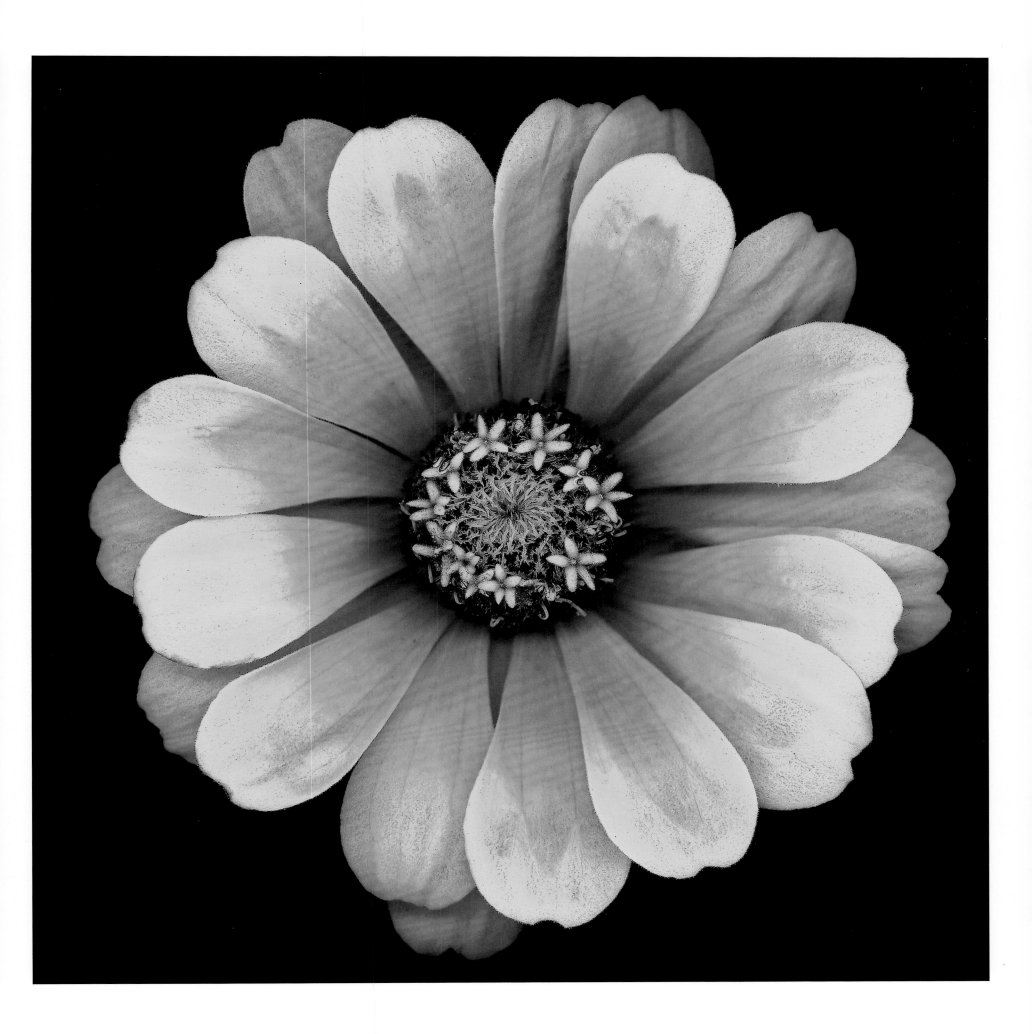

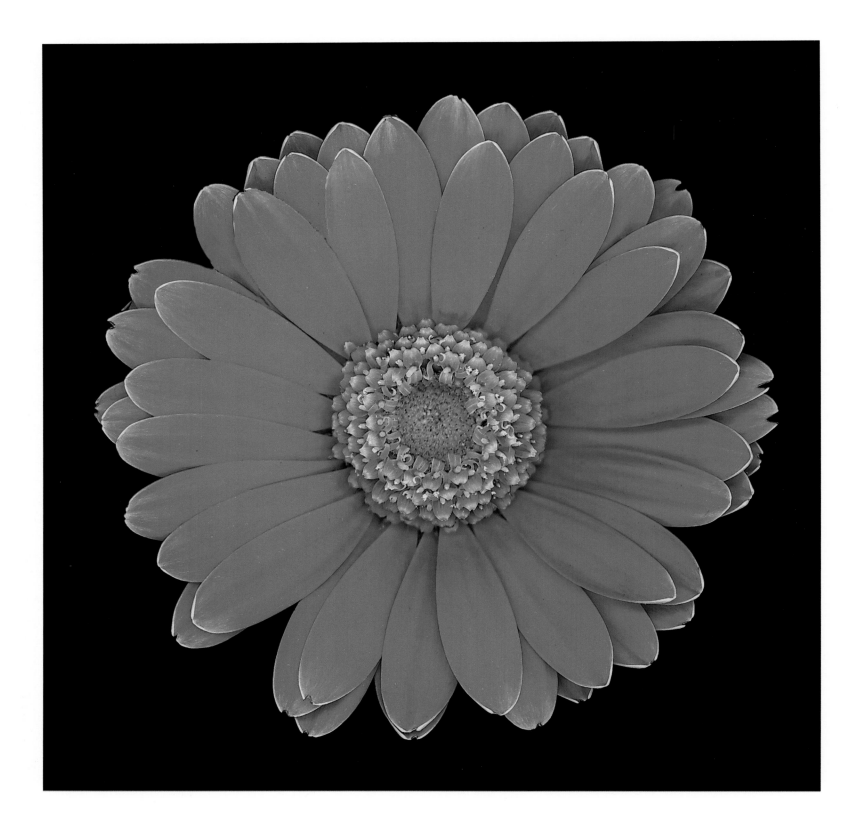

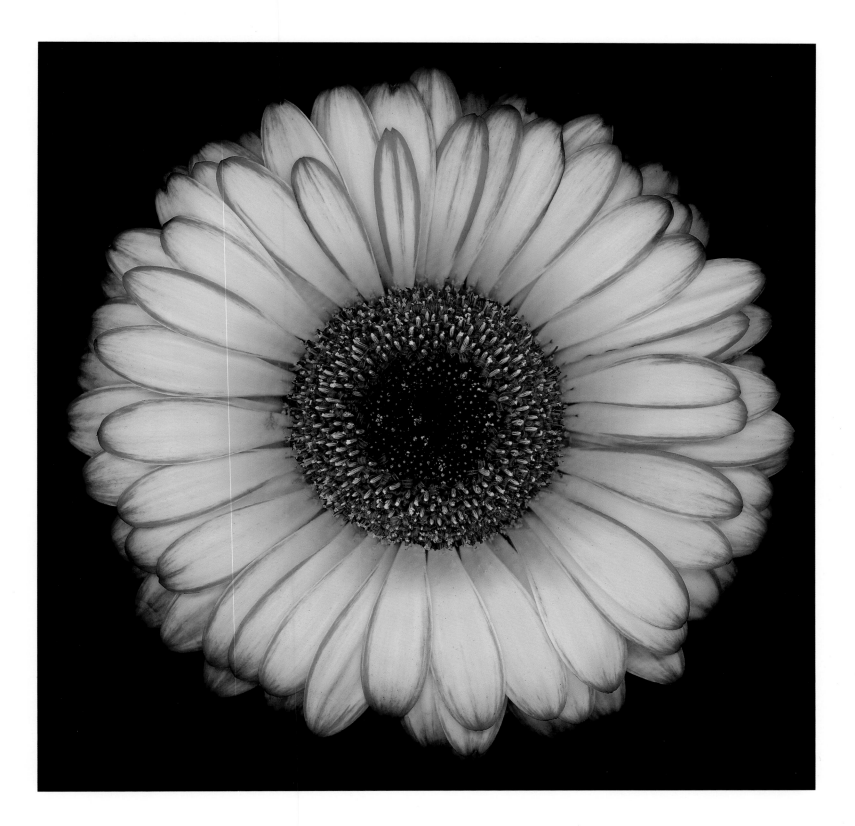

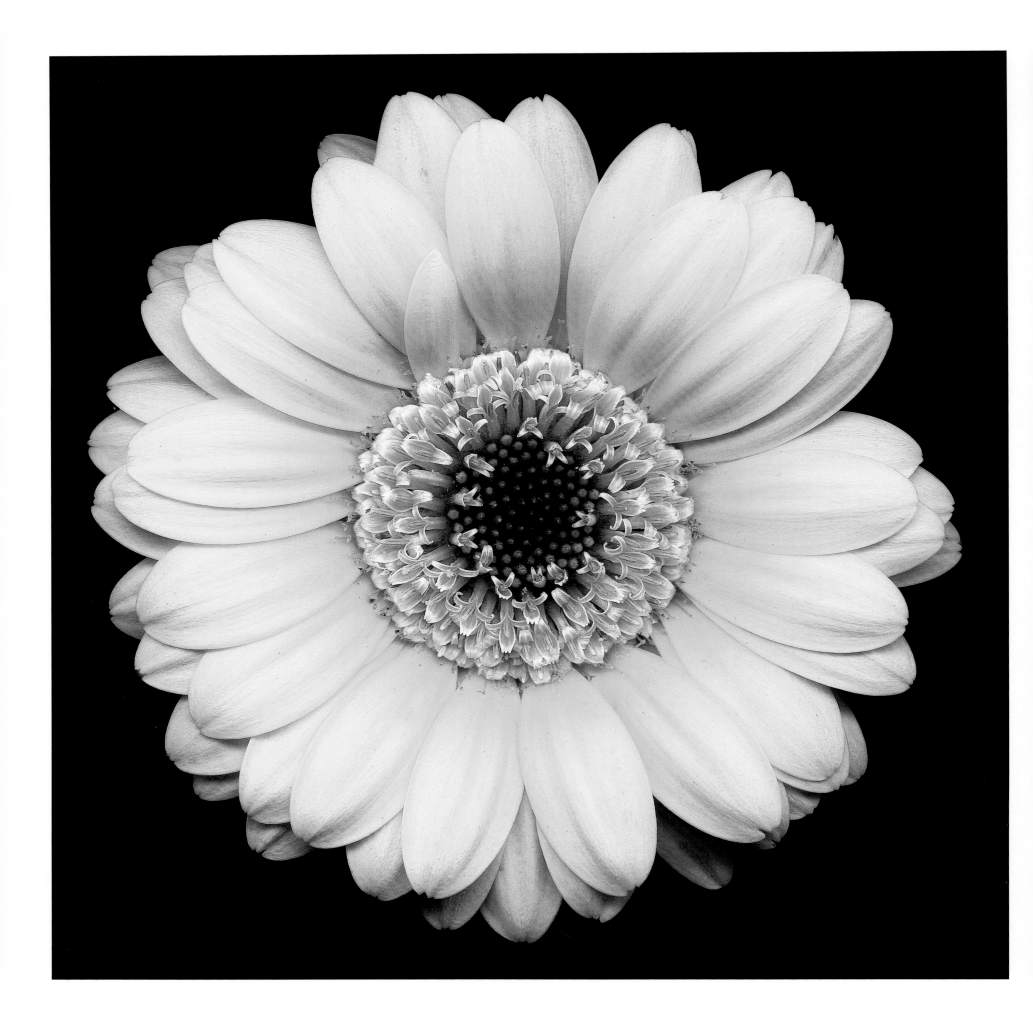

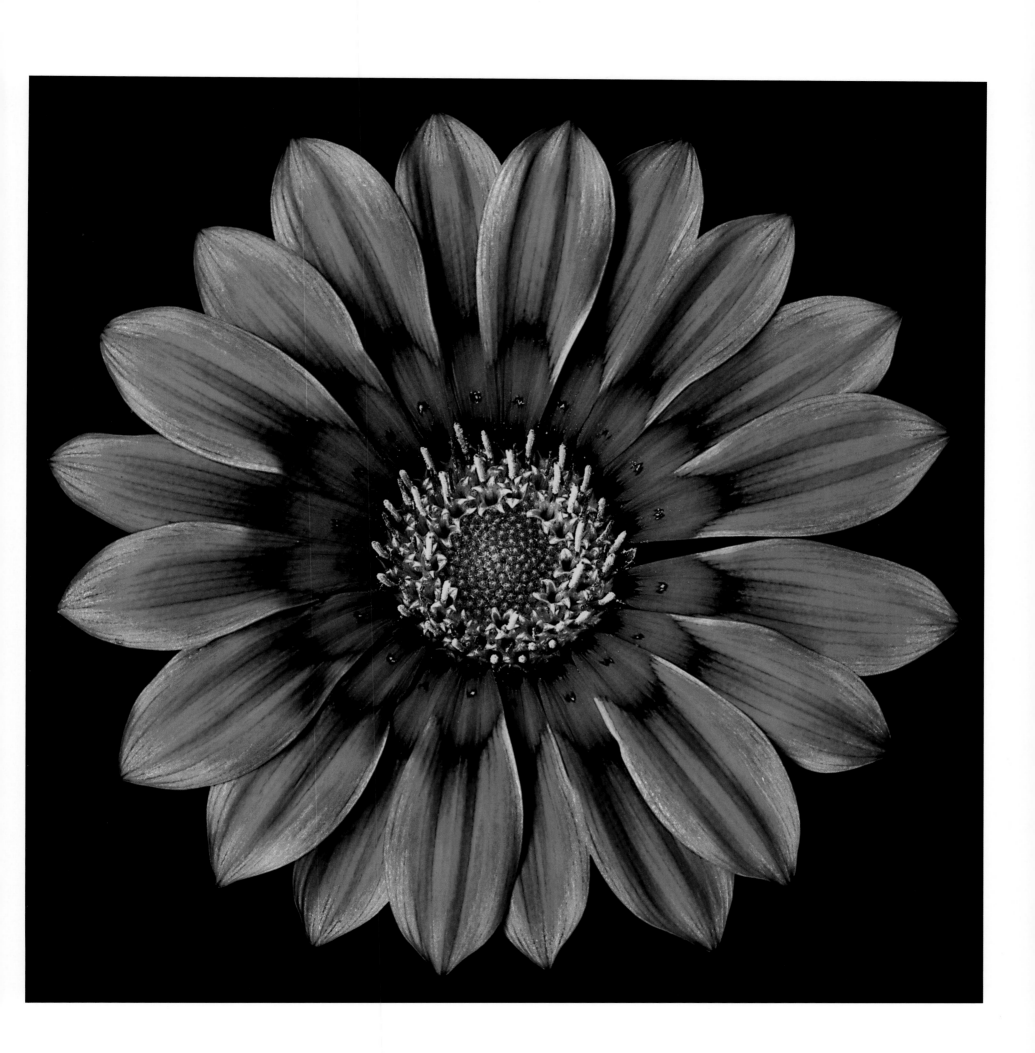

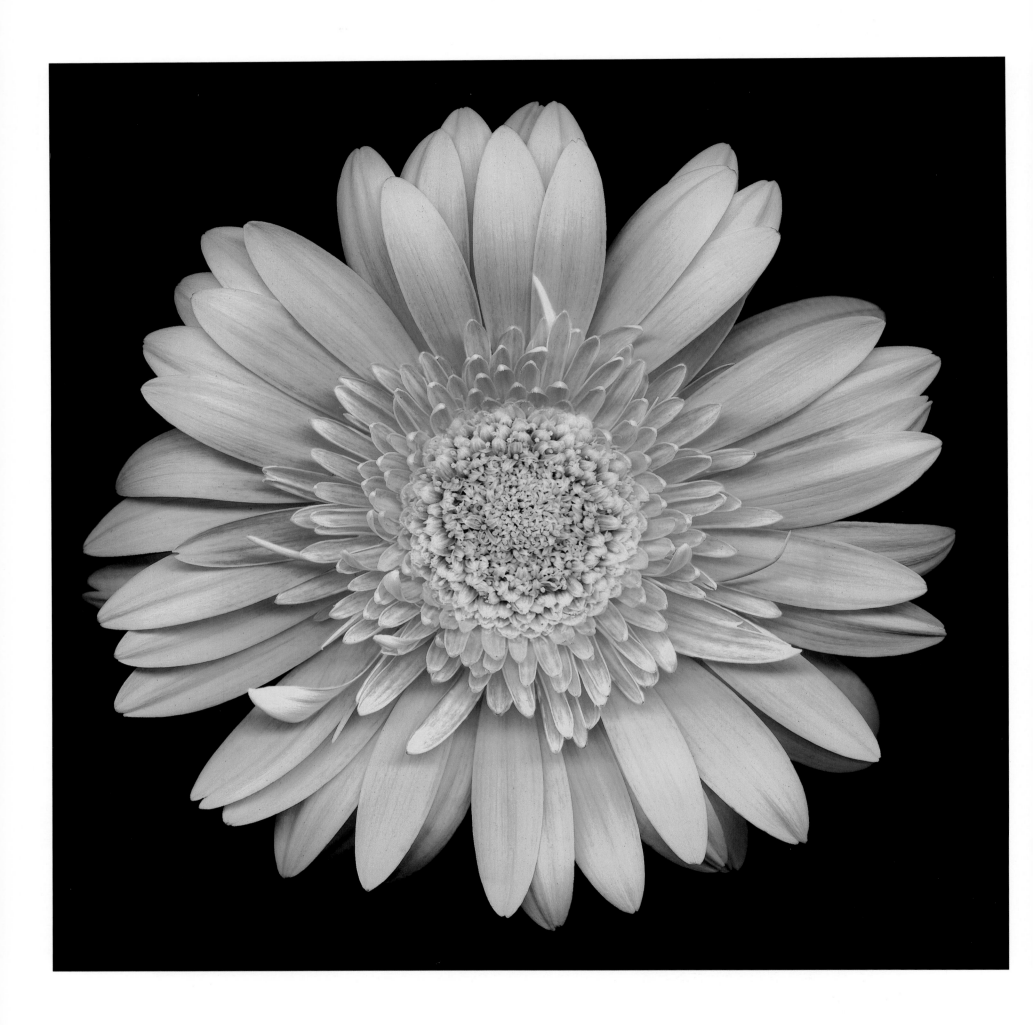

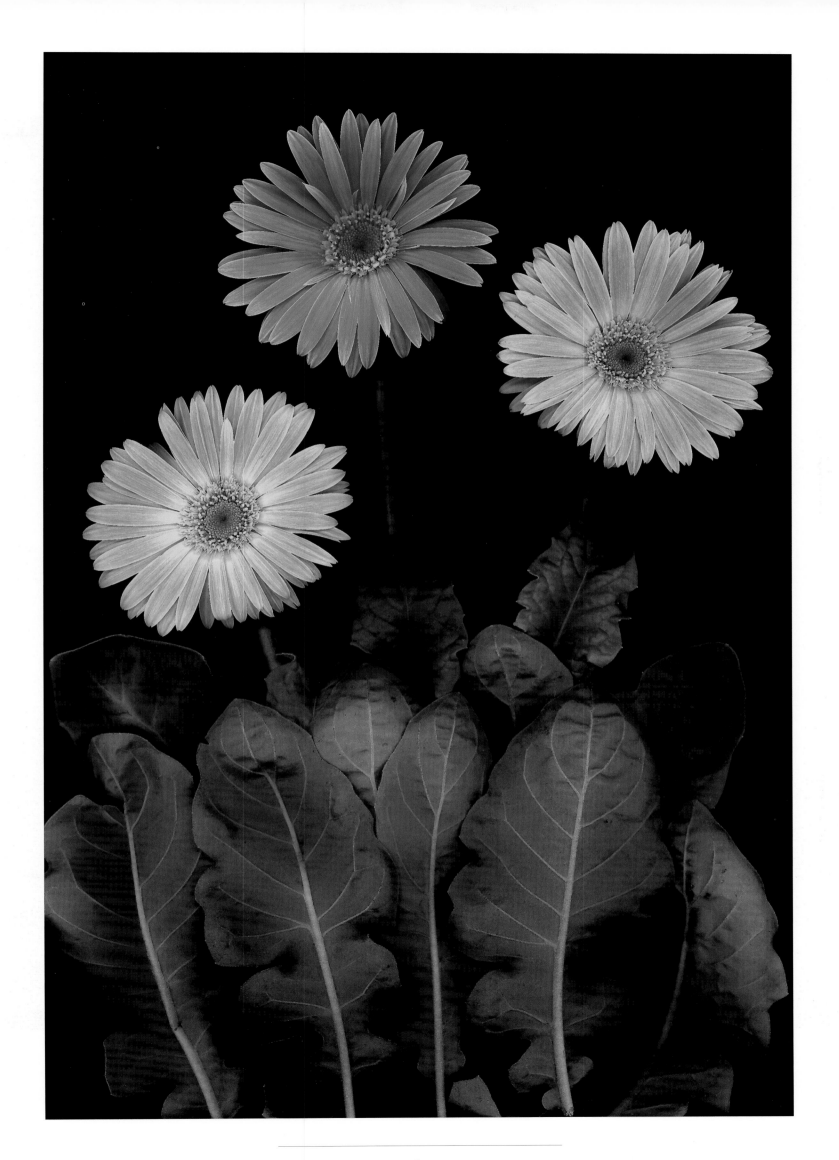

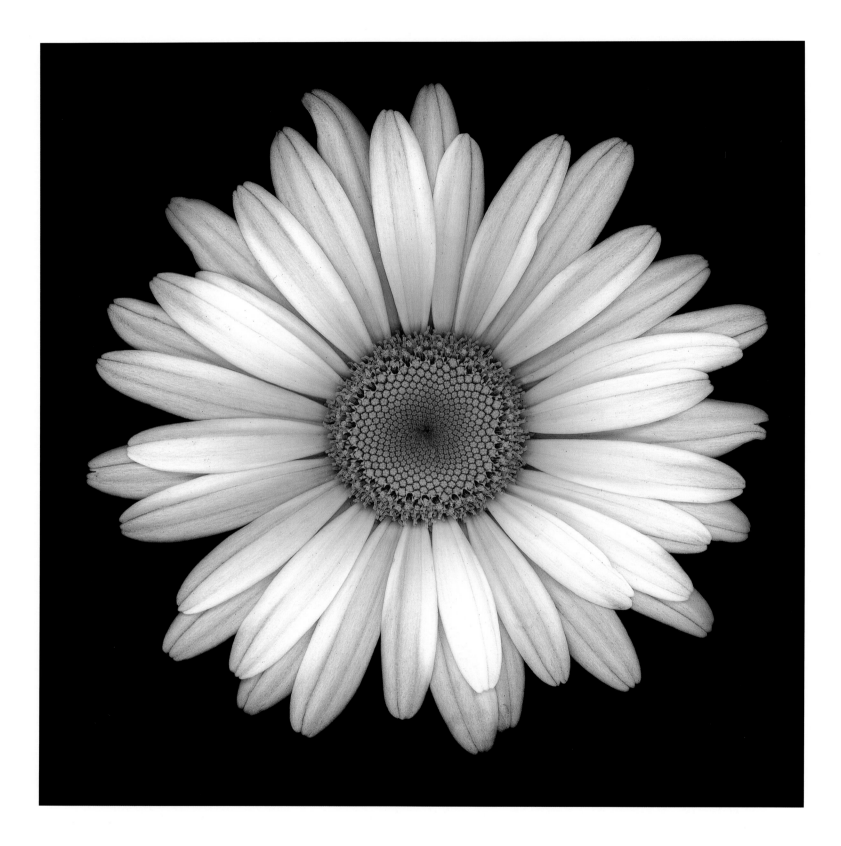

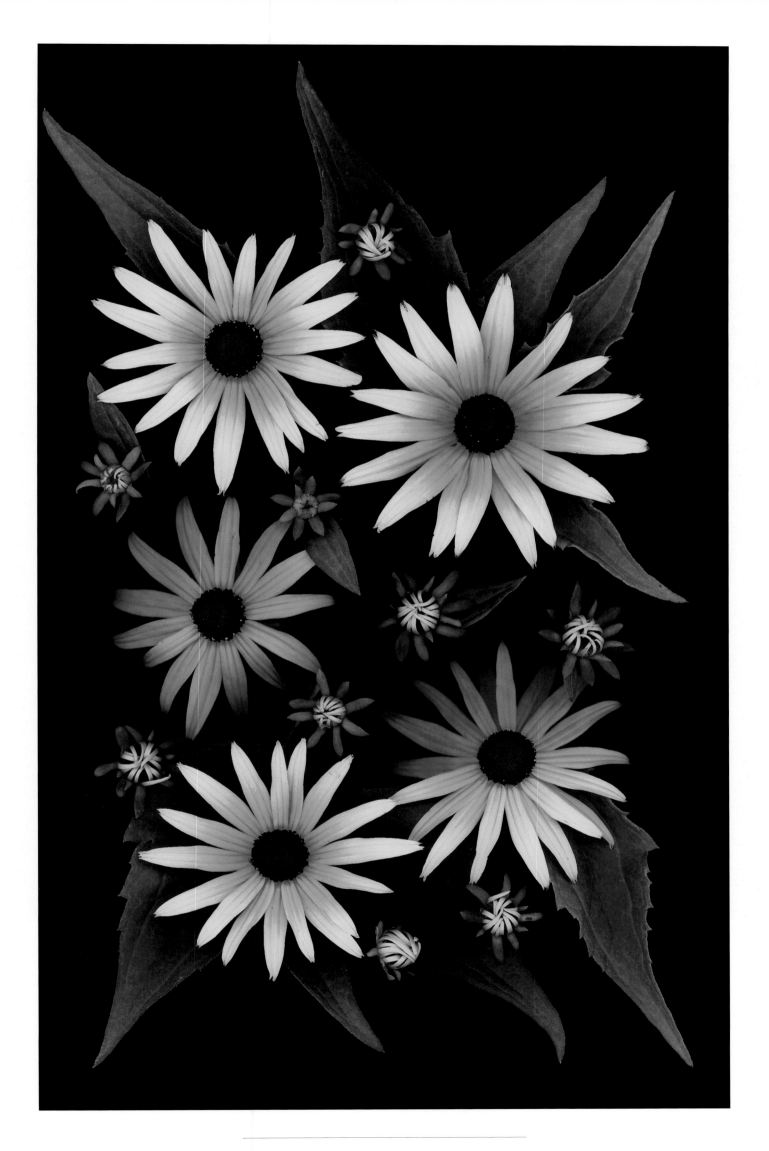

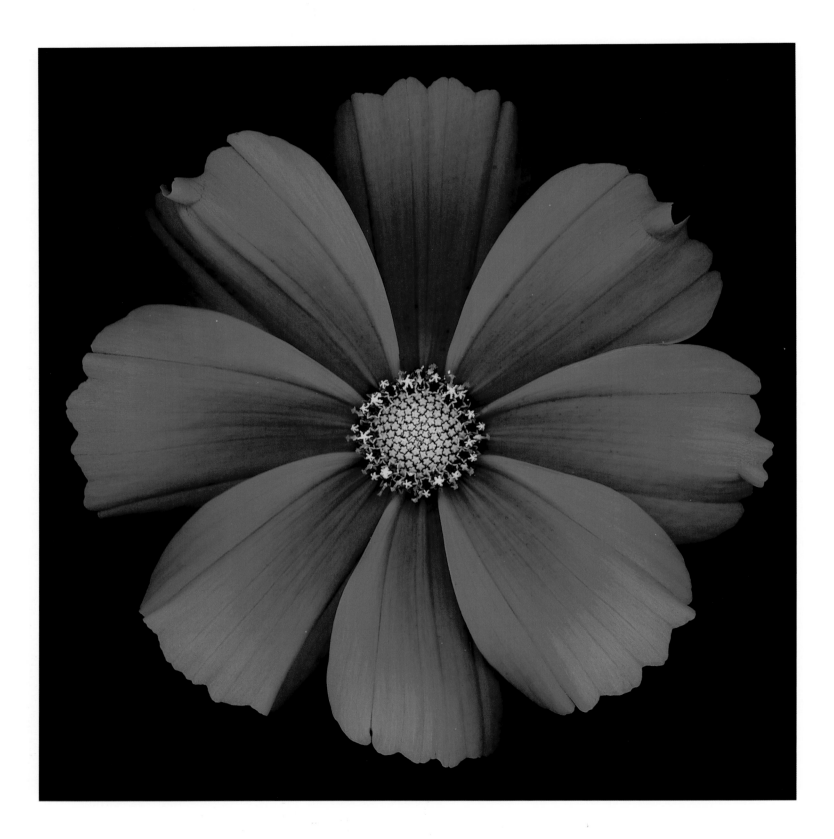

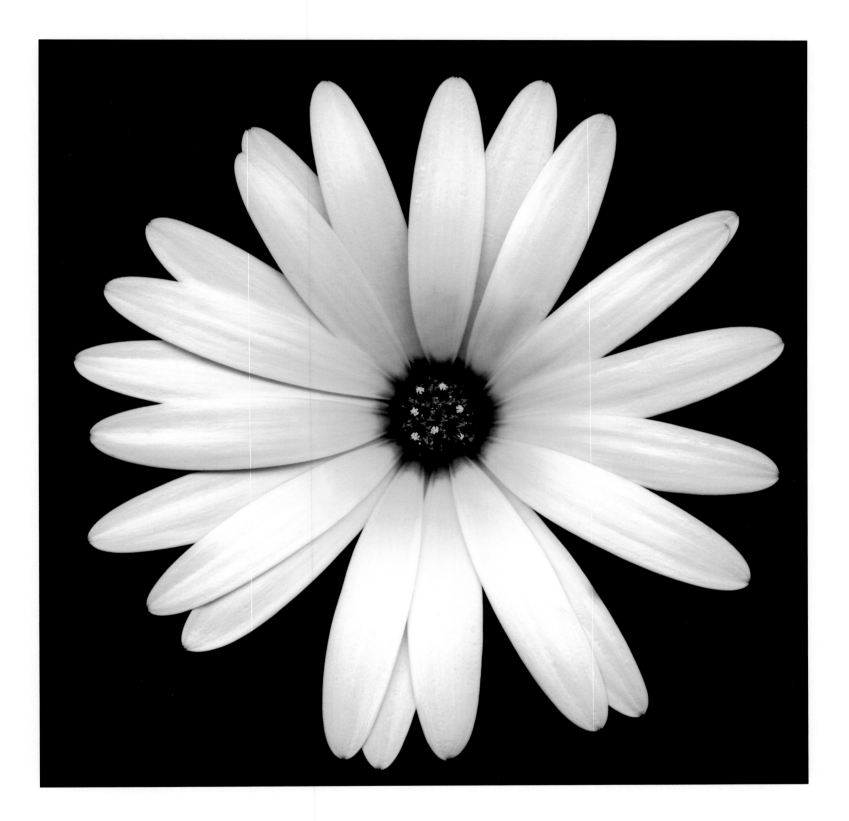

FLORAL DIVERSITY

Flowers lure us with their beauty and fragrance, just as they lure the pollinators they desperately need to attract. Flowers captivate and stimulate our senses and our imaginations; they're what we remember most vividly about plants.

Flowering plants surround us. They're the dominant form of plant life; their numbers are greater than the sum total of all other plants. So it's not surprising that our minds focus on the beautiful blossoms that are part of their design. But the importance of flowering plants goes beyond their beauty. The wealth of nations has been built by societies that are structured around the production of food crops. And the major crops of the world are flowering plants.

The reason so many flowering plants exist is because they're successful at their jobs—producing and dispersing seeds. This seemingly simple process has kept them alive and allowed them to evolve. The first flowering plants are thought to have evolved from the gymnosperms (non-flowering plants such as conifers) and an extinct group of seed ferns. The oldest flowering plant fossil is dated at 145 million years old. Flowering plants probably evolved even earlier, but no fossils have been found to prove it.

Botanists believe that a flower is best described as a compact stem of modified leaves. This tells us that each part of a flower (petals, anthers, etc.) evolved from the leaves, or the leaf-like structures of non-flowering plants. The transformation from green leaves to brightly colored flowers seems unbelievable. If flowers evolved from leaves, and most leaves are green, then why aren't the majority of flowers green? Pigments besides green do exist in leaves, but for the most part they're masked by an abundance of green pigmentation—chlorophyll. This living, life-giving pigment enables plants to make their own food by photosynthesizing. Other plant pigments show themselves in regions that experience autumn. As daylight hours decrease, plants begin preparing for winter by producing less food. This reduces their need for chlorophyll and unmasks some of the other pigments, making autumn one of the most colorful times of the year.

Colorful autumn foliage shows that plants contain other pigments besides green, pigments that flowering plants used as they evolved and adapted to their surroundings. By changing what they had into what they needed, the shapes, sizes, and colors of their flowers evolved to attract and accommodate pollinators. Insects were evolving at the same time, and many mutually dependent relationships developed between plants and insects. Other plants developed relationships with animals or the wind, not only for pollinating their blossoms, but for dispersing their seeds.

77. GLADIOLUS, *Gladiolus* cultivar
Vita Sackville-West wrote about gladiolus: ". . . supreme in late summer flower shows . . .
those great peacock-tail displays like swords dipped in all the hues of sunrise,
sunset and storm."

78. CLEMATIS, *Clematis* cultivar
The silky, voluptuous blooms of the clematis vine are why they're called the
"Queen of climbers." They support themselves by the unusual habit of twisting
their leaves around a prop.

79. LUPINE, *Lupinus* cultivar
The name "lupine" is derived from the Latin word *lupus*, which means wolf—
a ravenous beast. Like a devouring beast of prey, lupines were believed to exhaust the
soil of its nutrients.

80. GRAPE HYACINTH, *Muscari*

Grape hyacinths are easy to grow, spring-blooming perennial bulbs that quickly propagate themselves; a few bulbs will soon form a dense clump. In *One Man's Garden* Henry Mitchell wrote, "All of these are worth growing, even if only by the half-dozen. Ruskin once wrote of their cells of bossed and beaded blue."

81. GOOSENECK LOOSESTRIFE, *Lysimachia clethroides*

This odd-looking member of the primrose family comes by its name because of the shape of its flower spikes. Gooseneck loosestrife is a perennial that can be invasive; it spreads by underground stems, forming thick clumps.

82. ROSE OF SHARON, *Hibiscus syriacus* cultivar

Rose of Sharon is a shrubby plant reaching a height of ten feet or more with white, lavender, or pink hibiscus-like flowers that open in the summer. Some confusion surrounds its origin. Recently published reference works list its nativity as the Old World, while older sources cite China or eastern Asia.

83. FLORIST'S CYCLAMEN, *Cyclamen persicum* cultivar

It's true that many find the frosted leaves of cyclamen as inspiring as the flowers. "Cyclamen leaves/Toad filmy, earth iridescent/ Beautiful/Frost-filigreed . . ." From "Sicilian Cyclamens," by D. H. Lawrence.

84. FLORIST'S CYCLAMEN, *Cyclamen persicum* cultivar

The origin of the name "cyclamen" is from the Greek word *kylos*, meaning circular. After shedding its petals, the flower stems of cyclamens coil into spirals as the seed pods are formed.

85. FLORIST'S CYCLAMEN, *Cyclamen persicum* cultivar

In their book *The Vanishing Garden*, Christopher Brickell and Fay Sharman list several apothecary uses for cyclamen. The Roman philosopher Apuleius recommended ". . .in case that a man's hair fall off, take this same wort [cyclamen], and put it into the nostrils. . . ."

86. COMMON LILAC, *Syringa vulgaris* cultivar

Lilacs are fragrant flowering shrubs native to southeastern Europe, but have become old-fashioned favorites in many parts of the world. Like many plants, the botanical name of this lilac includes the word "vulgar" meaning that it is common, or common to the masses.

87. COMMON LILAC, *Syringa vulgaris*

You may not think of olives when looking at lilacs, but their flowers are similar— they belong to the same family, Oleaceae, the olive family. Another member of this family is privet. And if you've ever seen privet in flower, you'll notice a resemblance to lilacs, while their black, oval fruits look like bunches of olives.

88. BUTTER-AND-EGGS, *Linaria vulgaris*
The colors of egg yolk and butter have inspired the common name of this
snapdragon relative. Native to Europe, butter-and-eggs has naturalized in fields and
roadsides in many parts of eastern North America.

89. MEADOW FLOWERS, *Artemisia vulgaris, Tanacetum vulgare, Trifolium praetense*, etc.
"Here I am again with my sickle, spade, hoe/ To preside over life and death, presume to
call/ This plant a 'weed' that one a 'flower'/ Adam's prerogative, hereditary power/
I can't renounce." This poem by Michael Hamburger is from "Weeding."

90. CALLA LILY, *Zantedeschia rehmannii*
This calla lily and its white-flowered cousin, *Z. aethiopica*, are tender perennials from southern
Africa that are often grown for cut flowers. Like a daisy, the entire chalice is a false flower—
not an individual flower, but a cluster of tiny flowers. The colorful chalice conceals
and protects the true flowers arranged on the central spike inside.

91. FLAMINGO FLOWER, *Anthurium andraeanum* cultivar
In her book *Aroids*, Deni Bown writes that the flamingo flower ". . . was one of the most
exciting horticultural discoveries of the 19th century." Found growing in Colombia by
European plant collectors, it quickly became all the rage in Europe.

92. KOUSA DOGWOOD, *Cornus kousa*
The kousa dogwood is a late flowering alternative to the North American dogwood,
C. florida. Being native to Japan, Korea, and China, it is resistant to the disease problems
that are causing the decline of the North American native.

93. SOLOMON'S SEAL, *Polygonatum odoratum*
Like its cousin lily of the valley, Solomon's seal is a perennial that thrives in a shady garden.
The handsome, plastic-like leaves and gracefully arching stems lend a texture
to garden compositions that no other plant can.

94. CRAB APPLE, *Malus* cultivar
Crab apples and apples belong to the same genus of plants, *Malus*; they have similar
growth habits, and their flowers look the same. The defining difference between the two
is the size of the fruit: crab apples measure only two inches or less.
I would add that I've never tasted a crab apple that wasn't tart.

95. KOUSA DOGWOOD, *Cornus kousa*
The showy white flowers of the kousa dogwood, and other similar dogwoods, are really
insect attracting bracts (modified leaves) that surround the actual, tiny flowers.
This device is also used by poinsettias: the "flower petals" are colorful leaves that together
resemble a blossom.

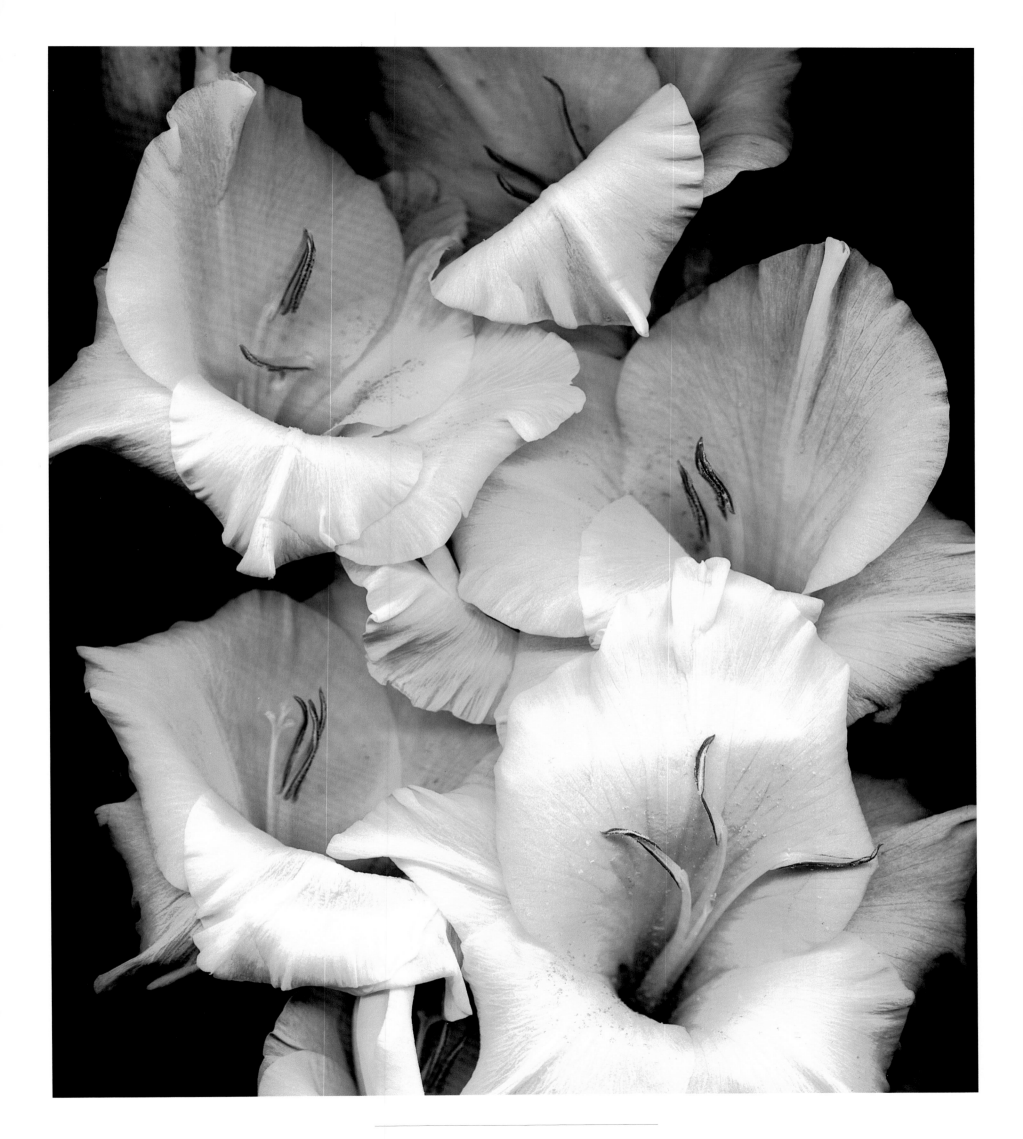

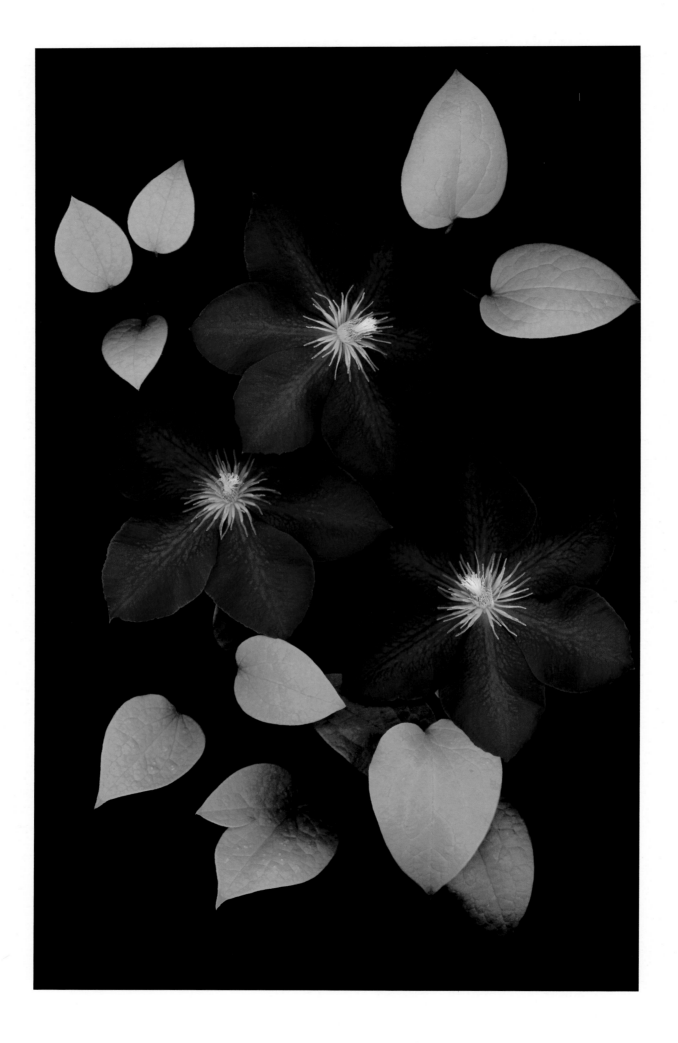

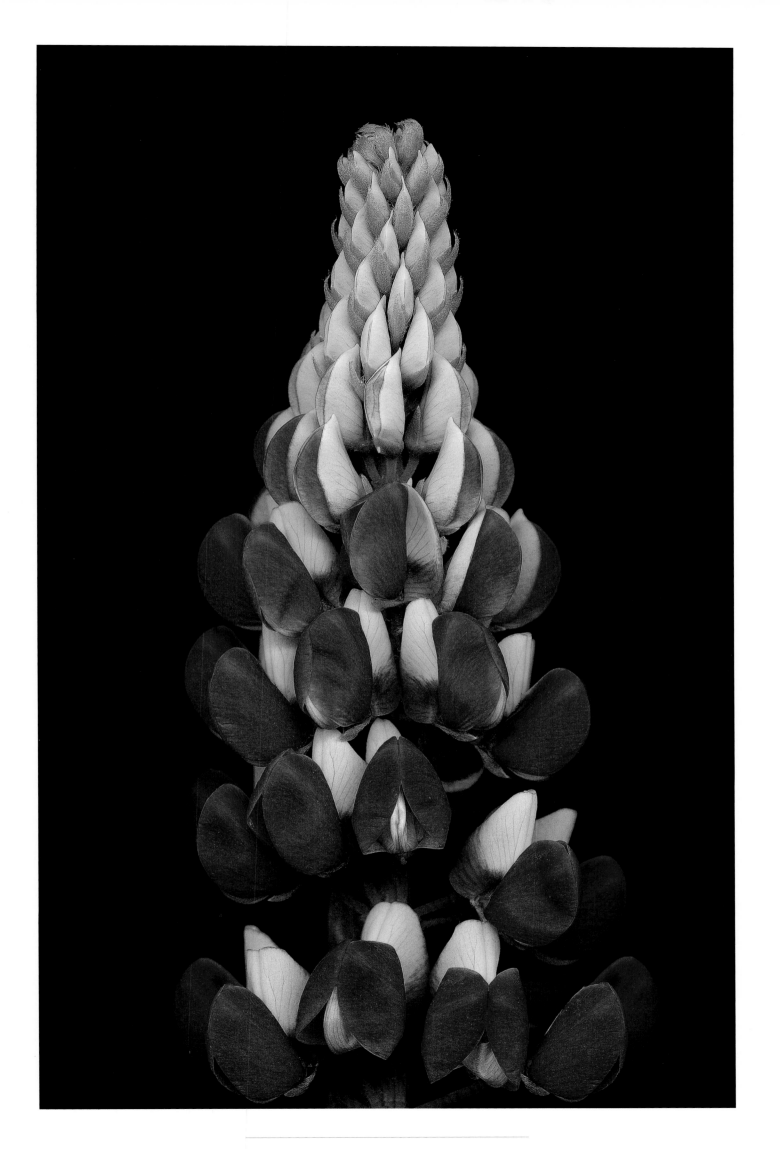

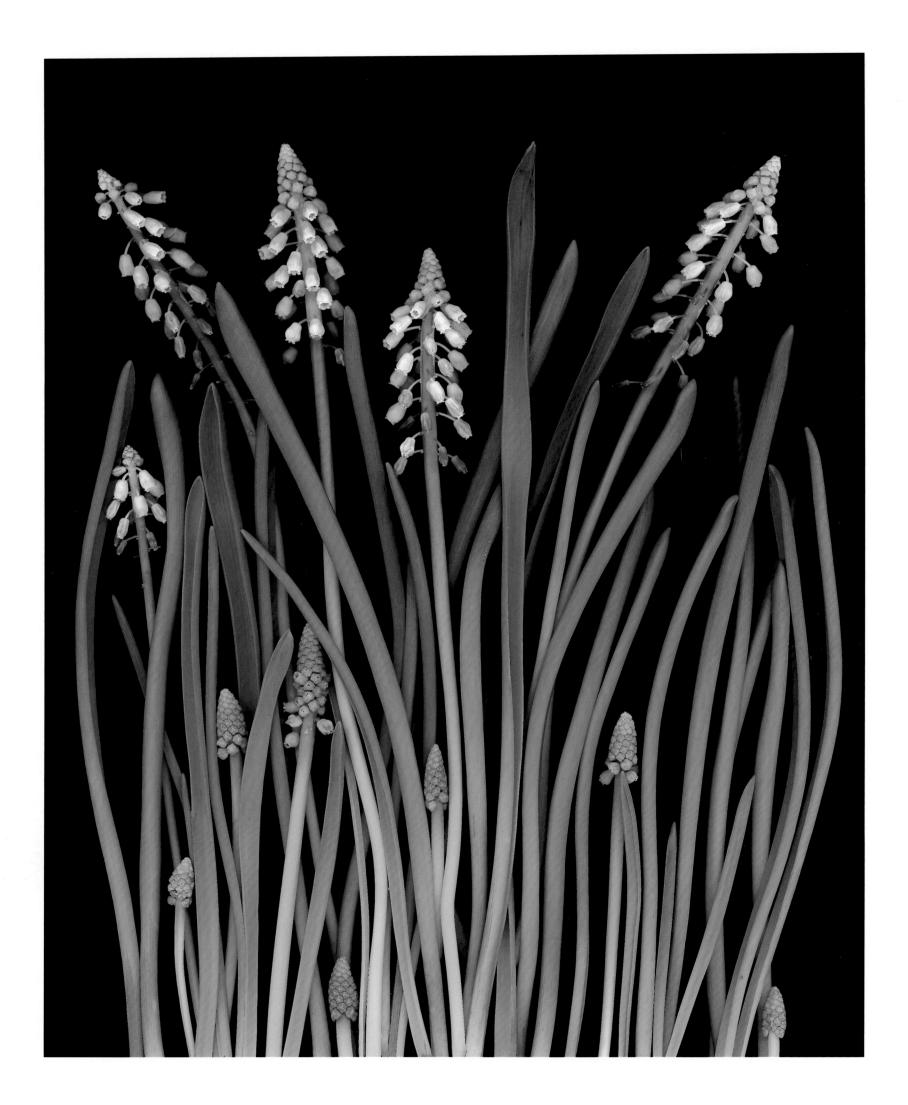

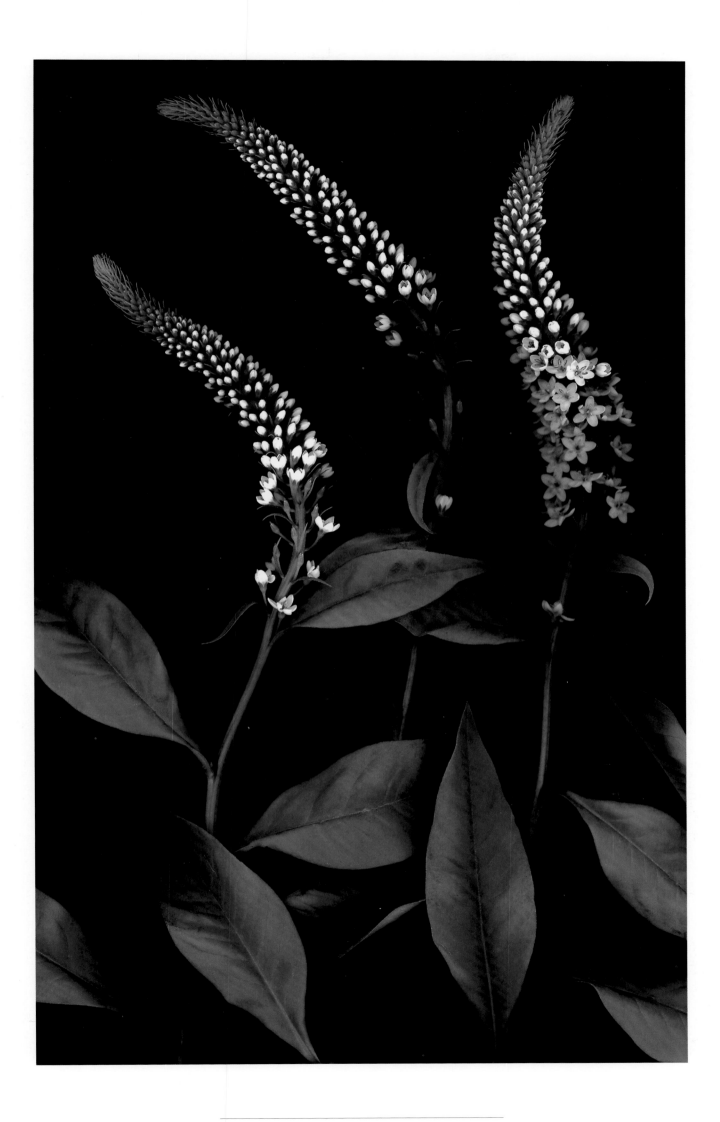

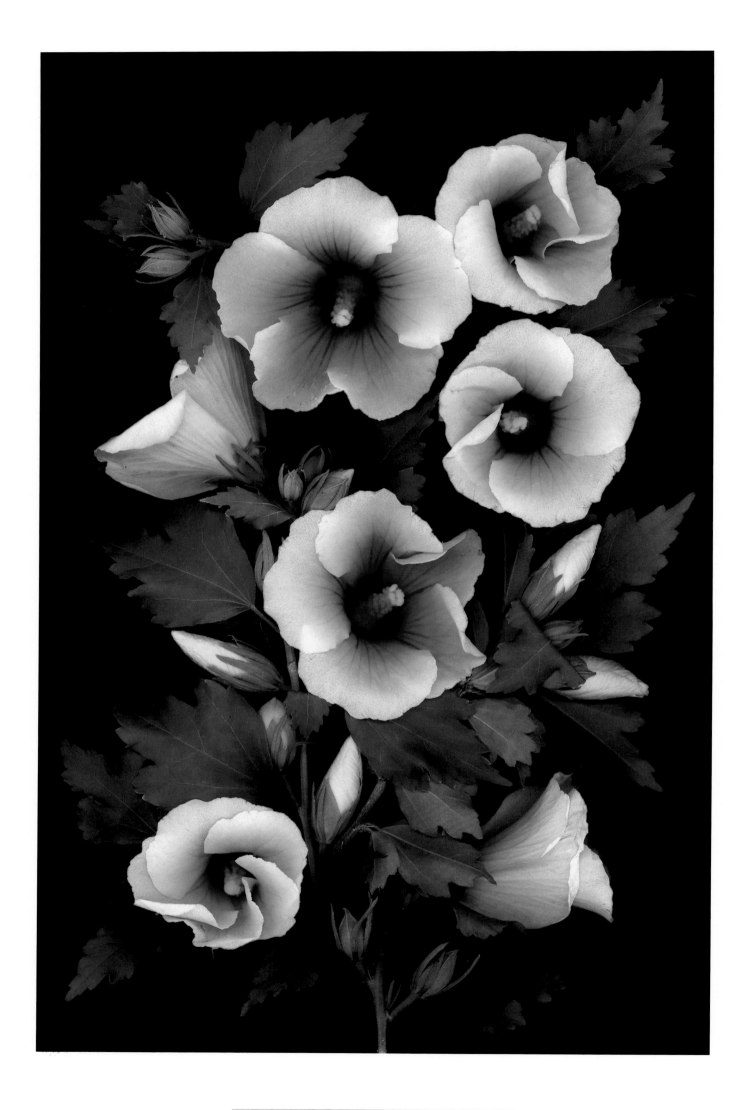

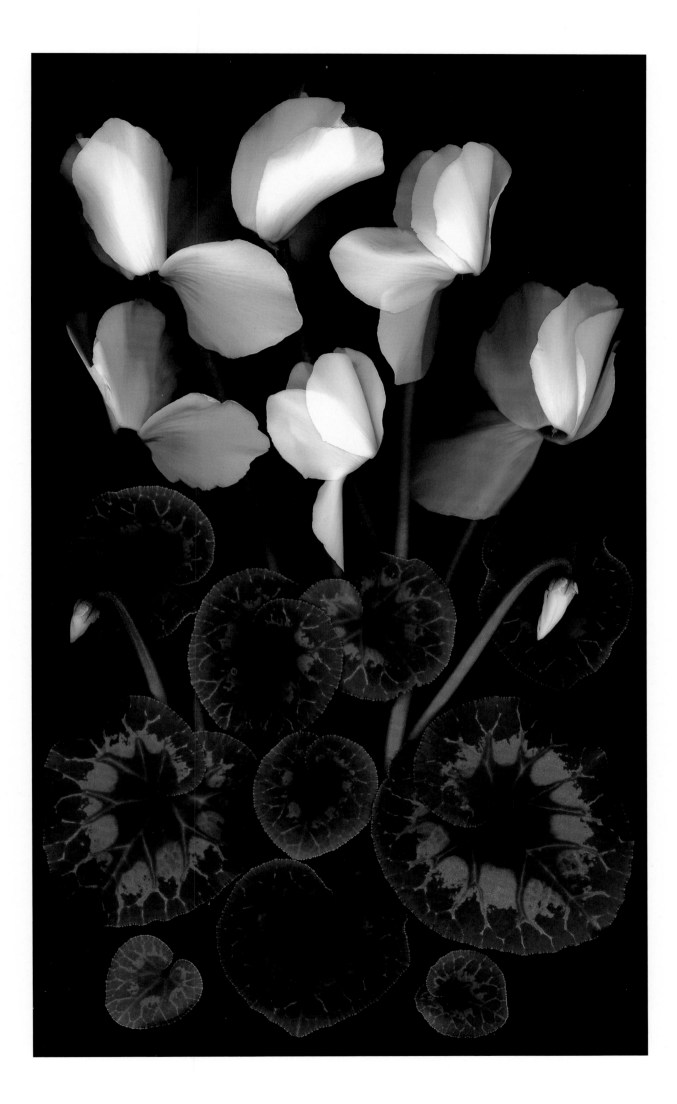

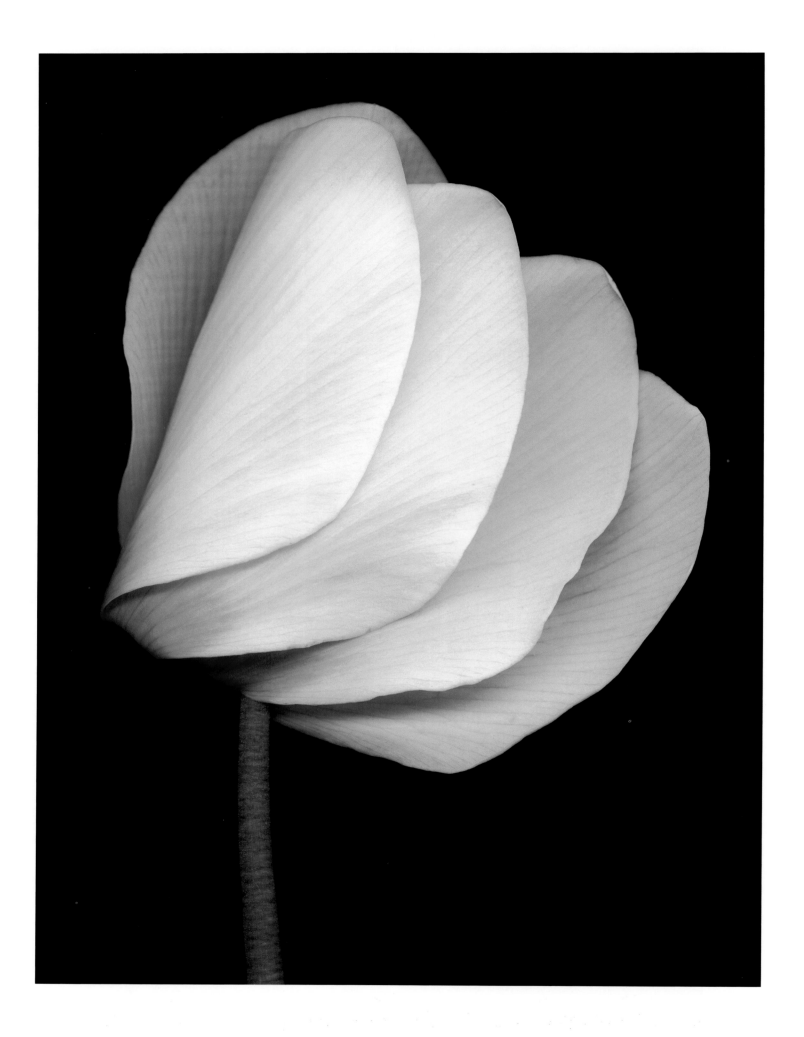

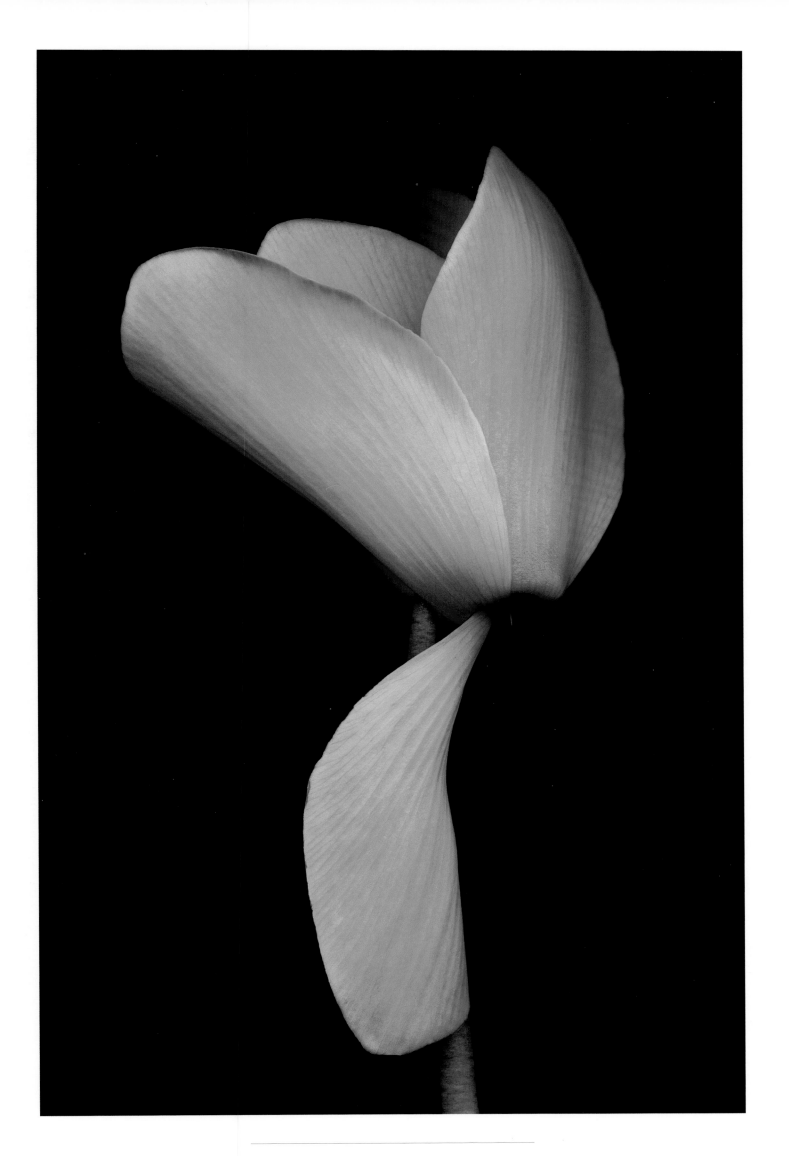

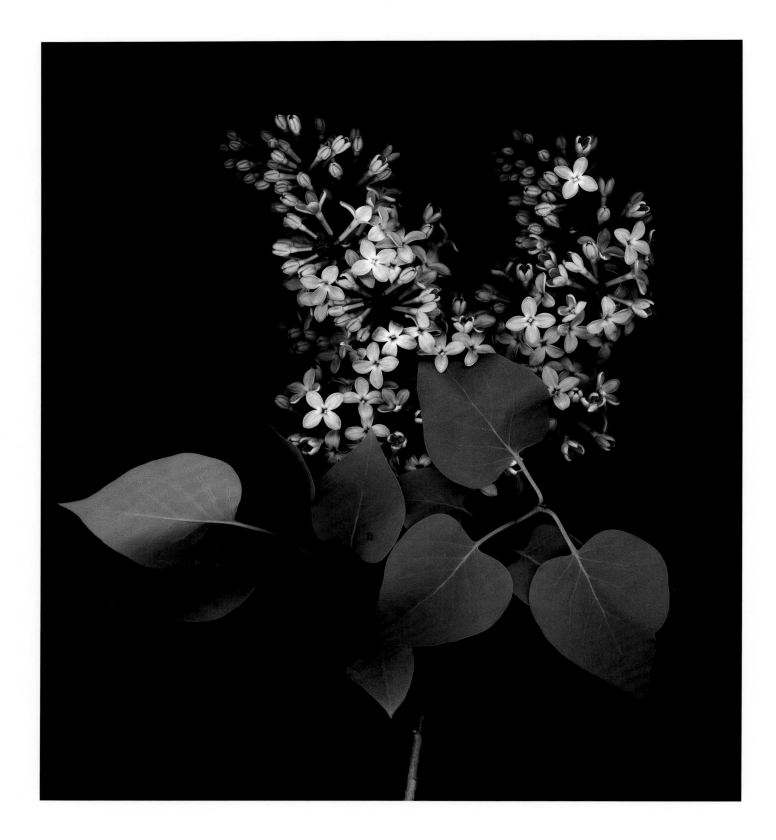

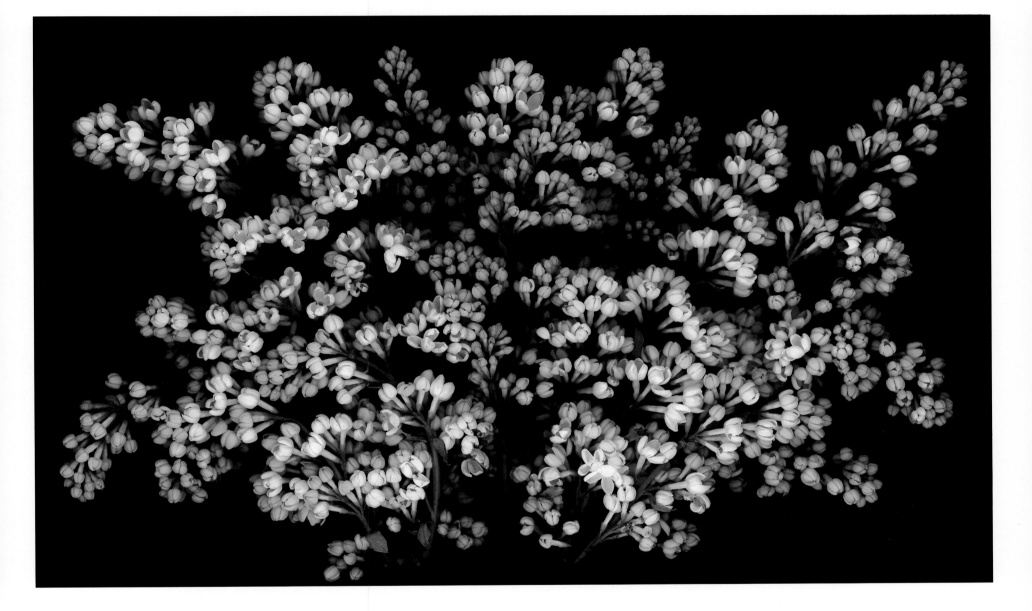

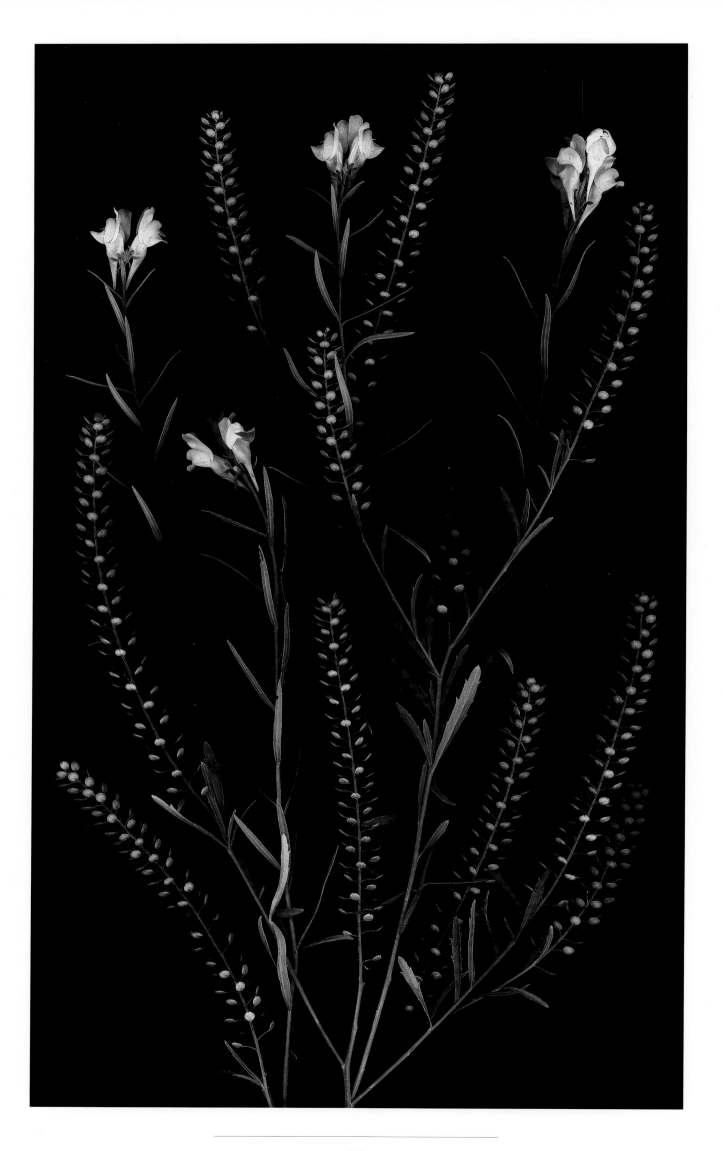

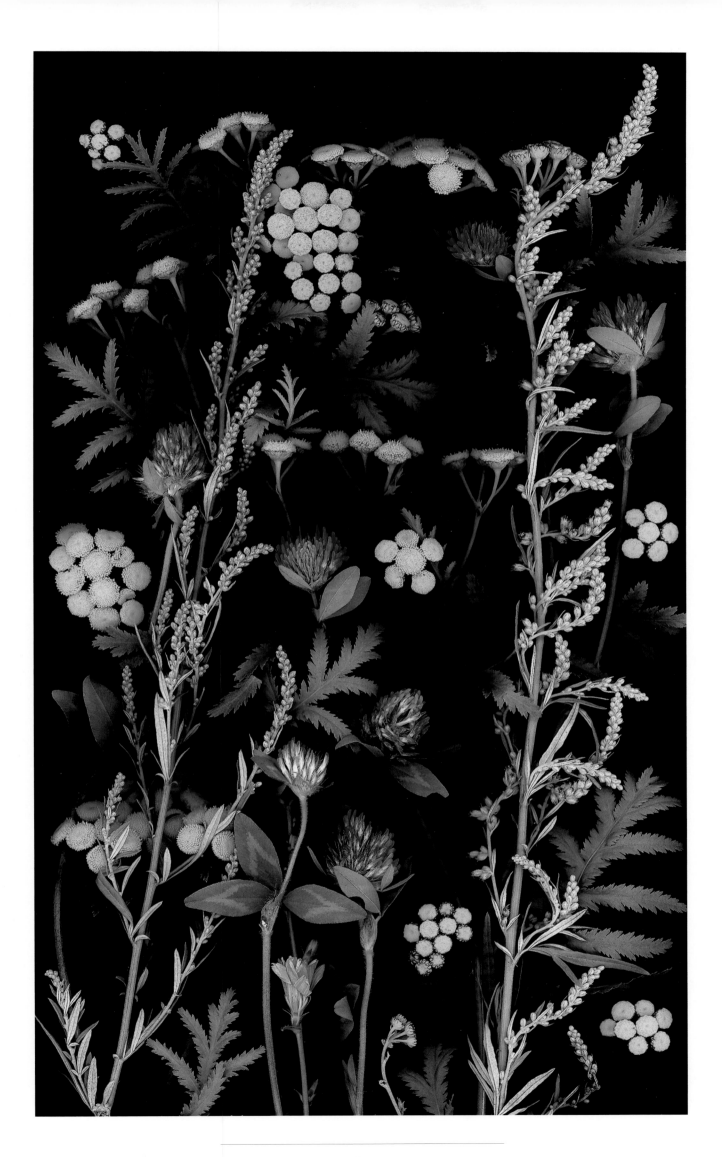

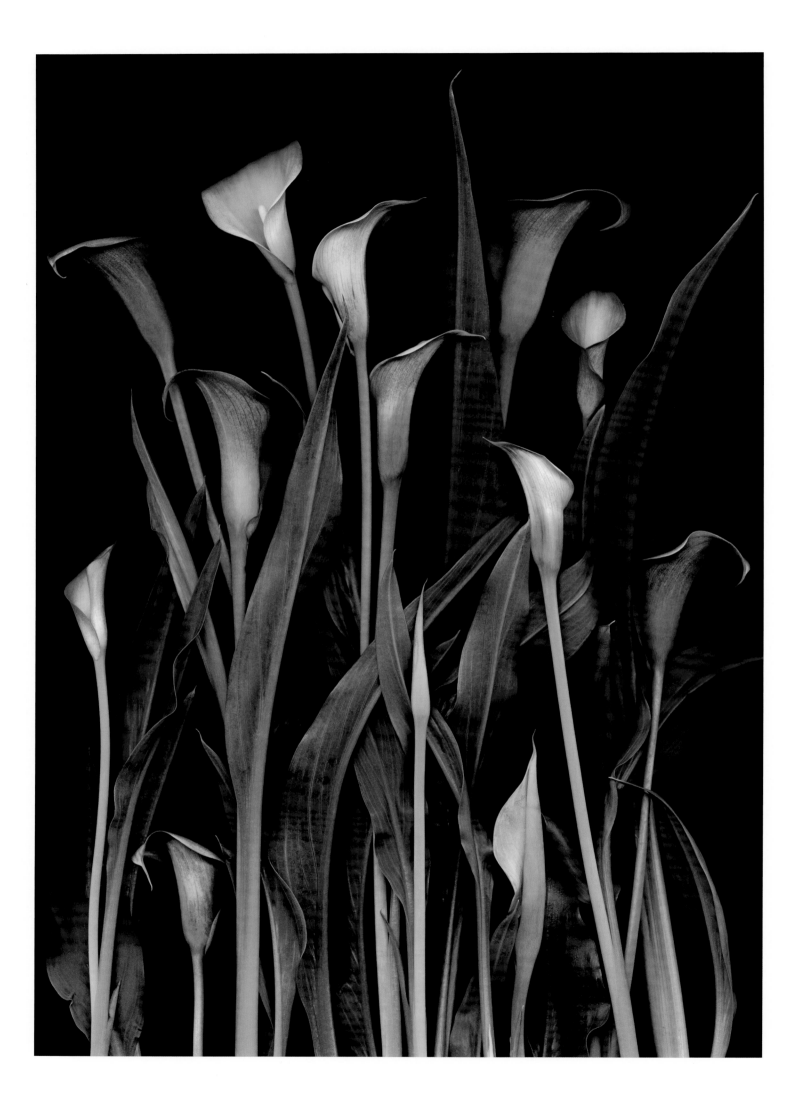

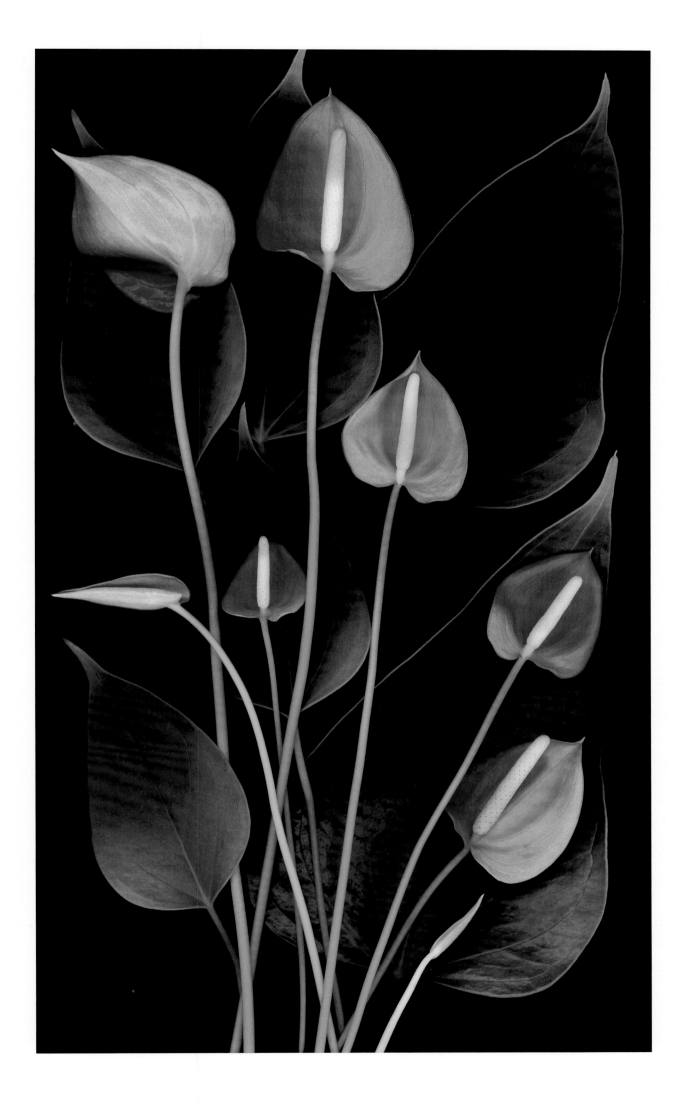

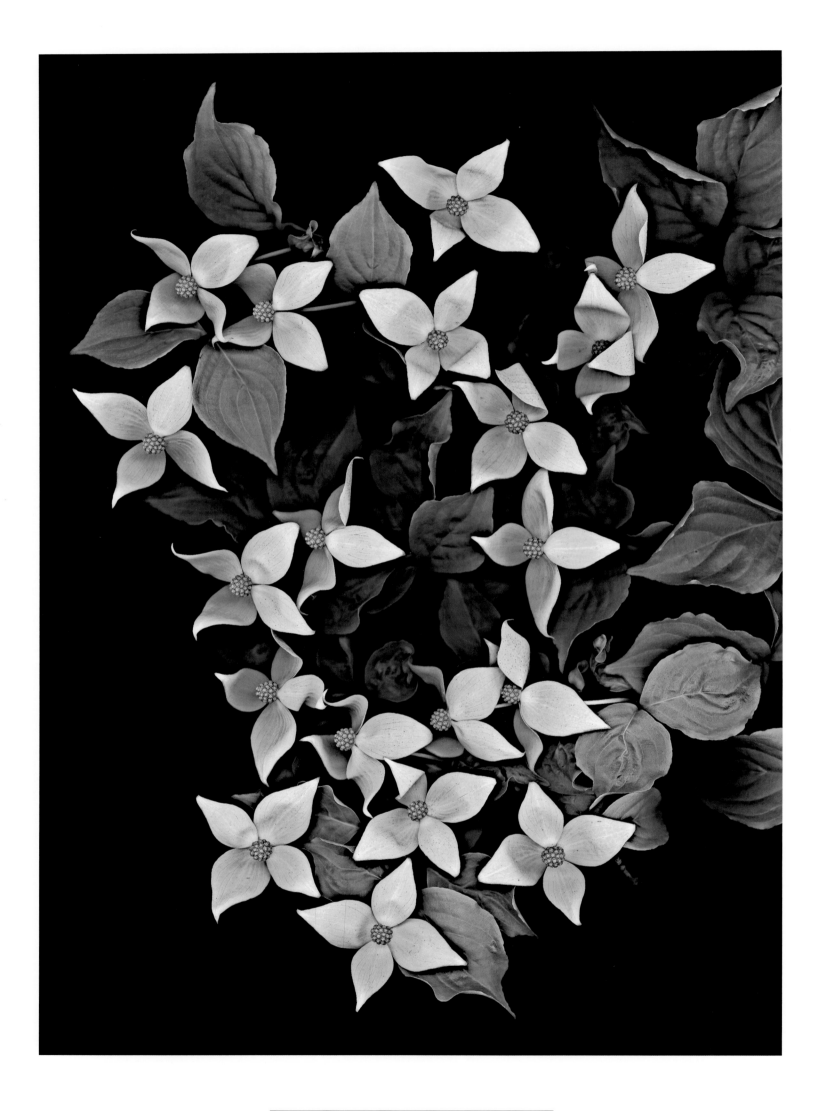

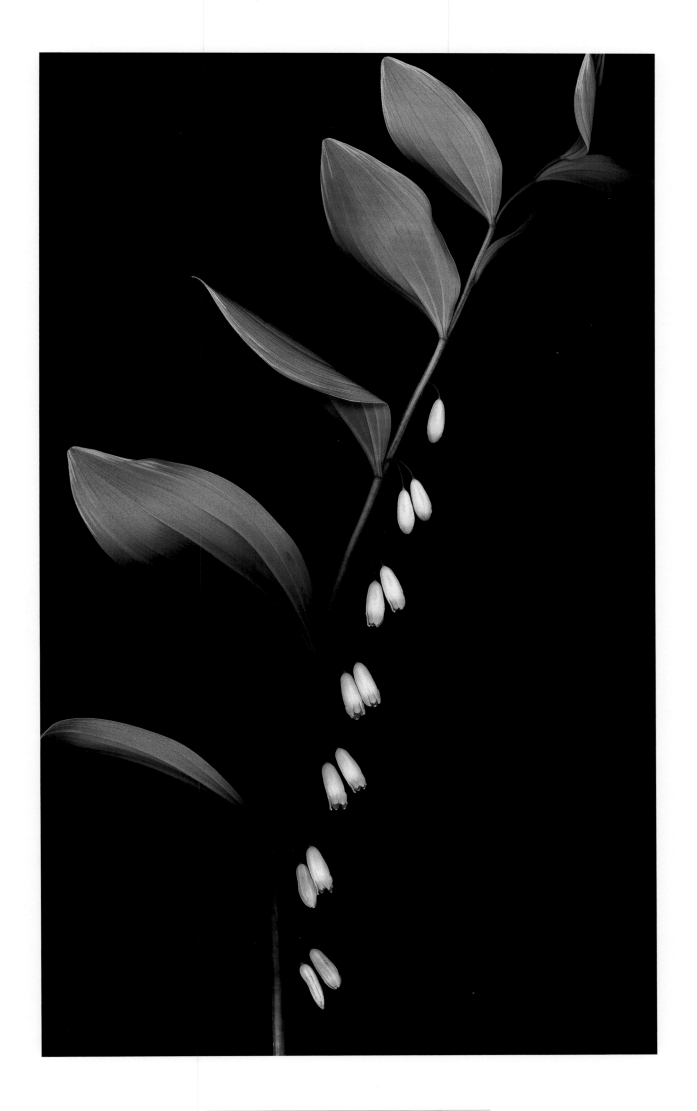

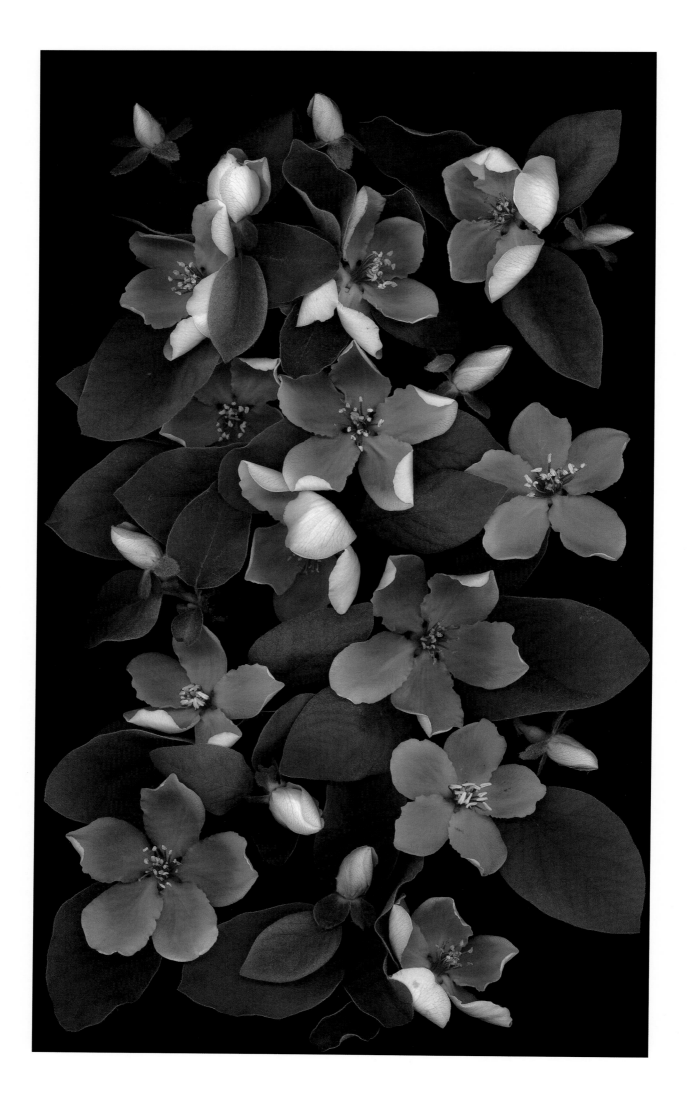

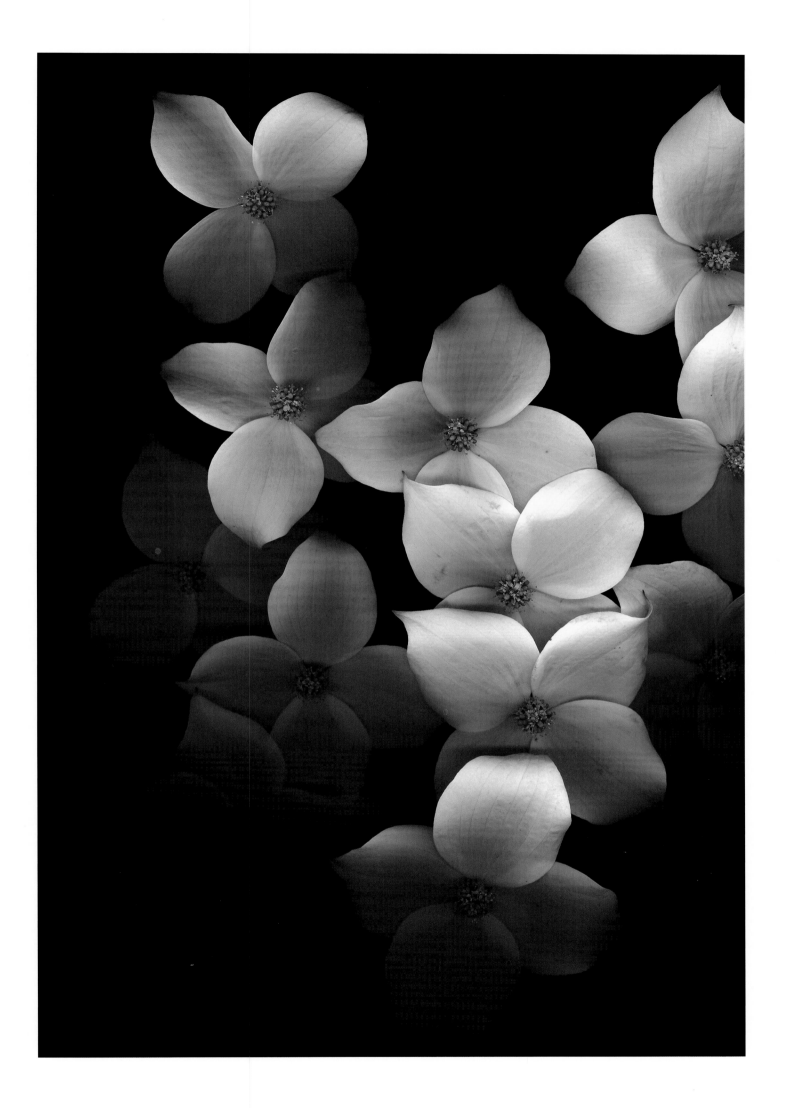

A NAME FOR EVERY FLOWER

Plant names are as expressive as language itself. They're rich and full of meaning. "First breath of spring" is a fitting name for a plant that opens its sweetly fragrant blossoms on warm and sunny winter days, a welcome reminder of the season to come. Some names associate plants with feelings or emotions. "Heart bursting with love" is the name of a plant native to the forest of the eastern United States. In the autumn, the reddish, heart-shaped fruits burst open to reveal scarlet seeds. Unusual names—such as "turban squash"—are created by combining ideas or words from distant lands or distinct cultures. Squashes are from the Americas, and their name comes from an abbreviated Native American word. Putting a name to this new kind of squash required knowledge of the Native American name, familiarity with Muslem turbans, and creativity to combine the two into a perfect description—a squash that resembles a Muslem headdress. While these names describe flowers and fruits, others call attention to leaves or stems: "waterleaf" is an aquatic plant with leaves that float on the water's surface, and "devil's walking stick" is a small tree that has long, straight, prickly stems. Other names come from words derived from ancient or foreign languages. "Poppy" is the English translation of the Latin word for the same plant. And the name "hickory" comes from the longer Native American word *pawcohiccora*. Plants are also named for people: "forsythia" honors William Forsyth, a Scottish gardener.

These are all common names—names that are informal and popular among local cultures. They are a useful part of language: they communicate by passing information on to others in a form that is easier to use than long descriptions. But names can sometimes be misleading. Usually, the misinterpretation of foreign languages and limited knowledge of geography at the time the name came into use are at fault. "Jerusalem artichokes" are closely related to sunflowers and have underground tubers that taste like artichoke hearts, but they're native to North America, not Jerusalem.

Names can also lead to confusion. When many names are given to the same plant, or one name is given to many plants, the concept of using names for better communication becomes useless. Since different regions or different cultures use different names, confusion often occurs. "Strawberry bush" is another name for "heart bursting with love"; the heart-shaped fruits resemble small strawberries before they burst open. And "buttercup" often describes a yellow, spring-blooming perennial in the northeastern United States, but in some areas of the southeast daffodils are called buttercups.

To avoid the confusion caused by common names, plants are also given botanical names. These names are universal and each name identifies only one plant. Latin is the language of science and medicine, and botanical names are derived from a standardized version of classical Latin and Greek, called botanical Latin. These names are set up in a binomial sequence, which literally means two names. The first part of the name represents the genus, a group that is a collection of closely related plants. There might be anywhere from one to hundreds of members in a group. Think of it in terms of a family. Siblings in the family will all have the same family name—or at least start out that way. Cousins, aunts, uncles, etc., might all share the same name. This shows they have similar ancestry. Plants are grouped together in a genus because they are thought to have a common ancestor. Family members are distinguished from one another by their given names. And plants belonging to the same genus are distinguished by a specific epithet. This is the second part of the binomial. *Lonicera fragrantissima* is the botanical name for the plant commonly known as "first breath of spring." The first part of the botanical name tells us the genus and classifies the plant as honeysuckle. The specific epithet identifies what kind of honeysuckle it is.

101. FLORIST'S CHRYSANTHEMUM, *Dendranthema grandiflorum* cultivar
According to the respected gardener and writer Elizabeth Lawrence, the sweet country name
for chrysanthemum is "October pink."

102. FLORIST'S CHRYSANTHEMUM, *Dendranthema grandiflorum* cultivar
The name "chrysanthemum" comes from two Greek words that mean "golden flower,"
referring to the many species that are yellow, or to those that have yellow centers.

103. SPIDER CHRYSANTHEMUM, *Dendranthema grandiflorum* cultivar
Chrysanthemums bloom in the fall when the days become shorter. But commercial growers
fool plants into flowering year-round by growing them in greenhouses and covering them
with black cloth to simulate short days.

104. BACHELOR'S BUTTON; CORNFLOWER, *Centaurea cyanus*
"Nothing is so beautiful as spring—When weeds, in wheels shoot long, lovely and lush."
From "Spring," by Gerard Manley Hopkins.

105. DOUBLE-FLOWERED EVERGREEN AZALEA, *Rhododendron* cultivar
The name "rhododendron" translates into "rose tree" in Greek. At one time the word "rose"
simply meant a large flower or a plant with large flowers.

106. DECIDUOUS AZALEA, *Rhododendron* cultivar
There are not many distinctions between azaleas and rhododendrons:
that's why they're grouped together. But they were once thought of as two separate groups
because the first azaleas discovered were deciduous (they lose their leaves),
while rhododendrons are evergreen.

107. EVERGREEN AZALEA, *Rhododendron* cultivar
Azaleas and rhododendrons belong to the same family of plants that includes heather,
blueberries, cranberries, mountain laurel, and wintergreen.

108. POT MARIGOLD, *Calendula officinalis* cultivar
The names of many plants carry the botanical epithet *officinalis*. This word identifies plants
used by apothecaries as official medicine.

109. GARDEN DAHLIA, *Dahlia* cultivar
In *Hardy Perennials*, his wonderfully informative and colorfully written book, Graham Rice
introduces a chapter about dahlias: "I am, perhaps, overstretching the concept of the hardy
perennial more than will be acceptable to many of my readers by including a chapter on
dahlias. Not only are the vast majority of dahlias not at all hardy, but many enthusiasts for
hardy perennials would give up gardening rather than have dahlias in their borders."

110. GARDEN DAHLIA, *Dahlia* cultivar
Plant dahlia tubers in a sunny spot of your garden after the last frost has occurred.
Several weeks prior to planting, incorporate an all-purpose fertilizer or manure into the
planting area along with organic matter to loosen the soil; dahlias prefer alkaline soils,
so add lime if necessary. Once the soil is prepared, dig a hole five inches deep and drive a
four-to-five-foot stake to one side of the hole. Lay each tuber horizontally, one per hole,
place the tuber with the growth bud, or "eye" pointing up and close to the stake,
which will be used to support the thick, central stem.

111. CACTUS-FLOWERED DAHLIA, *Dahlia* cultivar

Dahlias enjoy rich soils, but should not receive any nitrogen fertilizer after planting because this will decrease the formation of flower buds. It's acceptable to use fertilizers after planting, but only those that don't contain nitrogen.

112. SUMMER PHLOX, *Phlox paniculata* cultivar

The name "phlox" is derived from the Greek *phlego*, to burn. It is thought that this refers to the bright colors of some of the species, or to another plant that was once grouped with the phloxes, the catchfly.

113. SUMMER PHLOX, *Phlox puniculata* cultivar

In *The Essential Earthman*, Henry Mitchell describes how to grow phlox:
". . . nothing is more festive in late summer, provided there is full sun, deep soil, and plenty of water available. Phloxes usually fail in half-shady places, but where tomatoes flourish, the phlox does very well."

114. MOPHEAD HYDRANGEA, *Hydrangea macrophylla* cultivar

The name "hydrangea" comes from two Greek words meaning "water jug," referring to the cup-shaped seed capsules.

115. MOPHEAD HYDRANGEA, *Hydrangea macrophylla* cultivar

The flower clusters of mophead (also known as hortensia) hydrangeas are comprised of large, showy sterile flowers, while the lace-cap types have many small, inconspicuous fertile flowers surrounded by large sterile ones. All grow in most any soil but grow best in one that is well drained and rich in humus.

116. PEONY, *Paeonia lactiflora* cultivar

Peony enthusiast Alice Harding wrote in 1917: "To open a case of fine peony roots is a pleasure; the roots themselves are beautiful things, strong, firm and fleshy . . . big crisp eyes that hold the future glory of the garden. A label is attached to every plant: as one joyfully reads over the names, visions of each perfect flower arise."

117. PEONY, *Paeonia lactiflora* cultivar

In *Stearn's Dictionary of Plant Names for the Gardener*, William Stearn writes about the teaching methods of the pioneering botanist, Carolus Linnaeus: "He made a close study of what he called 'floral nuptials'...The petals of flowers he regarded as 'bridal beds adorned with such noble bed-curtains and perfumed with so many sweet scents that the bride-groom may celebrate his nuptials with his bride with all the greater solemnity.'"

118. PEONY, *Paeonia lactiflora* cultivar

The peony is named after the mythical Greek physician Pacon, who is thought to be the first to use the plant medicinally.

119. POPPY, *Papaver* cultivar

In *Flowers and Fruit*, Colétte describes ethereal poppy petals concealing large seed capsules. "So'light headed! . . . but far from empty. Beneath its round corona an array of little holes open up . . . and once it is mature . . . sprinkles with a fine black seasoning the well peppered ground."

120. MODERN ROSE, *Rosa* cultivar

"While one is in the prime of youth, one thinks that a flower is what one carries in a buttonhole, or presents to a girl; one somehow does not rightly understand that a flower is something which hibernates, which is dug round and manured, watered and transplanted, divided and trimmed, freed from weeds, and cleaned of seeds, dead leaves, aphis and mildew . . ." From *The Gardener's Year*, by Karel Čapek.

121. FREESIA, *Freesia* cultivar

Known mostly as a cut flower or potted plant, freesias are grown for their fragrant blossoms. This member of the iris family is native to South Africa and grows from bulblike corms, which are swollen stems.

122. WAX BEGONIA, *Begonia semperflorens-cultorum* cultivar

Wax begonias are one of the easiest plants to grow, and one of the least expensive to obtain. They grow outdoors in sun or shade, but indoors they should be in a brightly lit area. Many gardeners bring plants indoors for the winter, or break off stems to root in water.

123. SNAPDRAGON, *Antirrhinum majus* cultivar

The playful, squeezable snapdragon flower gets its botanical name from its resemblance to a broad nose—"resembling a snout" is a loose translation.

124. CHINESE HIBISCUS, *Hibiscus rosa-sinensis* cultivar

"Hibiscus" is a name first used by the Roman poet Virgil for a mallow flower. A European mallow, the marsh mallow, yields a mucilaginous substance from its root that, when sweetened, became the first marshmallows.

125. CHINESE HIBISCUS, *Hibiscus rosa-sinensis* cultivar

". . . and what is my experience of the flower—if it is not color."—Georgia O'Keeffe.

126. CHINESE HIBISCUS, *Hibiscus rosa-sinensis* cultivar

"In the faint dying light
Of the waning moon
The first hibiscus flower falls."
"Twilight" by Chén Yun

127. CHINESE HIBISCUS, *Hibiscus rosa-sinensis* cultivar

The Chinese hibiscus is native to tropical Asia but is grown worldwide—outdoors in mild climates, and in colder areas as summer bedding or in pots and greenhouses.

128. SQUASH BLOSSOMS, *Cucurbita* cultivar

Pumpkins, gourds, and squashes are all natives of the warm and tropical Americas. Pumpkins are the orange jack-o'-lantern fruit; gourds are bitter-tasting and used for decorative purposes only. Every other edible type is a squash.

129. PARROT TULIP, *Tulipa* 'Flaming Parrot'

"But come, tulip I deride, come and sit here by my side. Come painted like an Easter egg, red and streaked with yellow and orange." From *Flowers and Fruit*, by Colétte.

130. TULIP, *Tulipa* cultivar

The root of the word "tulip" comes from the Persian word for turban, a head covering. Some feel that certain tulip flowers resemble turbans, while others think that the papery covering of the tulip bulb (the tunic) is the source of the association.

131. QUEEN ANNE'S LACE (back of flower), *Daucus carota*

"It is a field of the wild carrot . . . the grass does not raise above it . . . white as white can be, with a purple mole in the center of each flower." From "Queen Anne's Lace" by William Carlos Williams.

132. ANEMONE, *Anemone coronaria* cultivar

Many feel the name "anemone" is derived from the Greek words (*anemos* and *mone*) meaning windy place. Anemones also have the common name of windflowers.

133. ANEMONE, *Anemone coronaria cultivar*

The delicate petals of some anemones dance in the wind; they are animated and seem to breathe with life. Perhaps this is why the words "anemone" and "animate" are derived from the same Greek root.

134. ASIATIC LILY, *Lilium cultivar*

In Liberty Hyde Bailey's *Cyclopedia of American Horticulture*, F. A. Waugh writes of lilies: "They are among those good 'old-fashioned' plants which frequently and justly come newly into vogue."

135. ASIATIC LILY, *Lilium cultivar*

True lilies differ from daylilies in many ways. The most obvious being that lilies grow from bulbs and daylilies do not. Most lilies need soil that is rich in humus and drains well but will retain enough moisture to keep the bulbs from drying out. They grow well in full or partial sun; some shade prolongs the life of the flowers.

136. ORNITHOGALUM, *Ornithogalum dubium*

The ornithogalums are a group of about eighty species native to South Africa, Europe, and Asia. The name stems from two Greek words meaning "bird's milk." One interpretation suggests that these plants "yield birdlime," a viscous substance that, when smeared on tree branches, aids the entrapment of small birds.

137. TUBEROUS-ROOTED BEGONIA, *Begonia tuberhybrida cultivar*

As the name implies, these begonias grow from a tuber, which is a modified stem, much like a potato. Plants can be purchased already in flower in the spring, or they can be started indoors from dormant tubers. Placed in a loose growing medium two months prior to your last frost date, they need bright, direct sun to get a good start indoors, but shade outdoors.

138. RIEGER BEGONIA; WINTER-FLOWERING BEGONIA, *Begonia hiemalis cultivar*

First bred in Germany in the 1950s, these free-flowering begonias come in many shades of red, pink, orange, and yellow. They're often sold in the winter as houseplants.

139. CHRISTMAS CACTUS, *Schlumbergera buckleyi*

This unusual member of the cactus family is a stem succulent—it has no leaves, photosynthesizing instead through its green, leaf-like stems. Although this doesn't look like a typical cactus, it belongs to the cactus family because of its cactus-like flower structure and the succulence of its stems.

140. FUSCIA, *Fuchsia cultivar*

"Mrs. Master's fuchsias hung/Higher and broader, and brightly swung,
Bell-like, more and more /Over the narrow garden-path,
Giving the passer a sprinkle bath/In the morning.
She put up with their pushful ways,/And made us tenderly lift their sprays,
Going to her door:/But when her funeral had to pass
They cut back all the flowery mass/In the morning."
"The Lodging-House Fuchsias," by Thomas Hardy.

141. GERANIUM, *Pelargonium hortorum cultivar*

Harold Feinstein's photographs are reminiscent of Georgia O'Keeffe's huge floral paintings. Both force the viewer to see details, to become intimate with the flowers. Georgia O'Keeffe explains: "When you take a flower in your hand and really look at it, it's your world for the moment. I want to give that world to someone else."

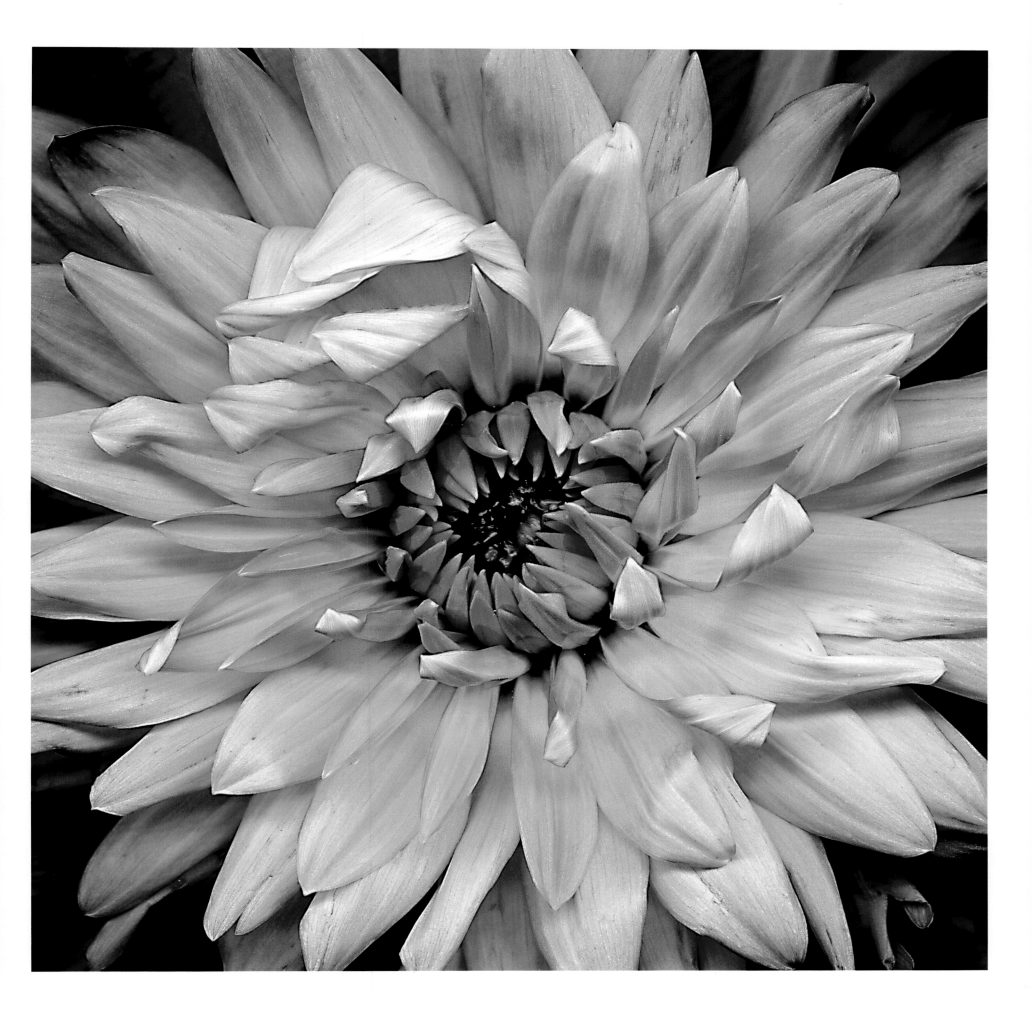

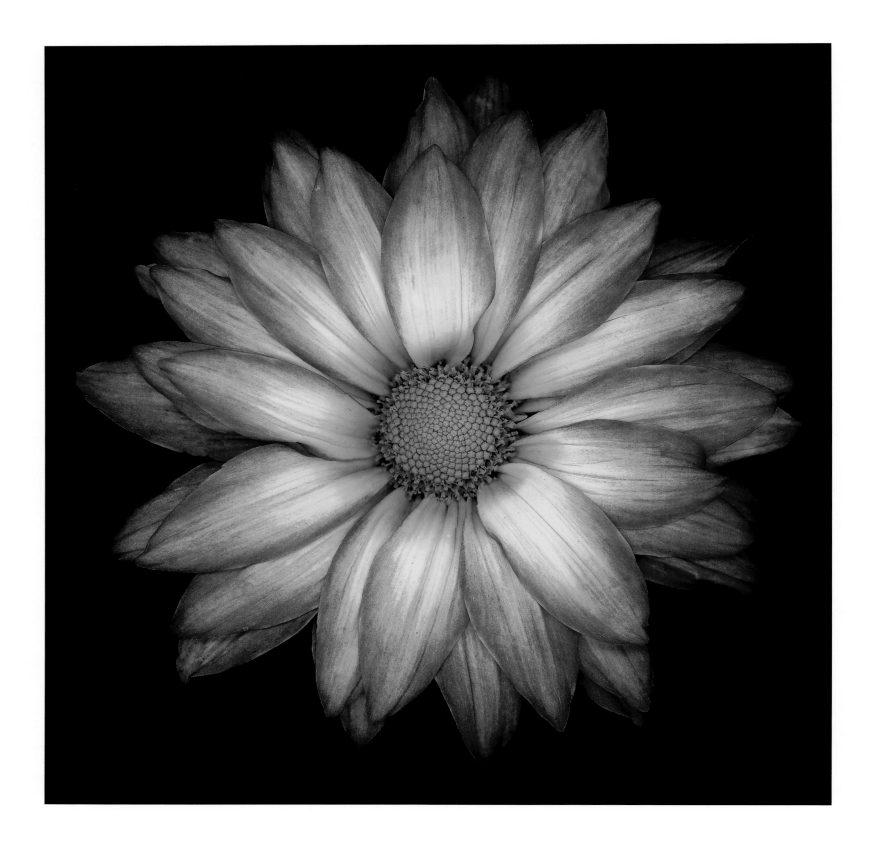

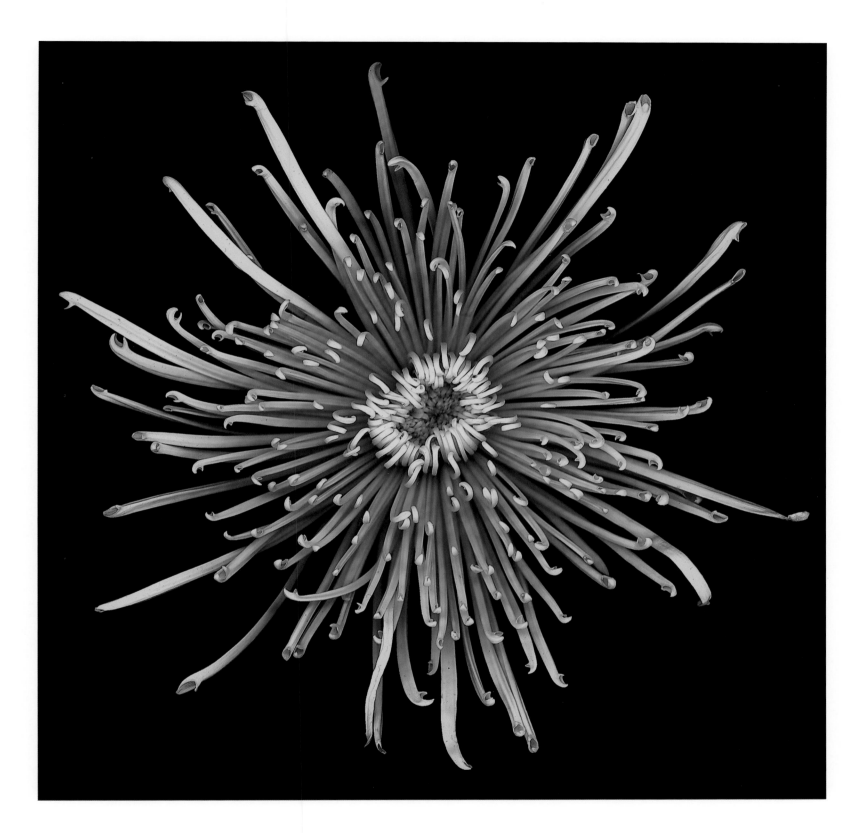

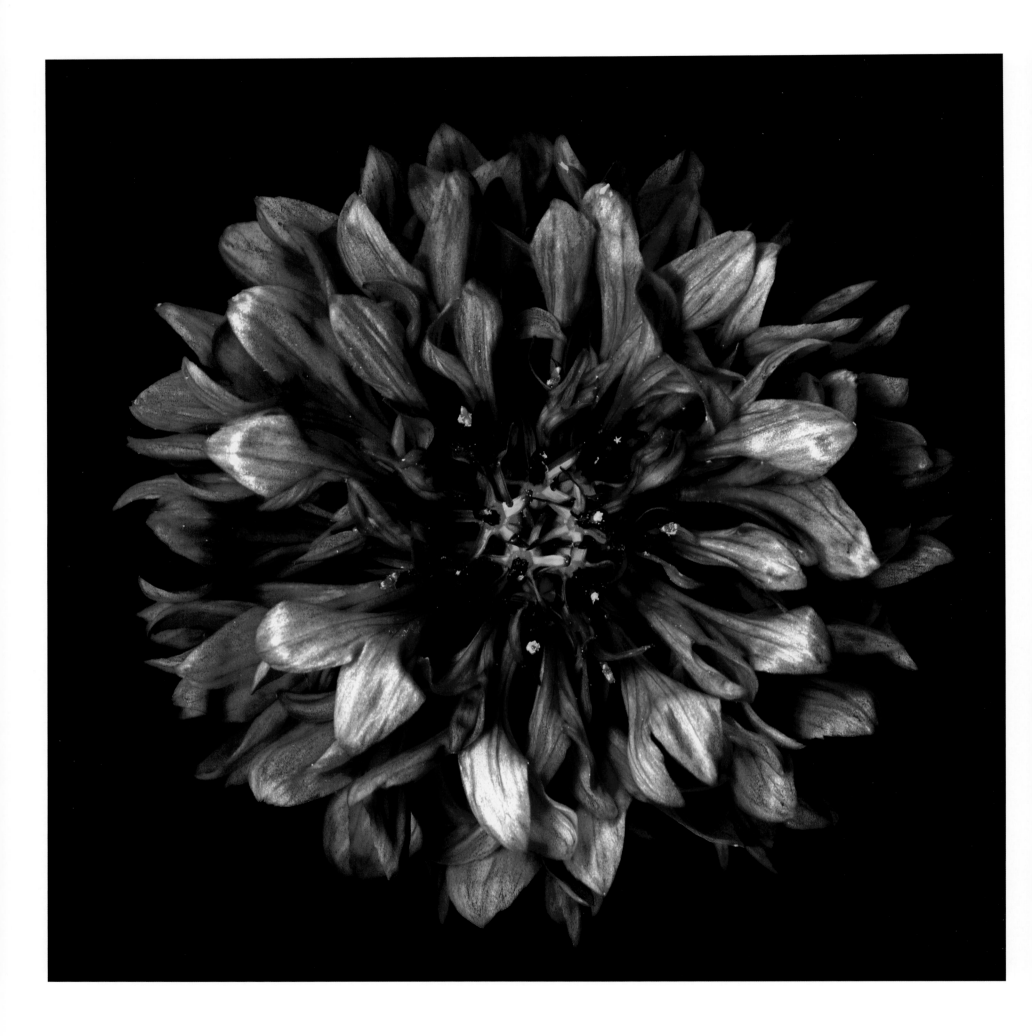

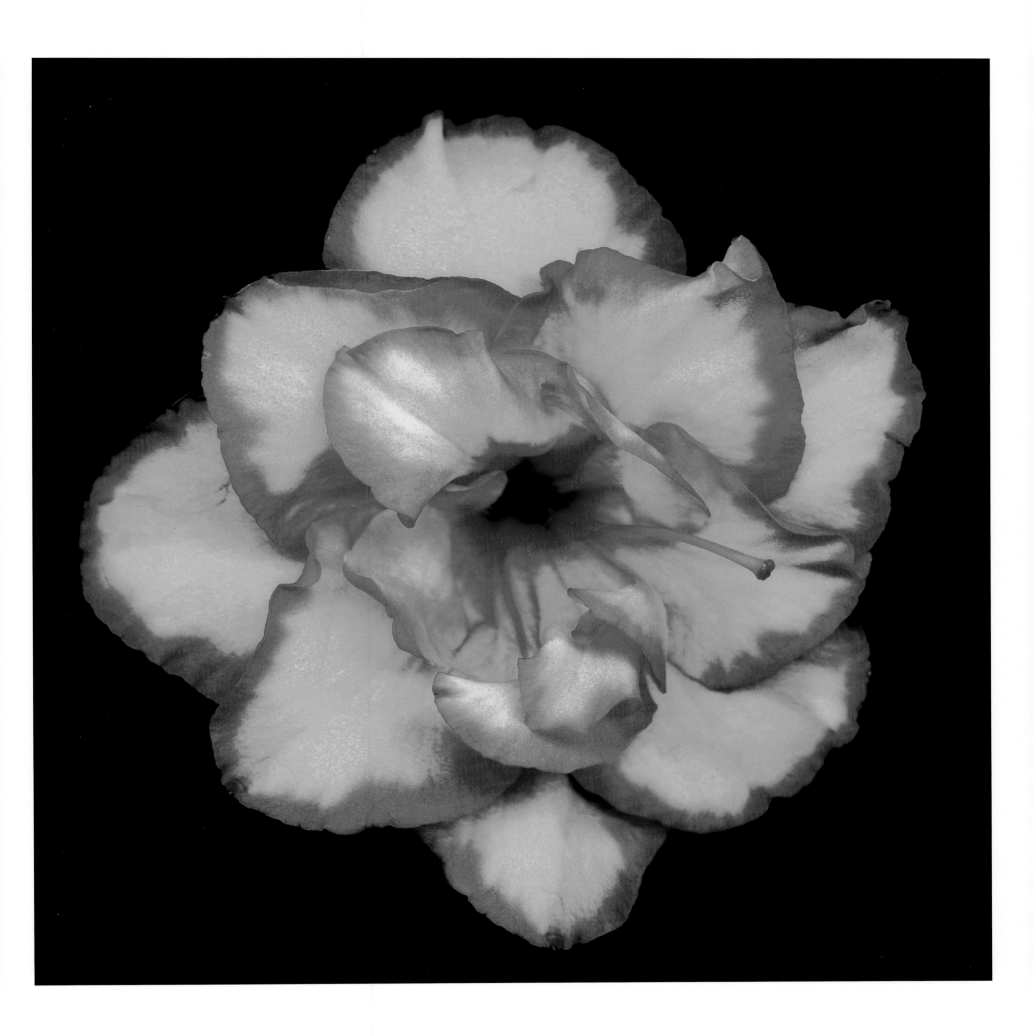

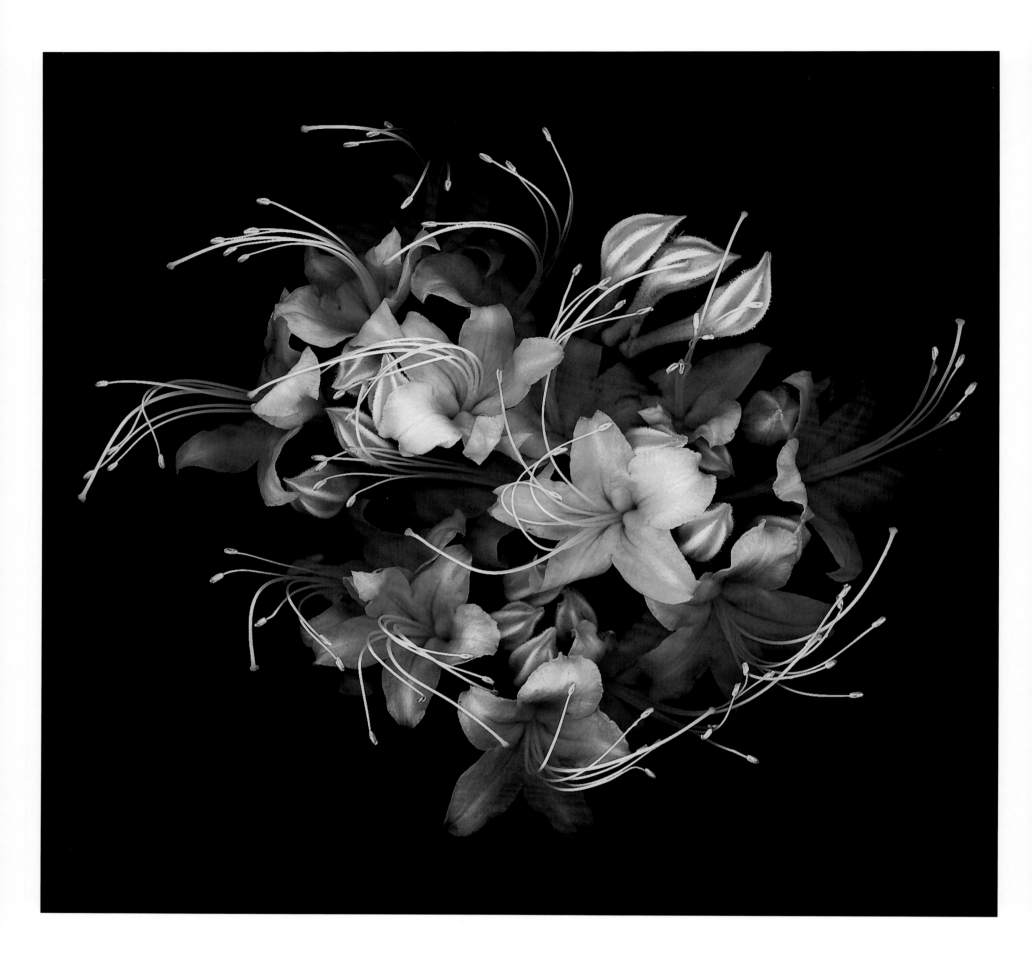

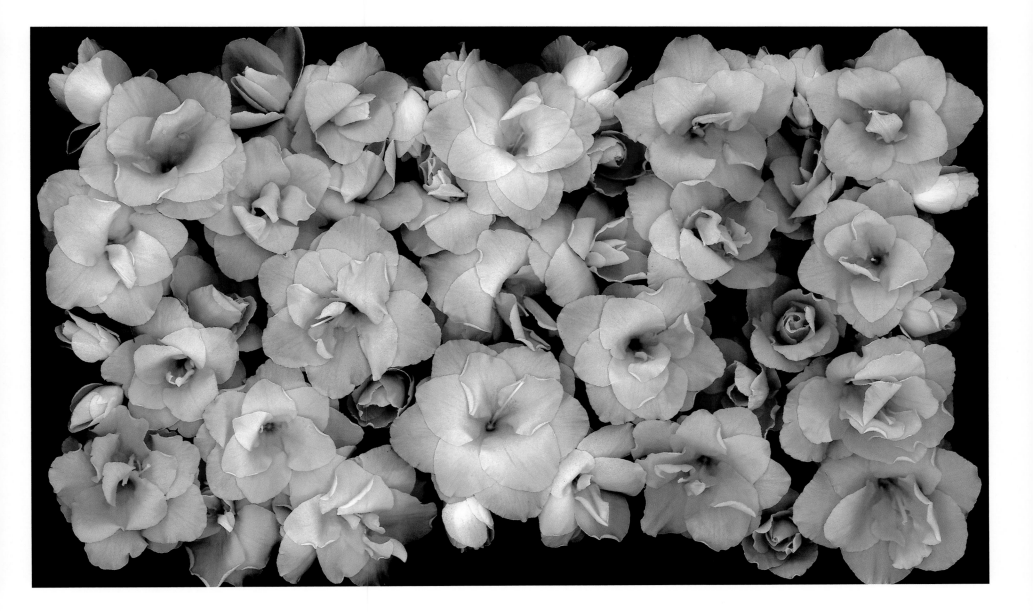

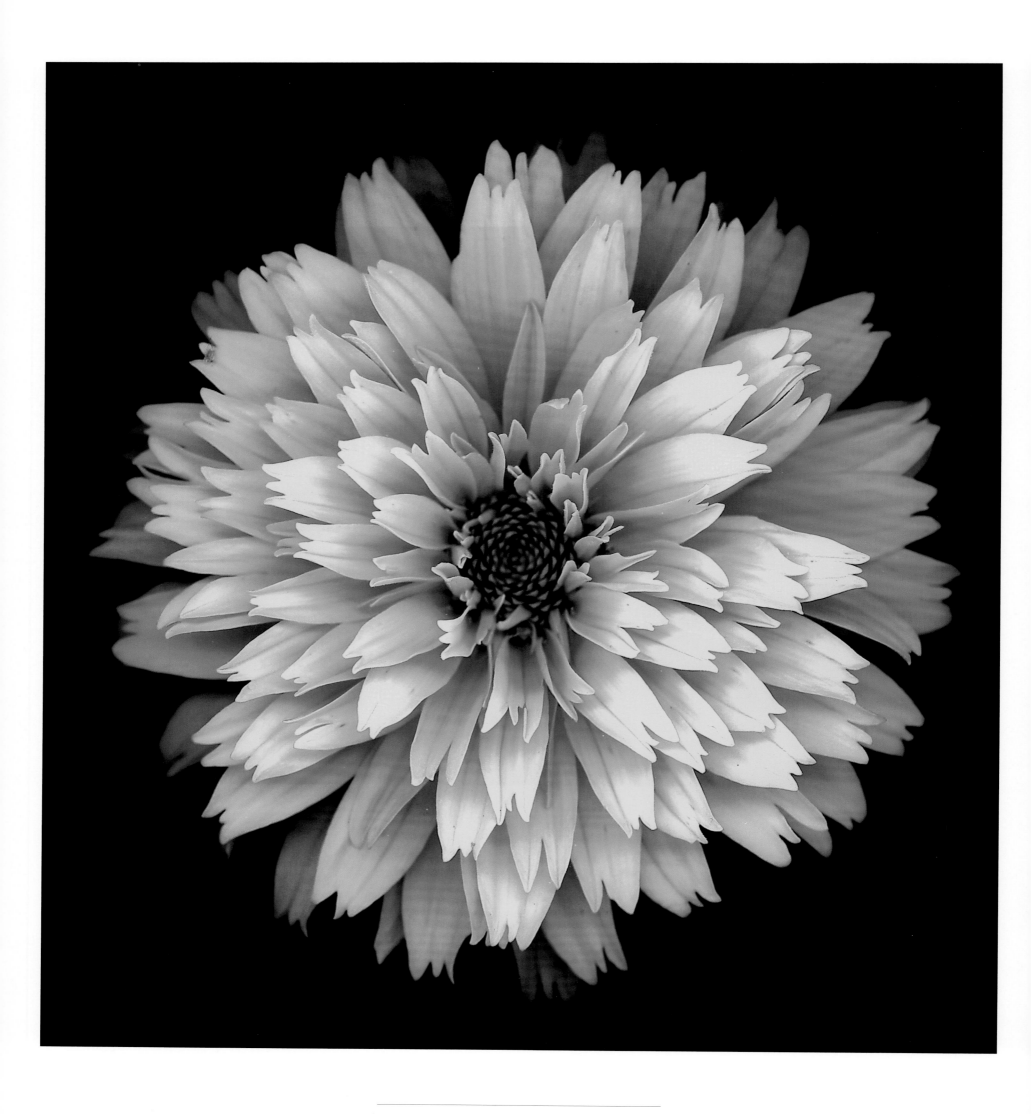

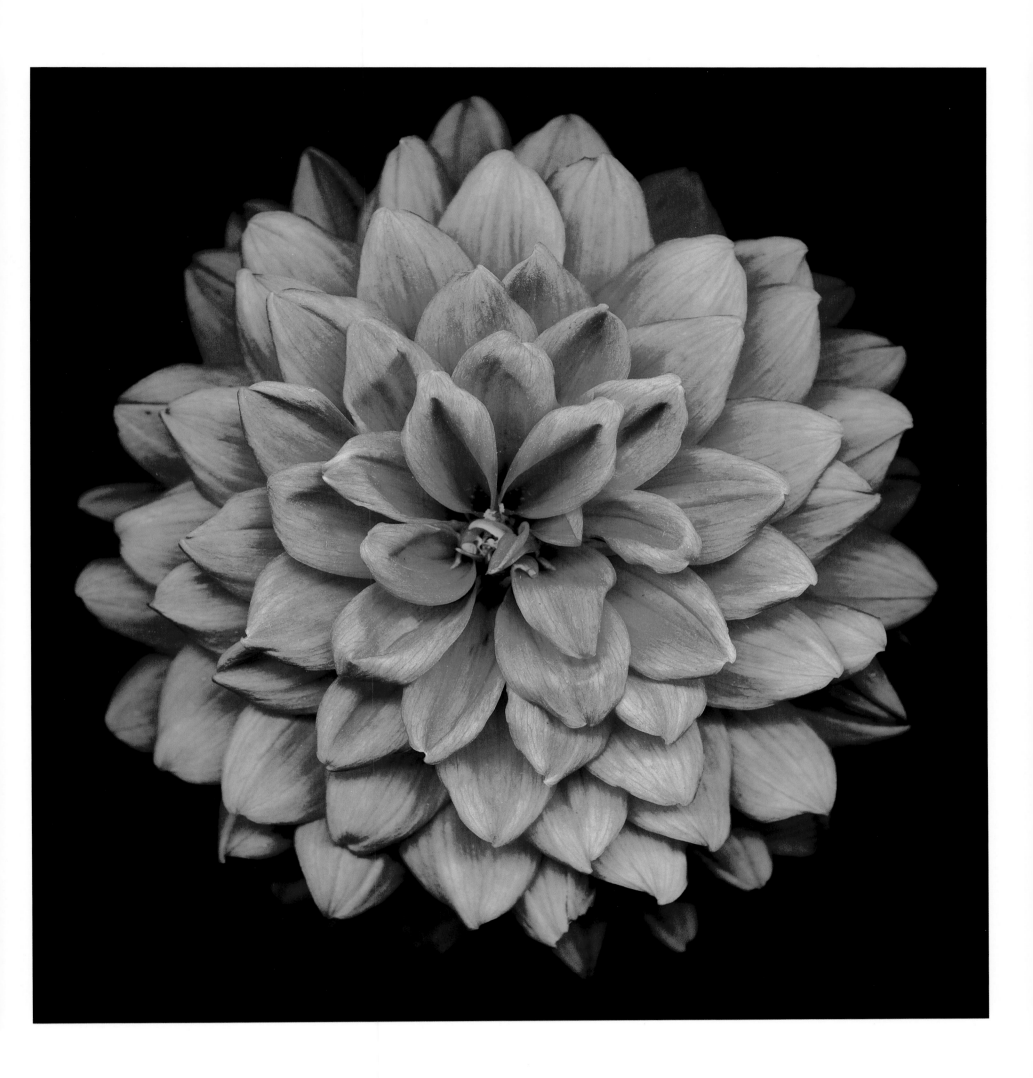

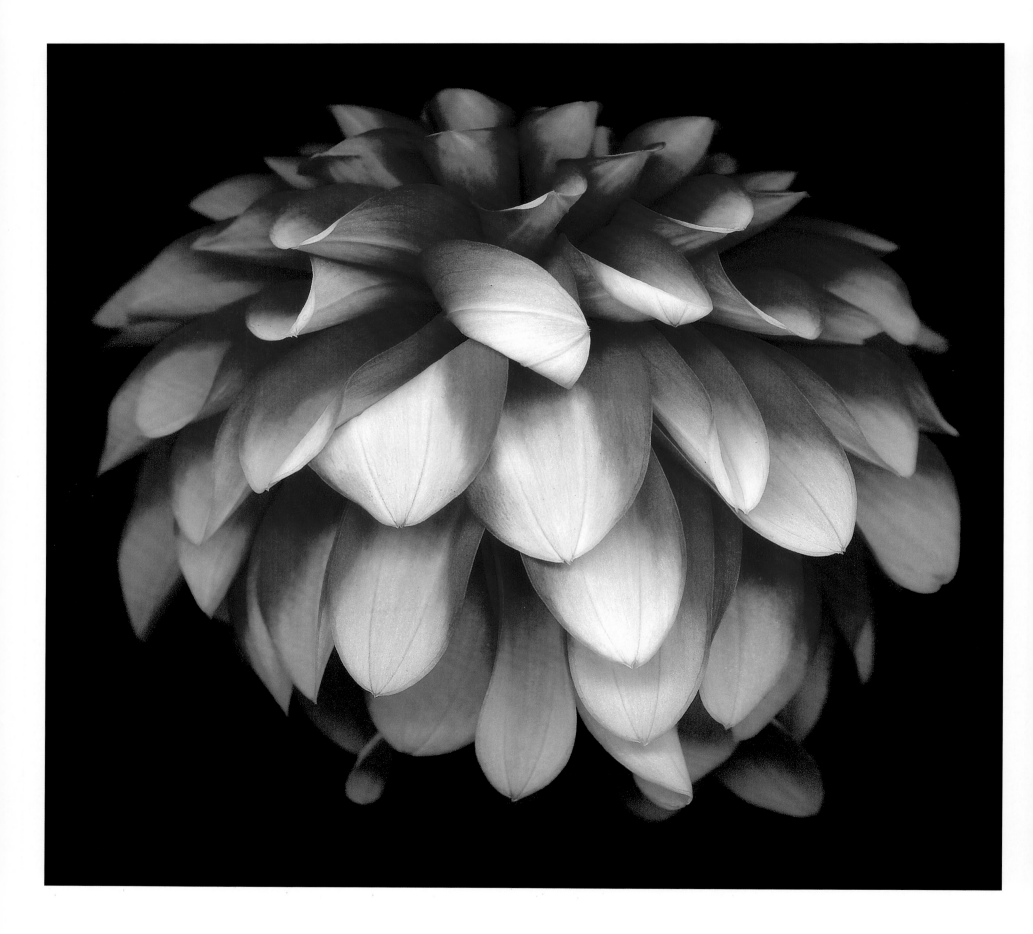

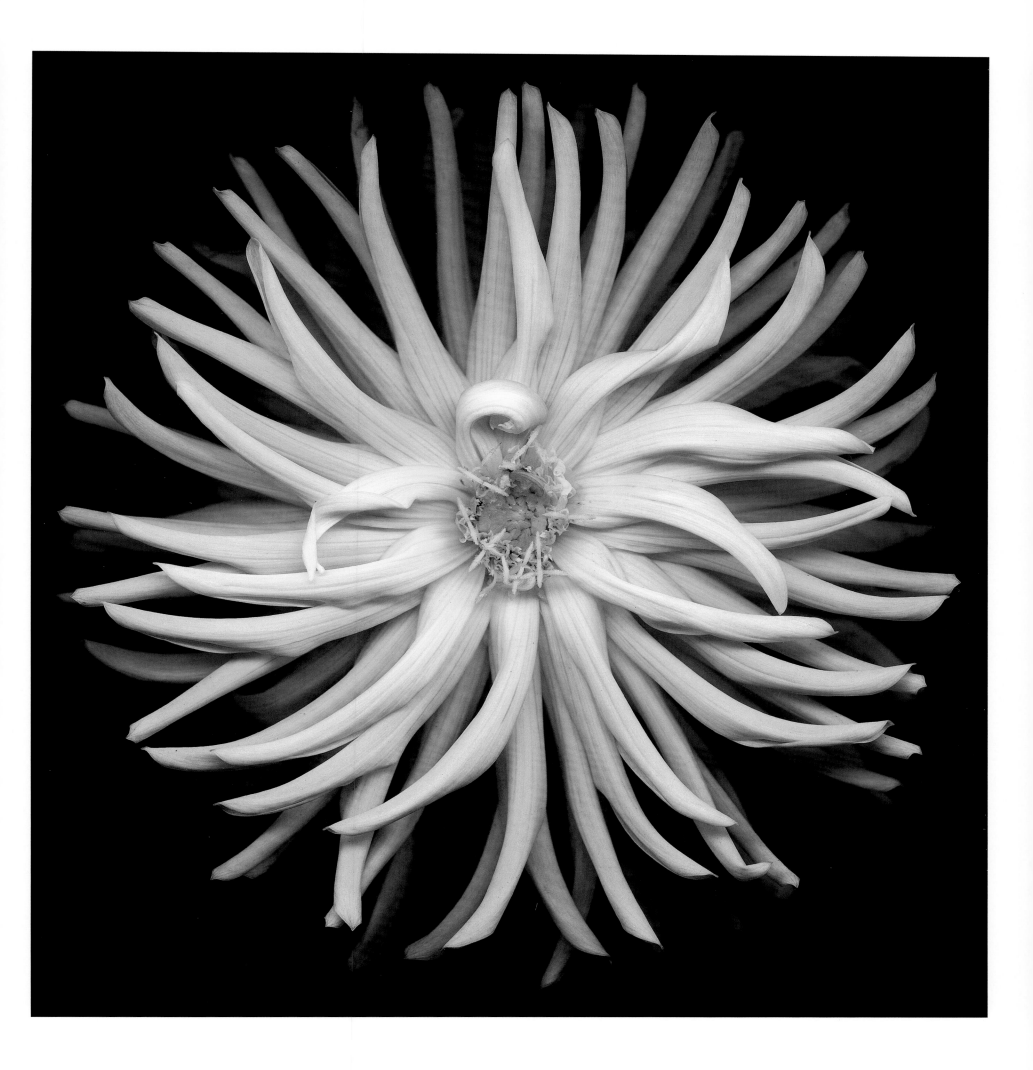

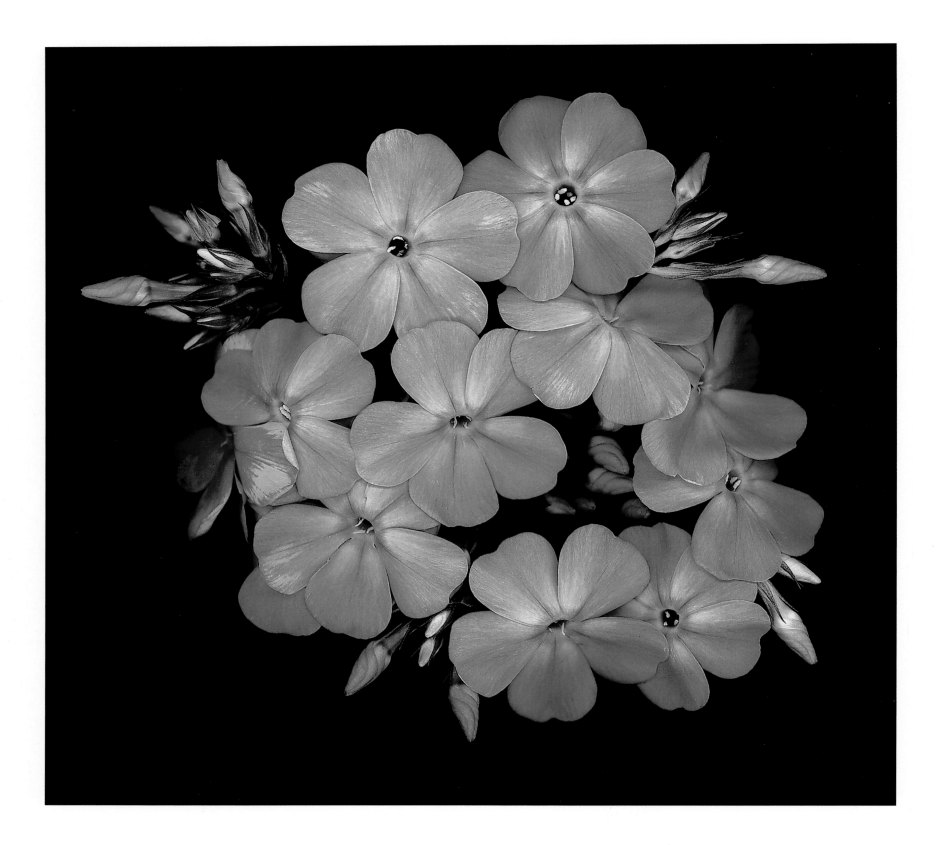

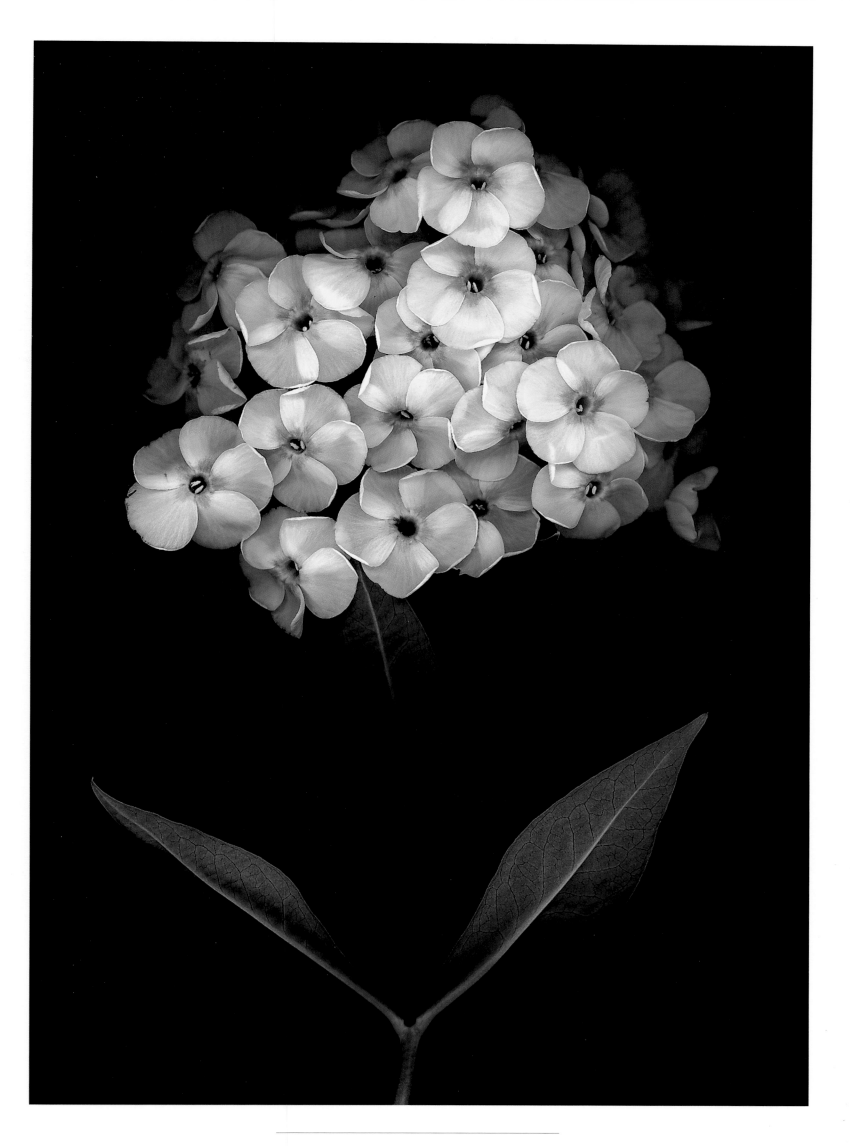

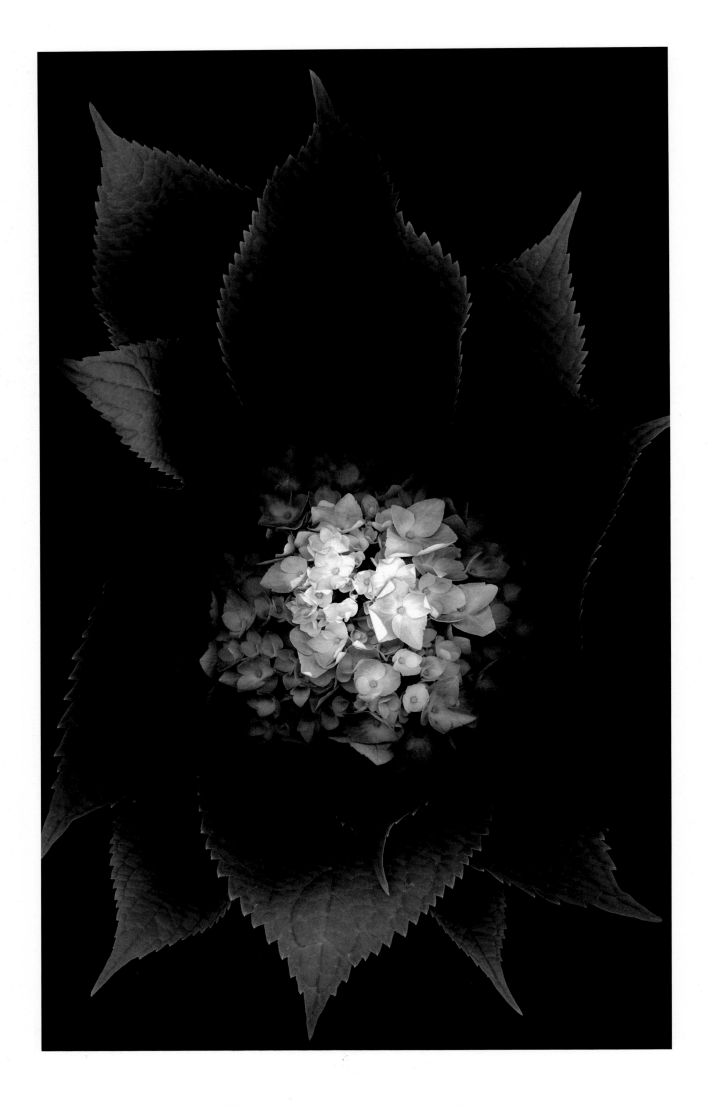

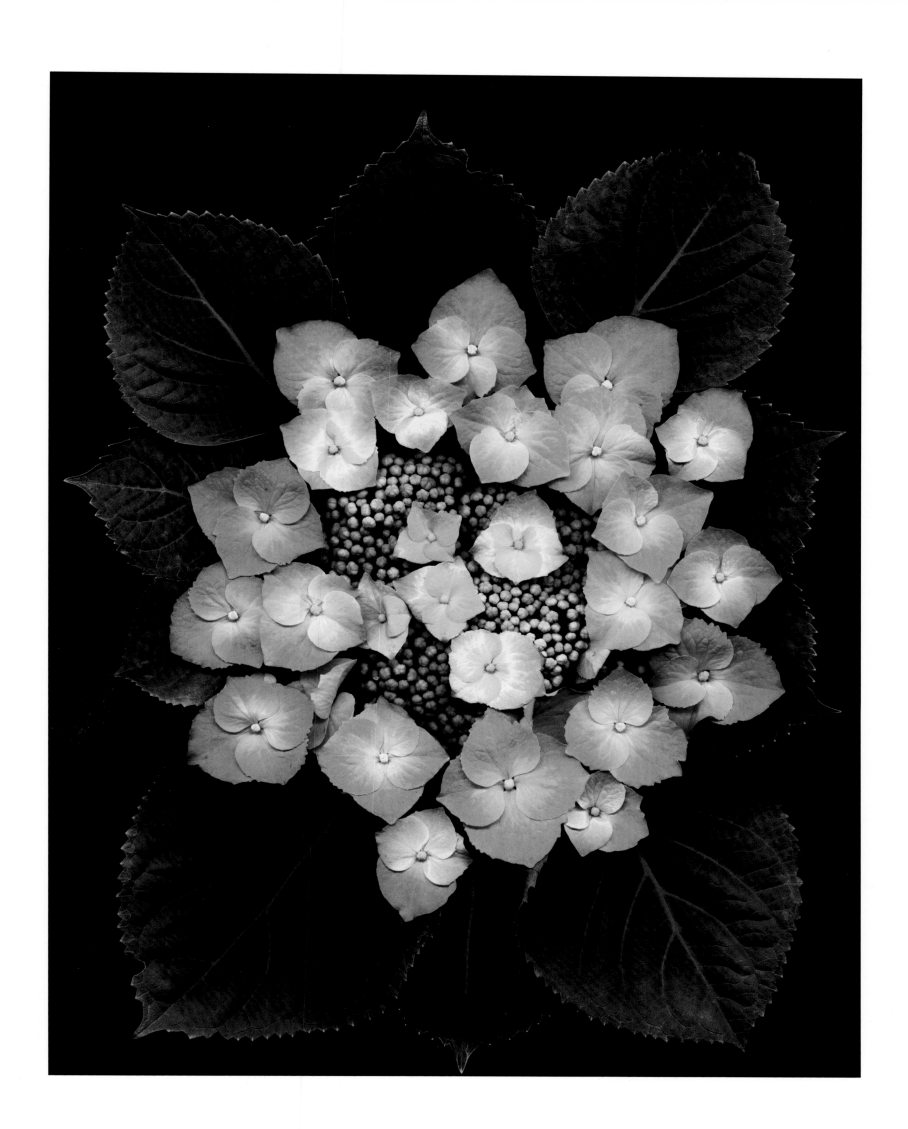

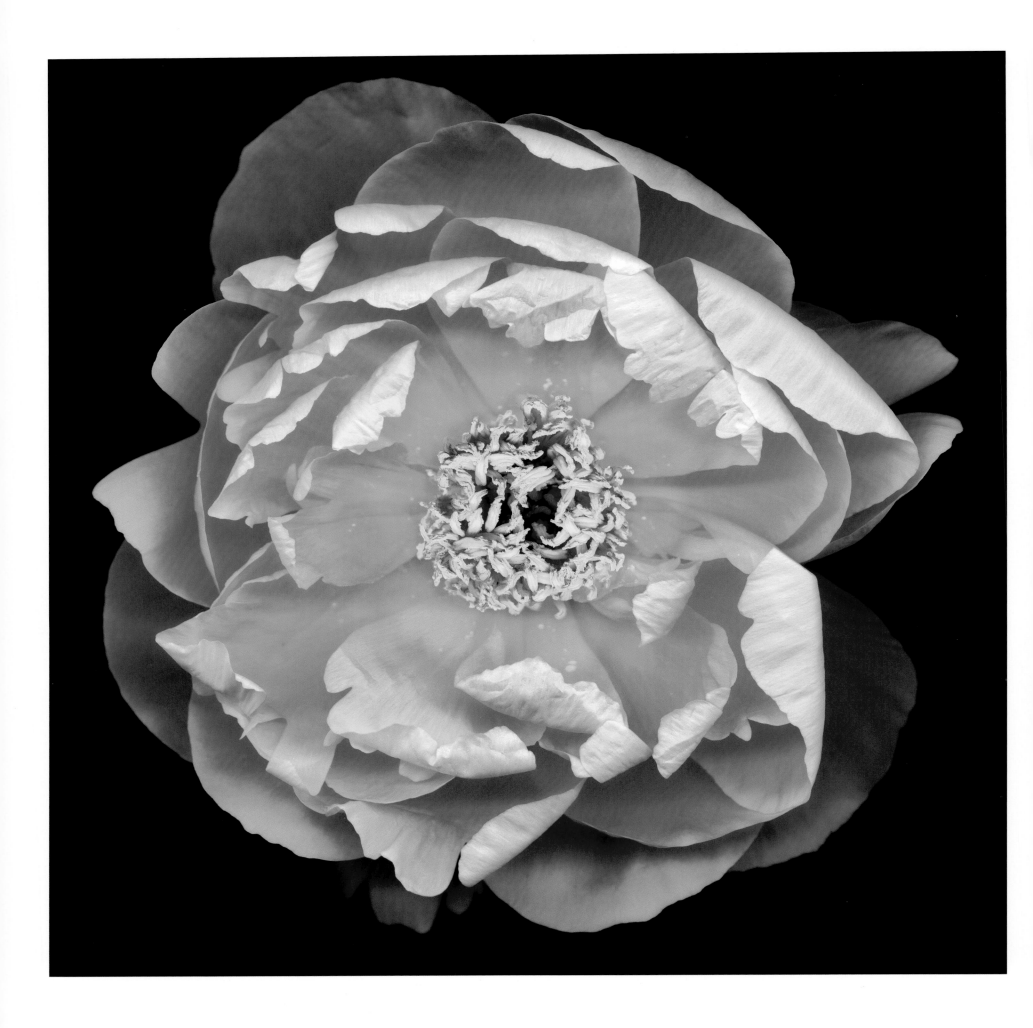

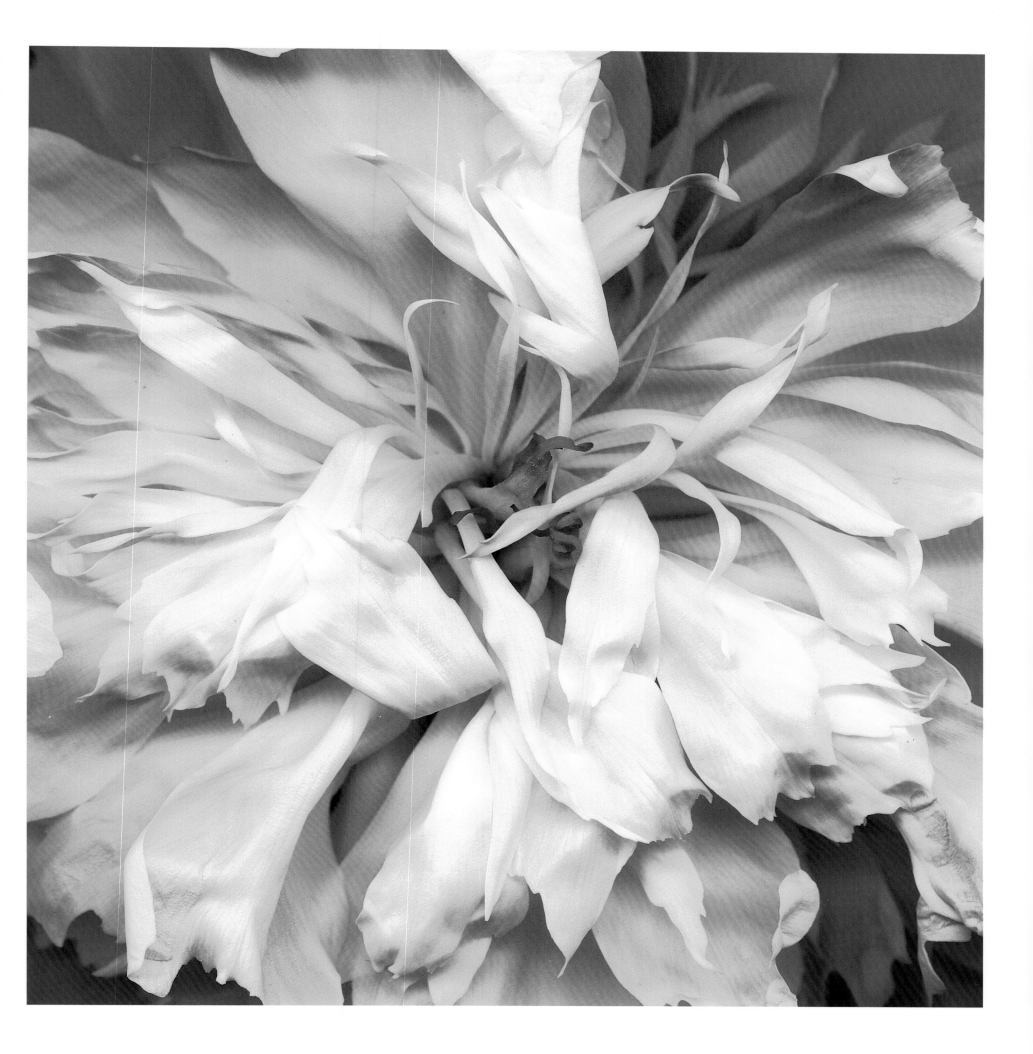

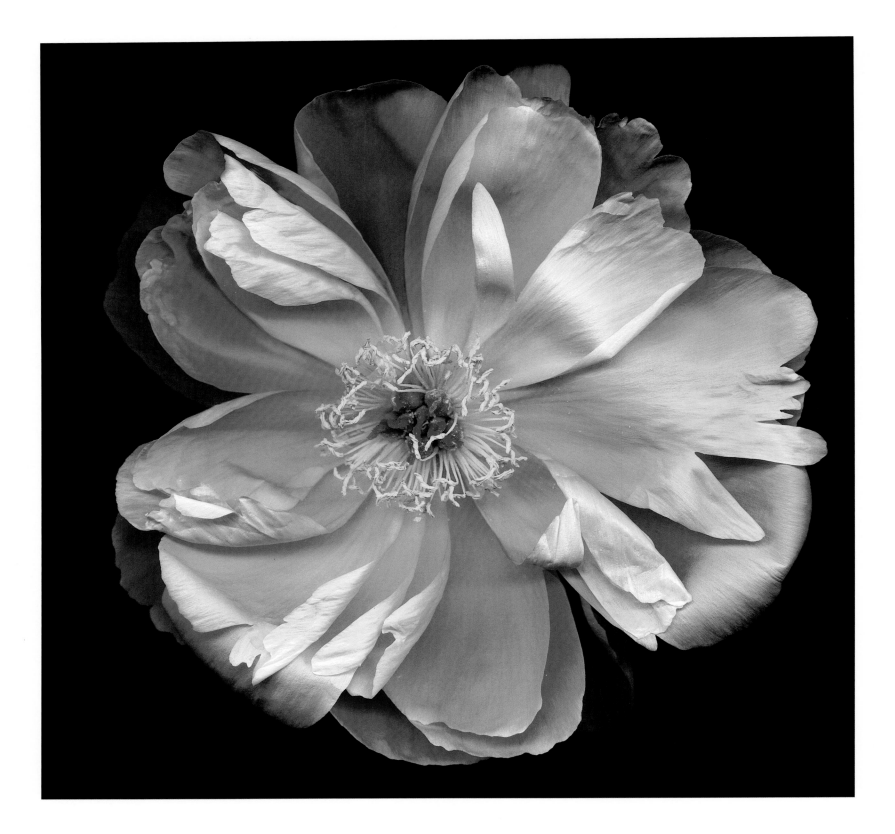

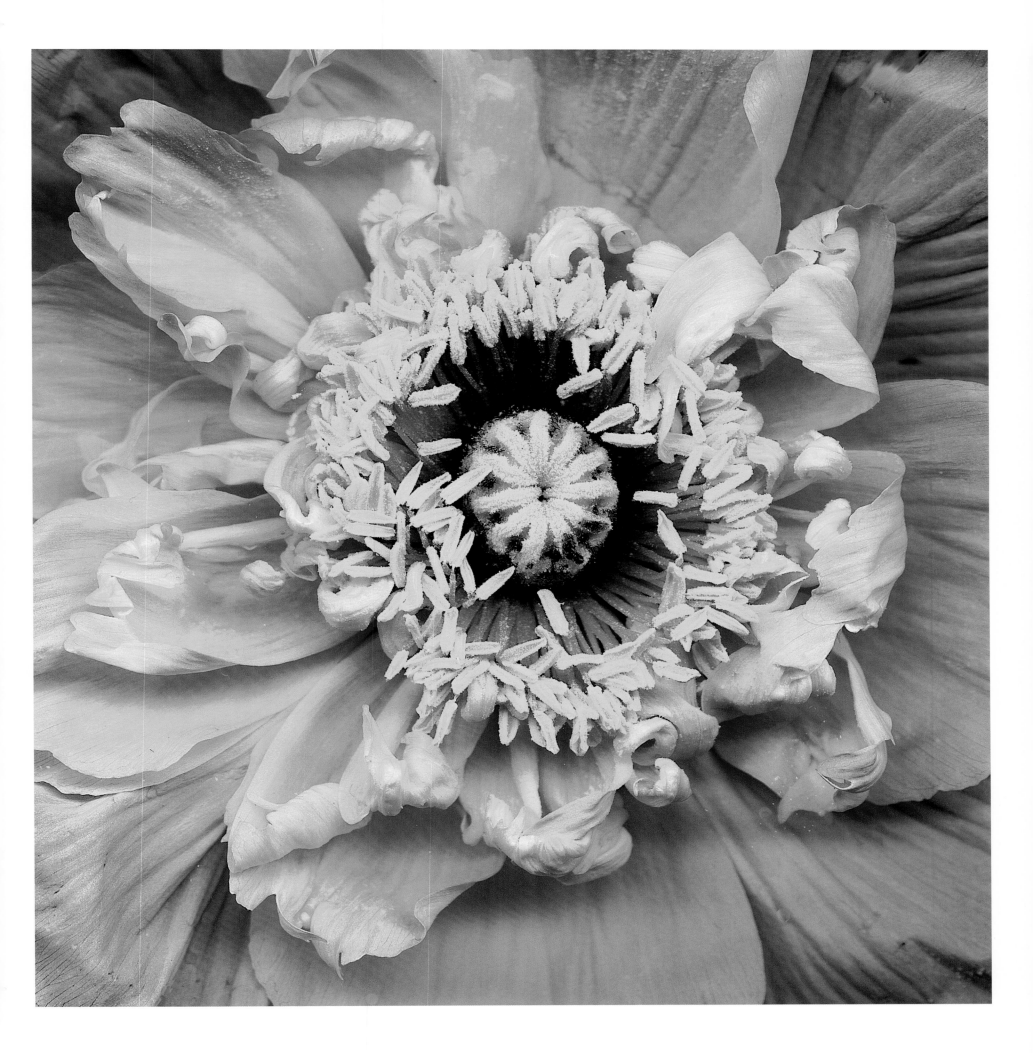

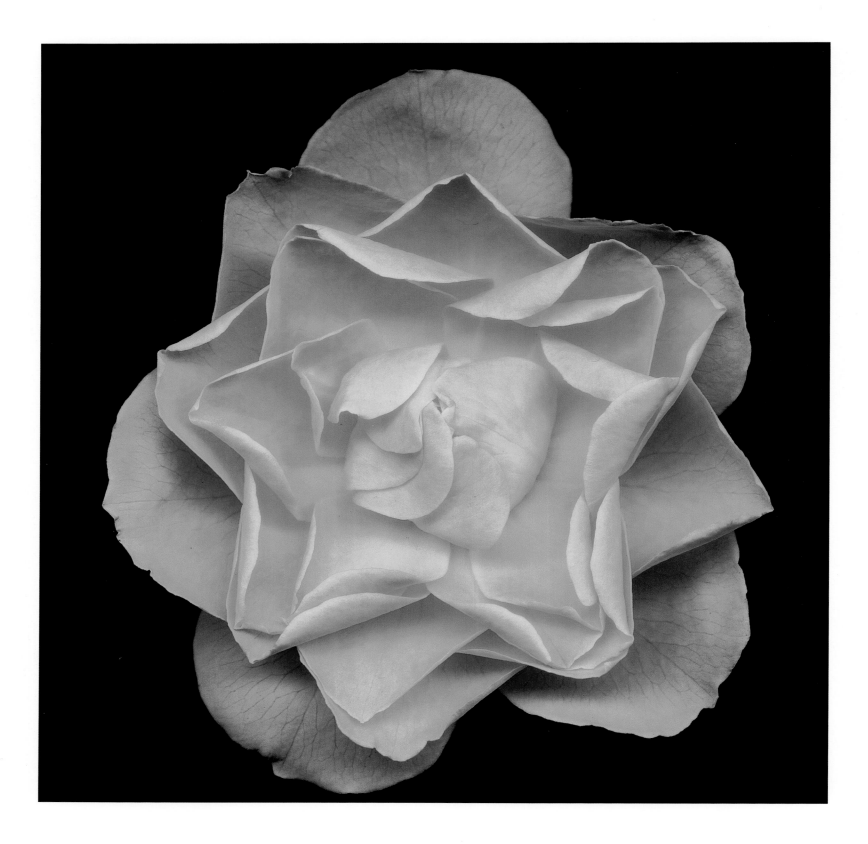

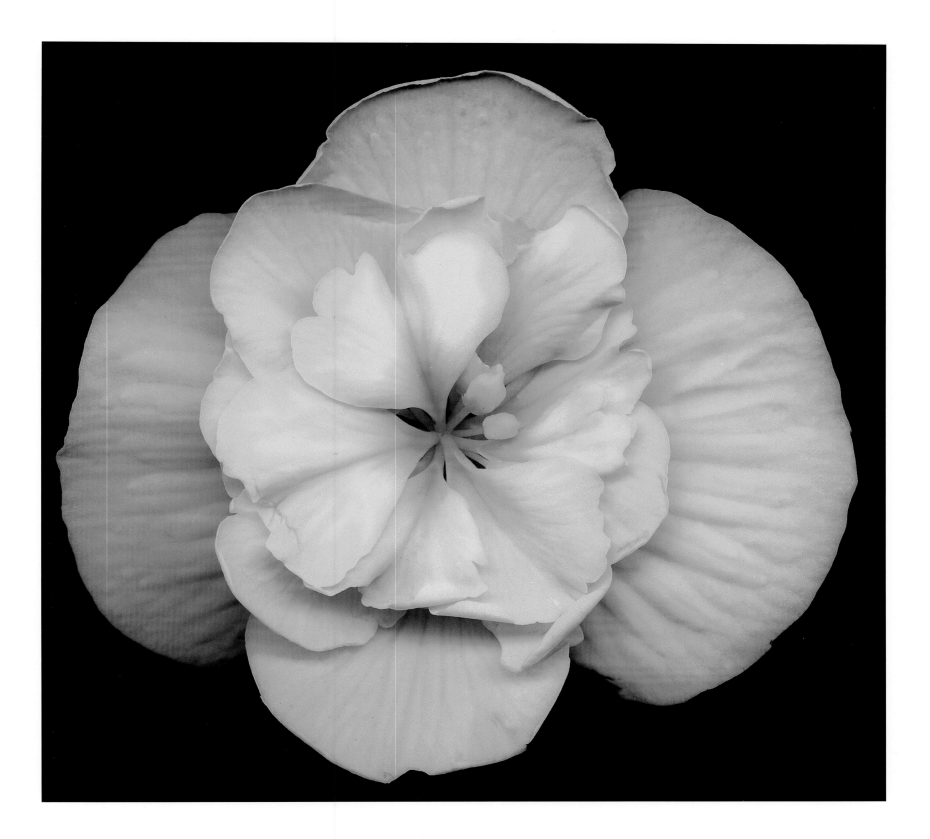

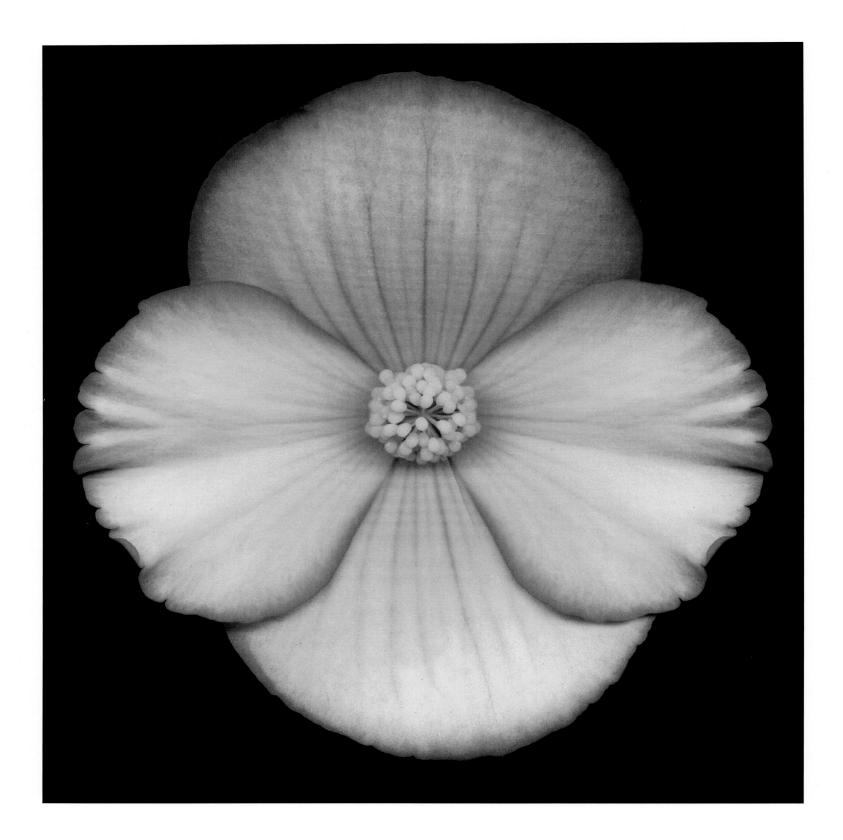

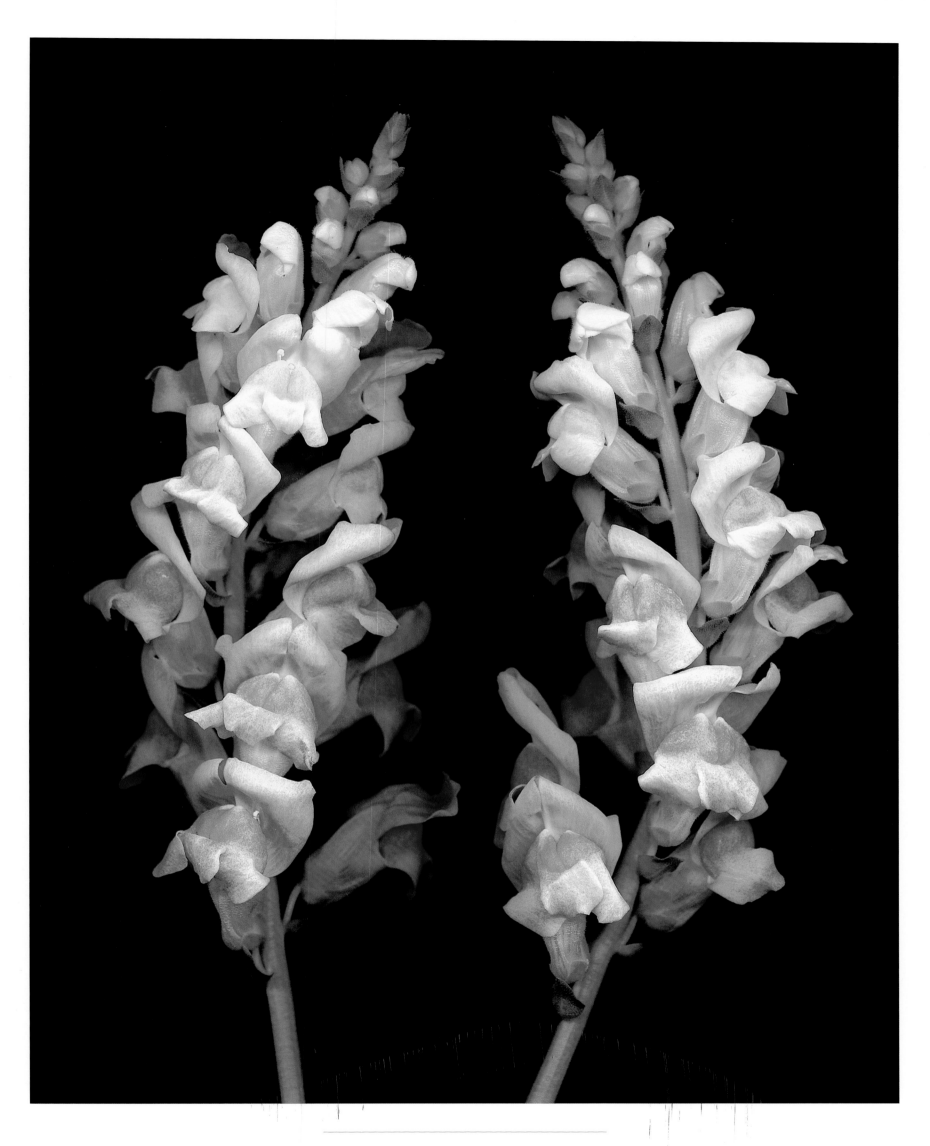

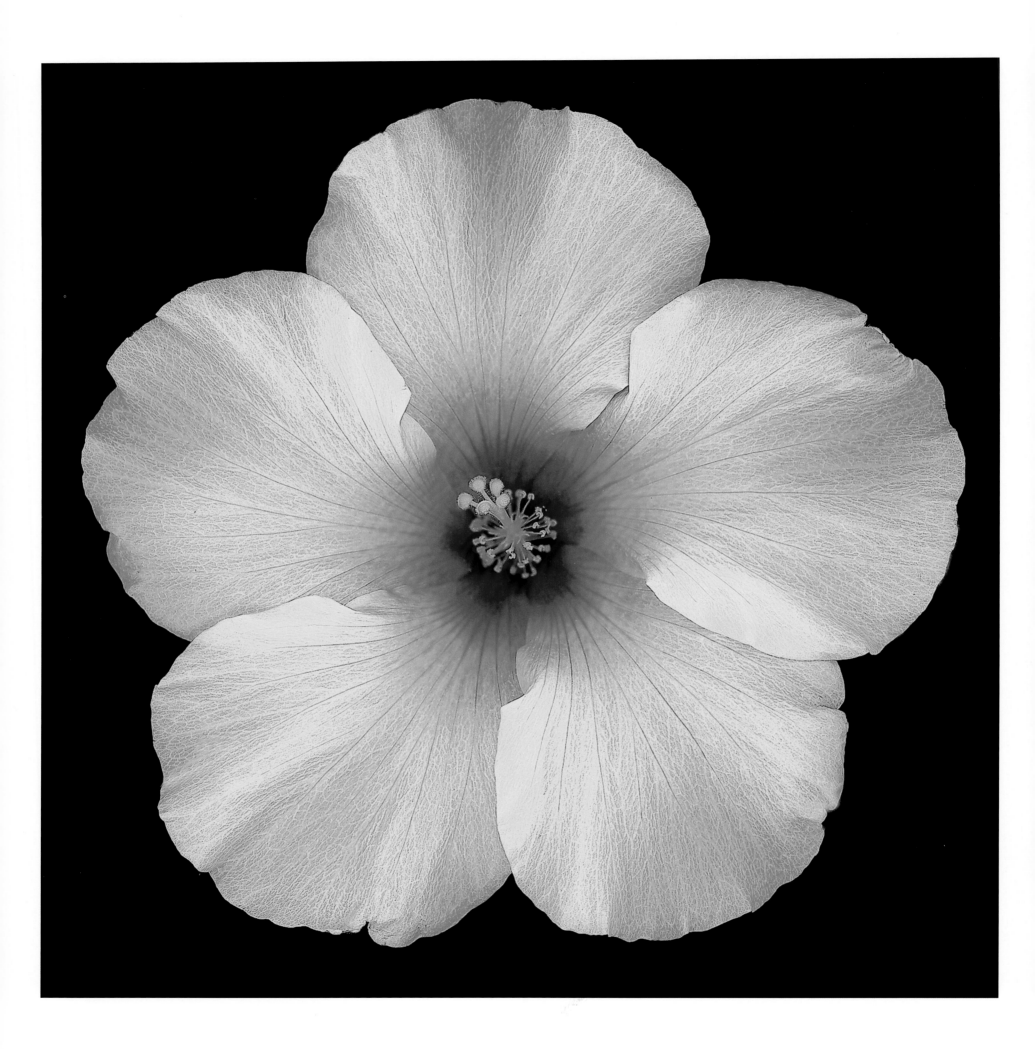

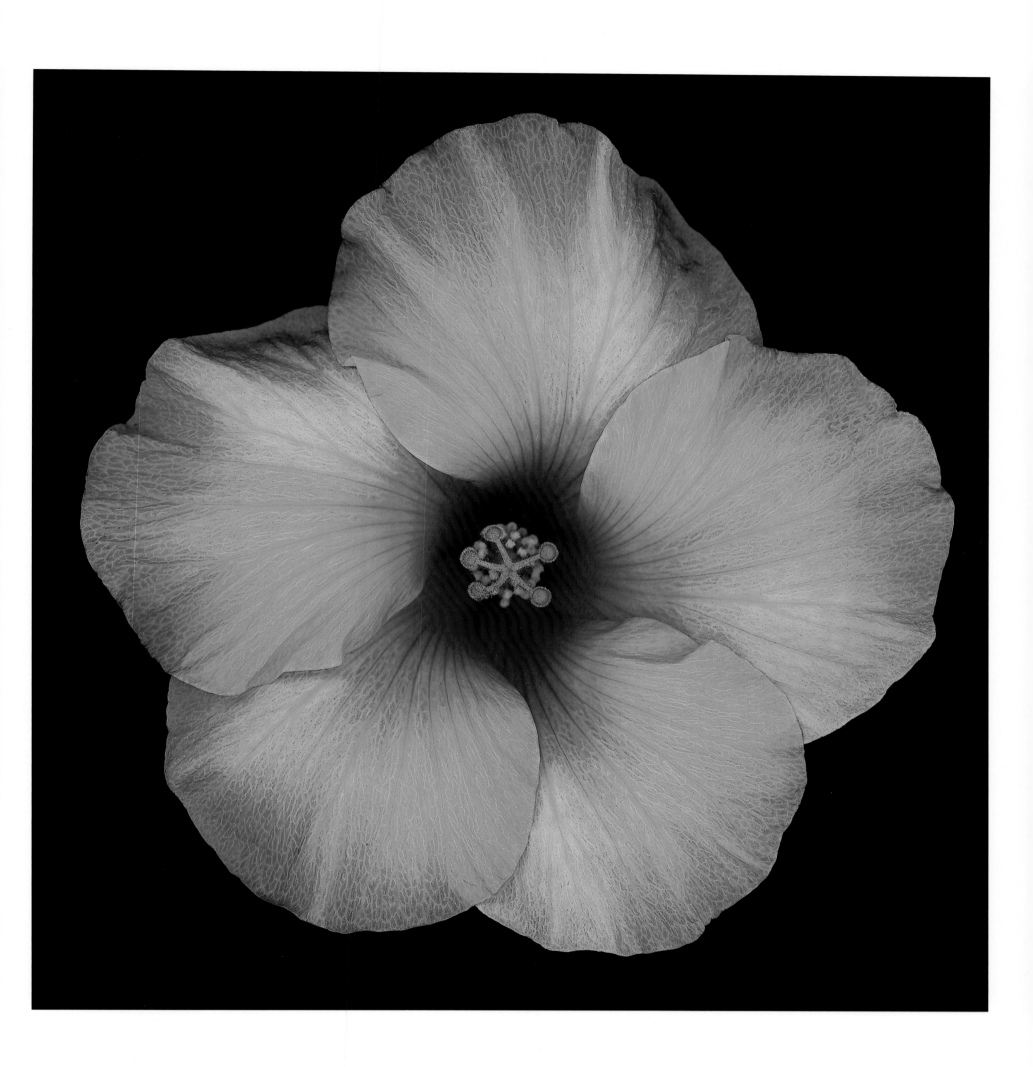

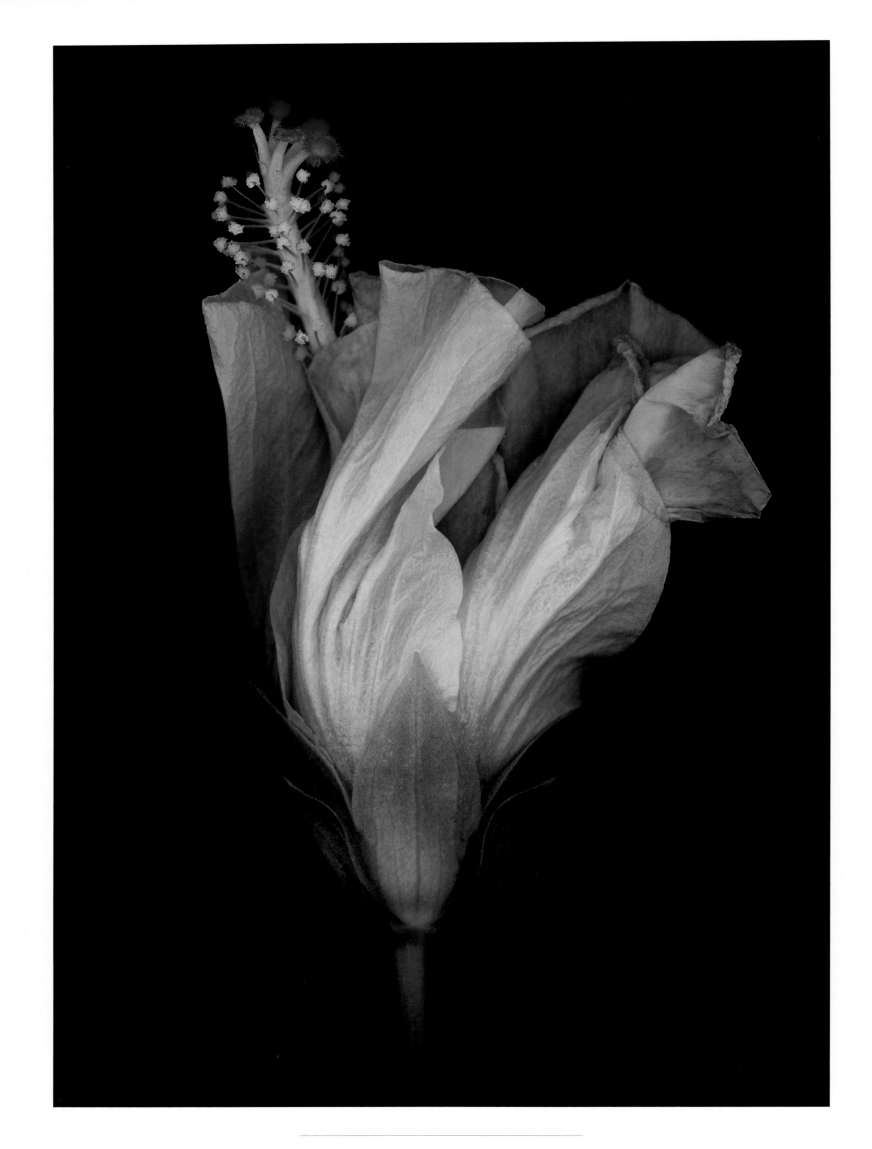

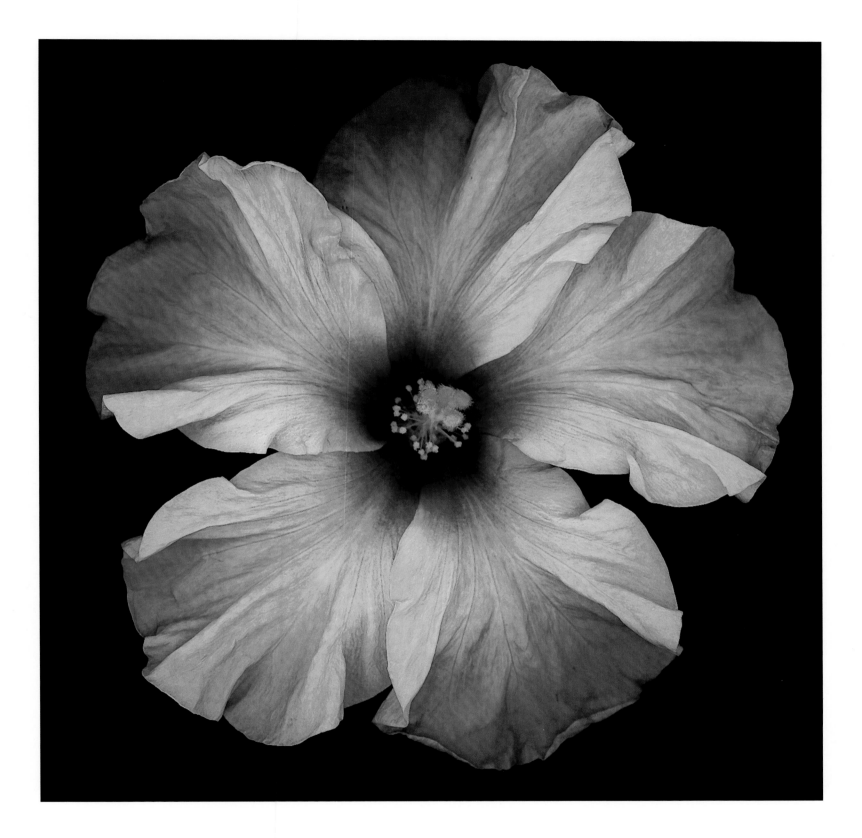

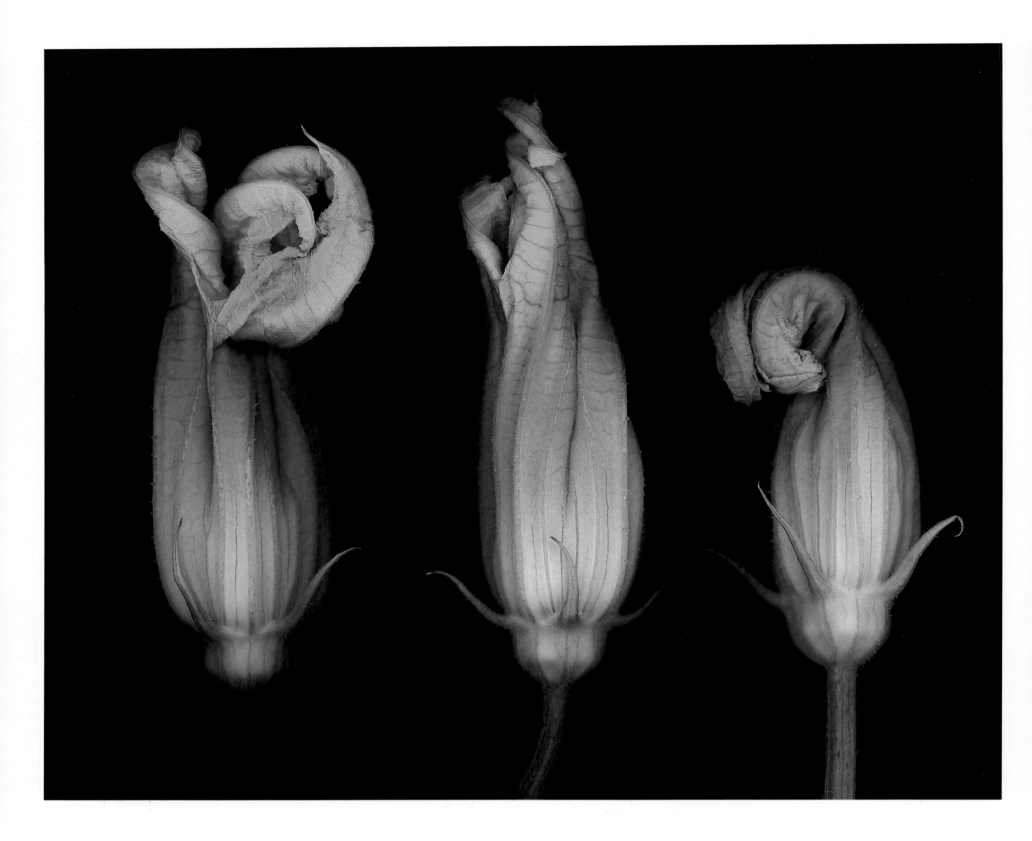

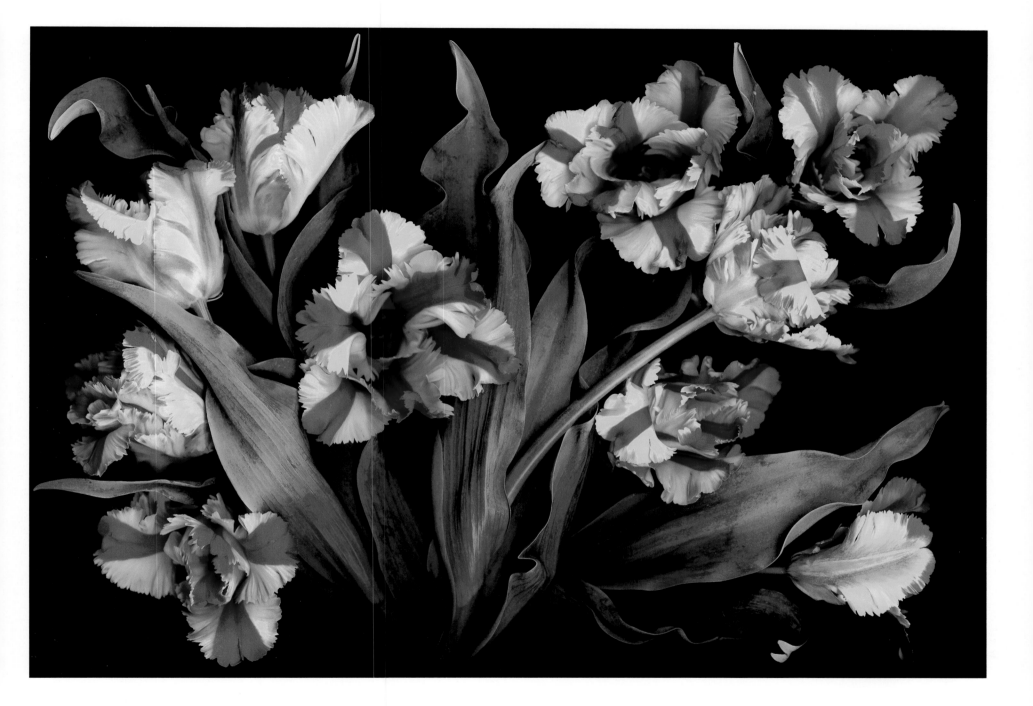

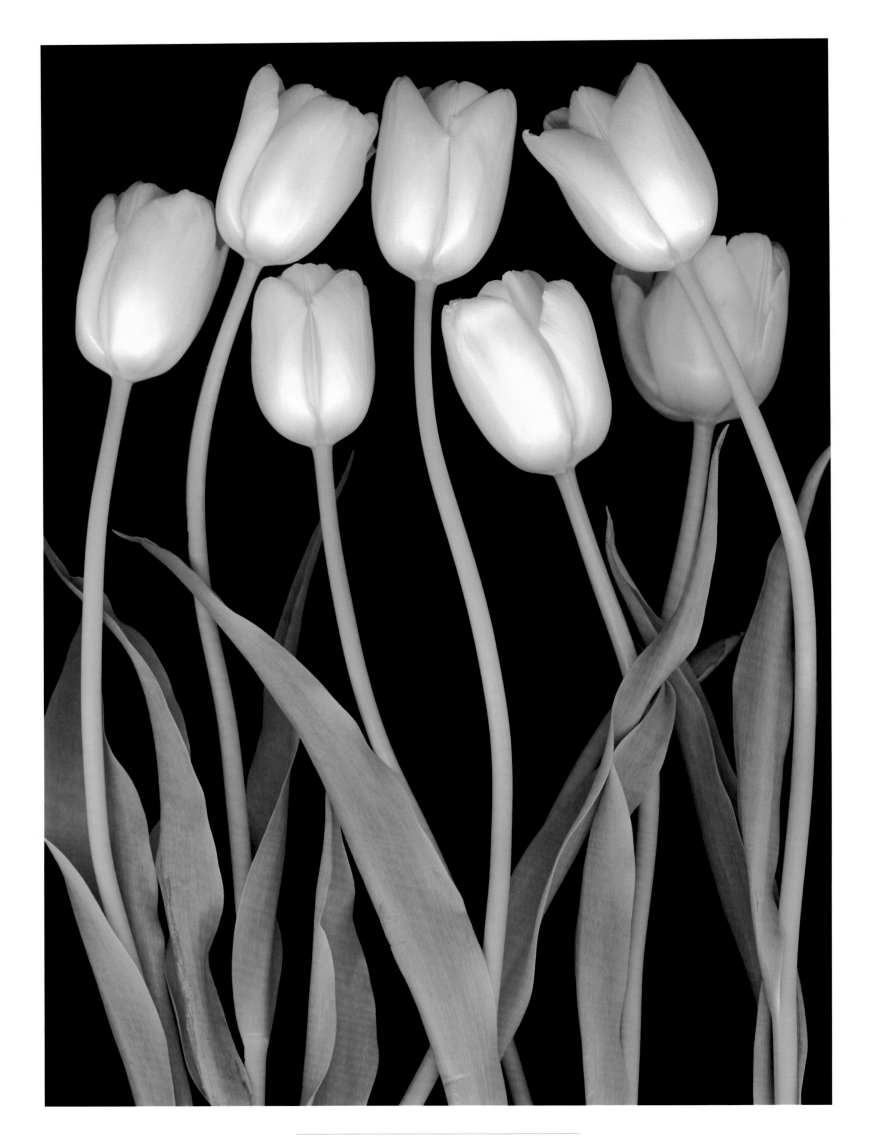

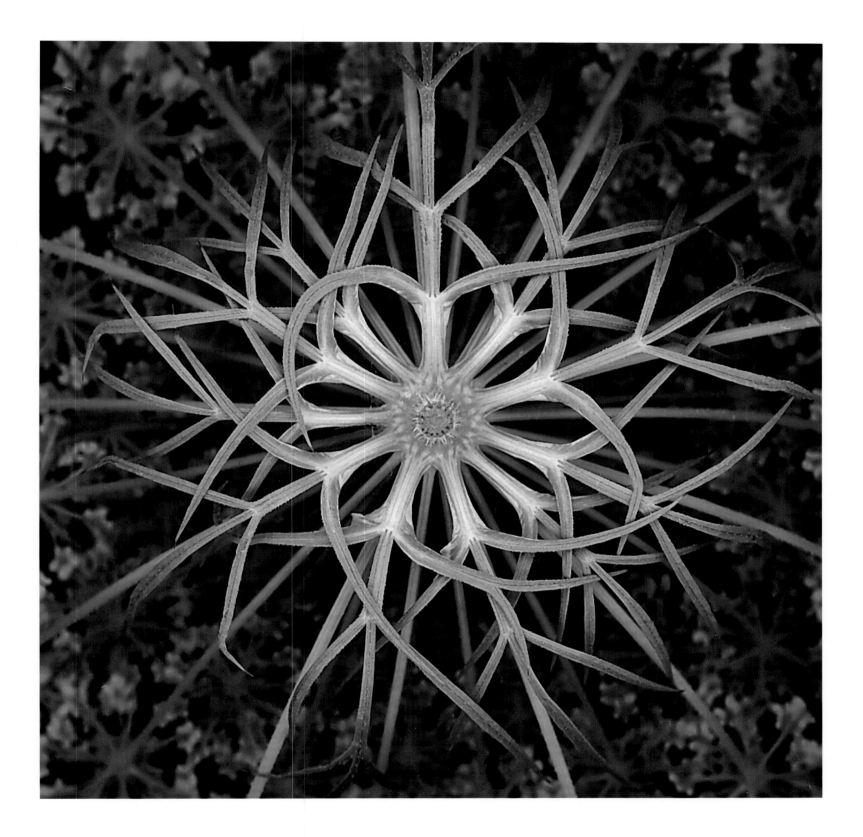

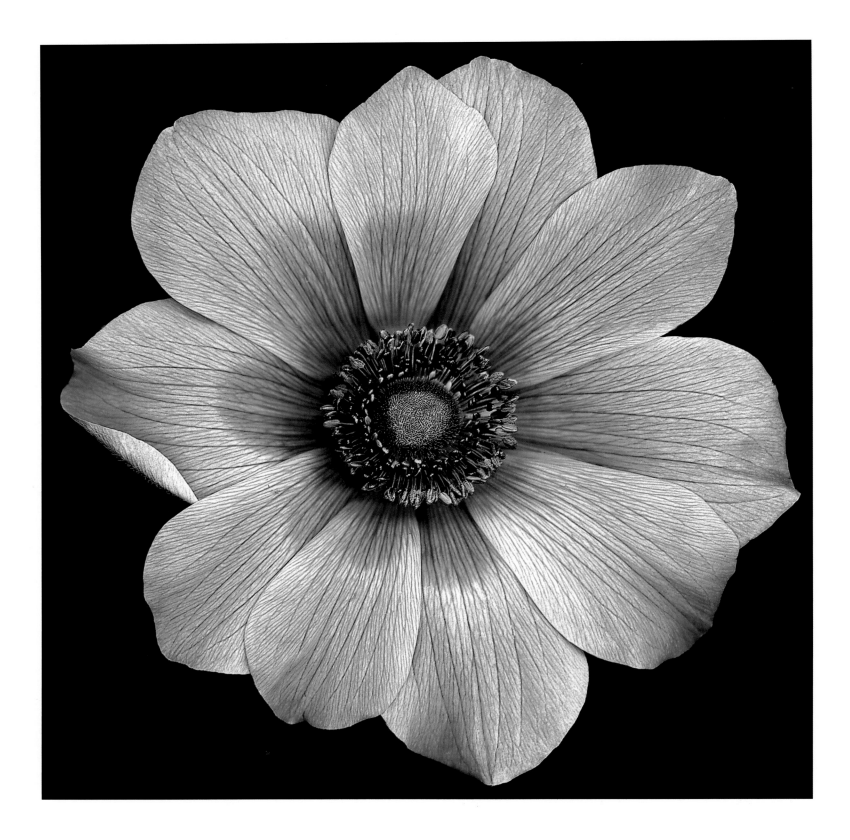

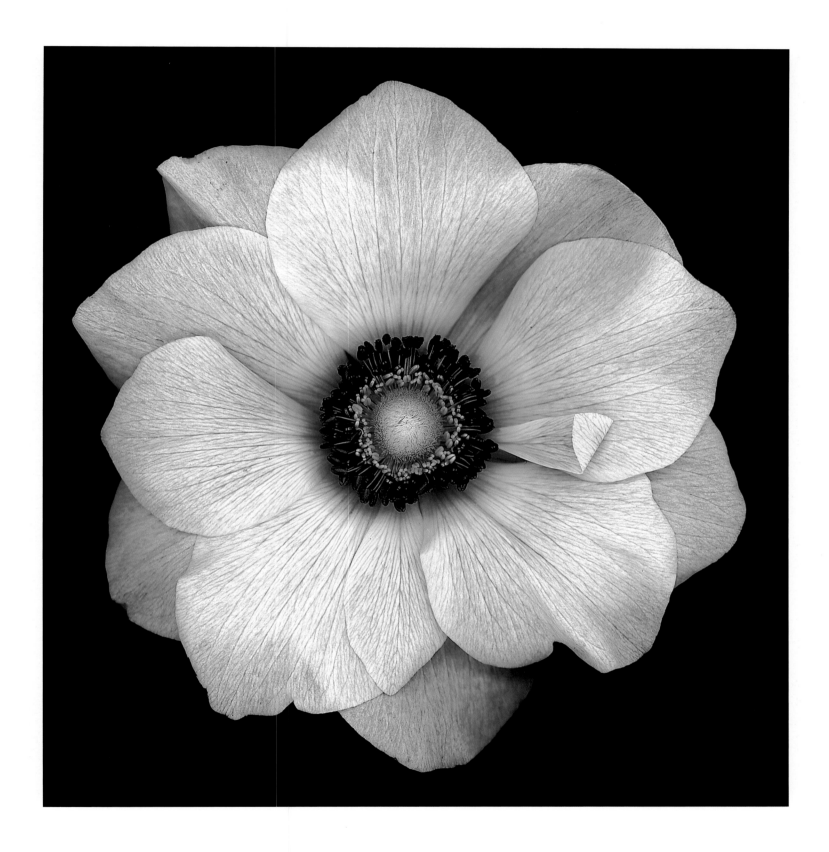

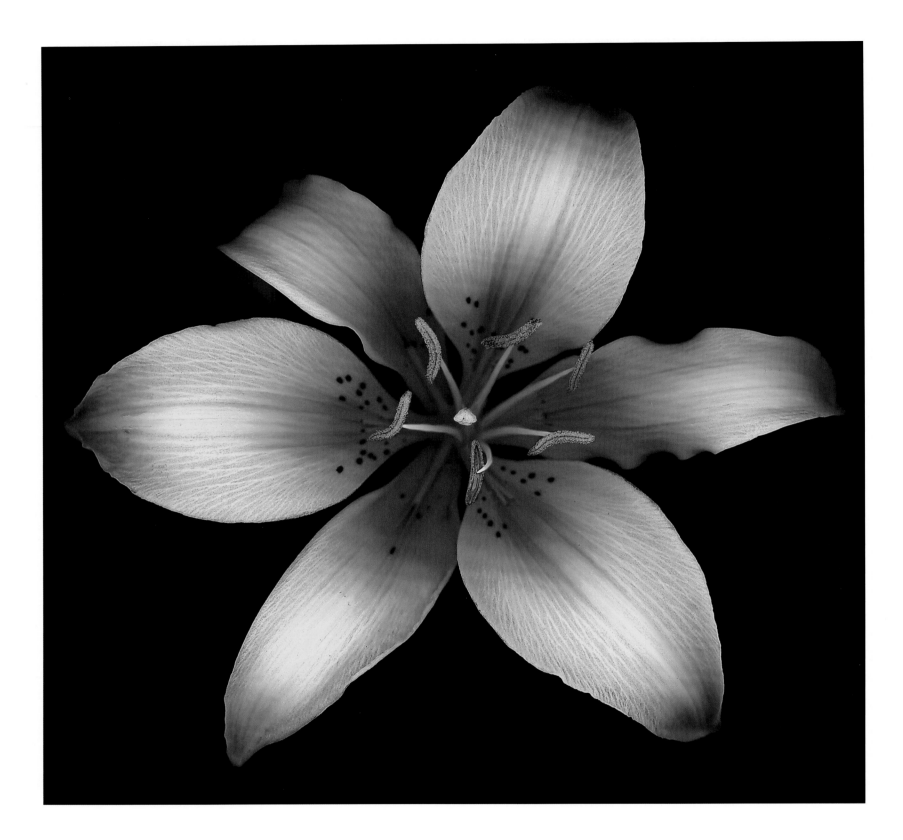

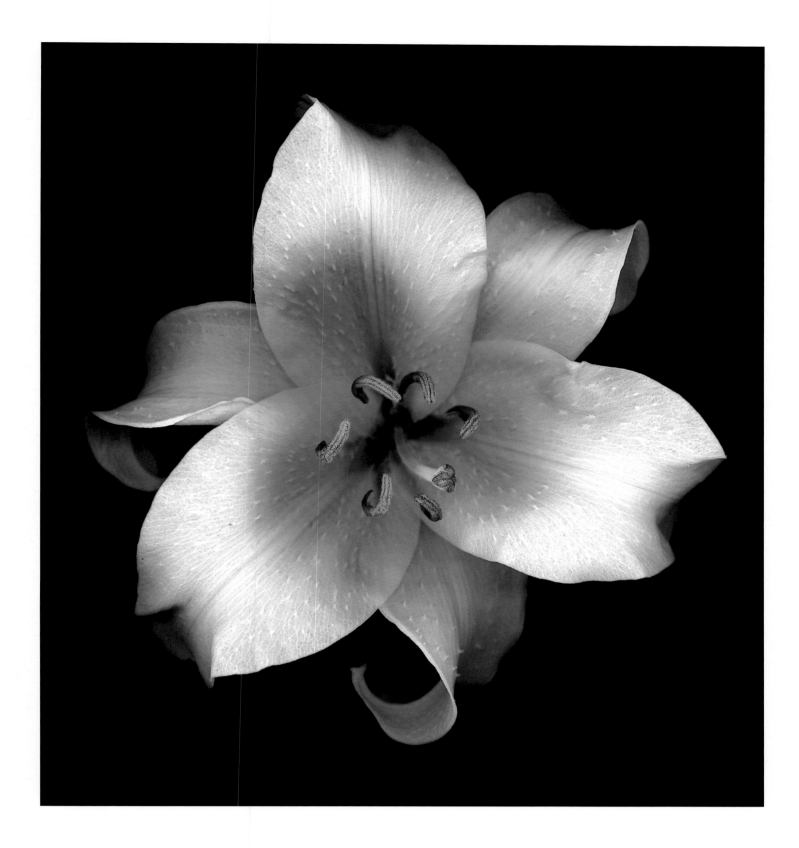

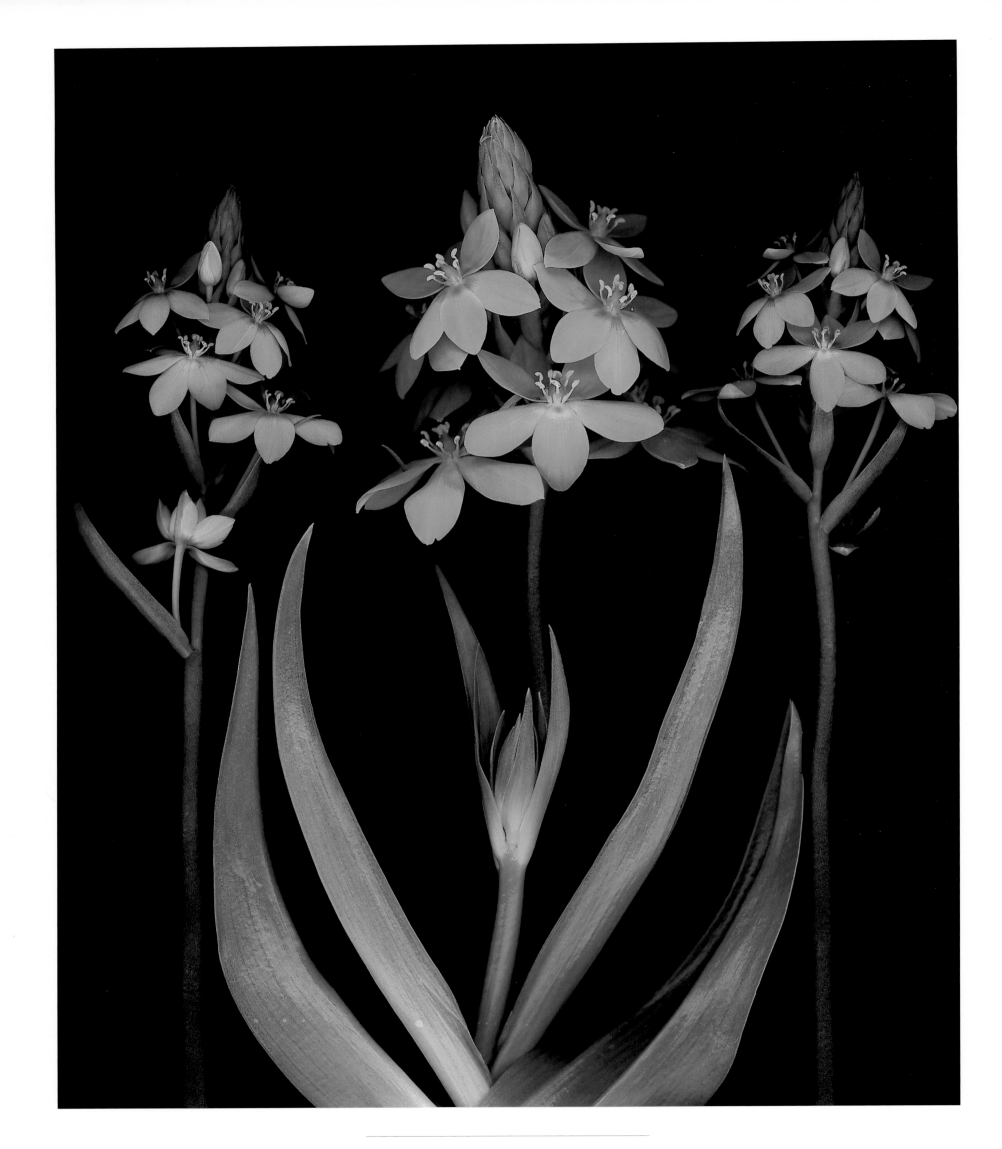

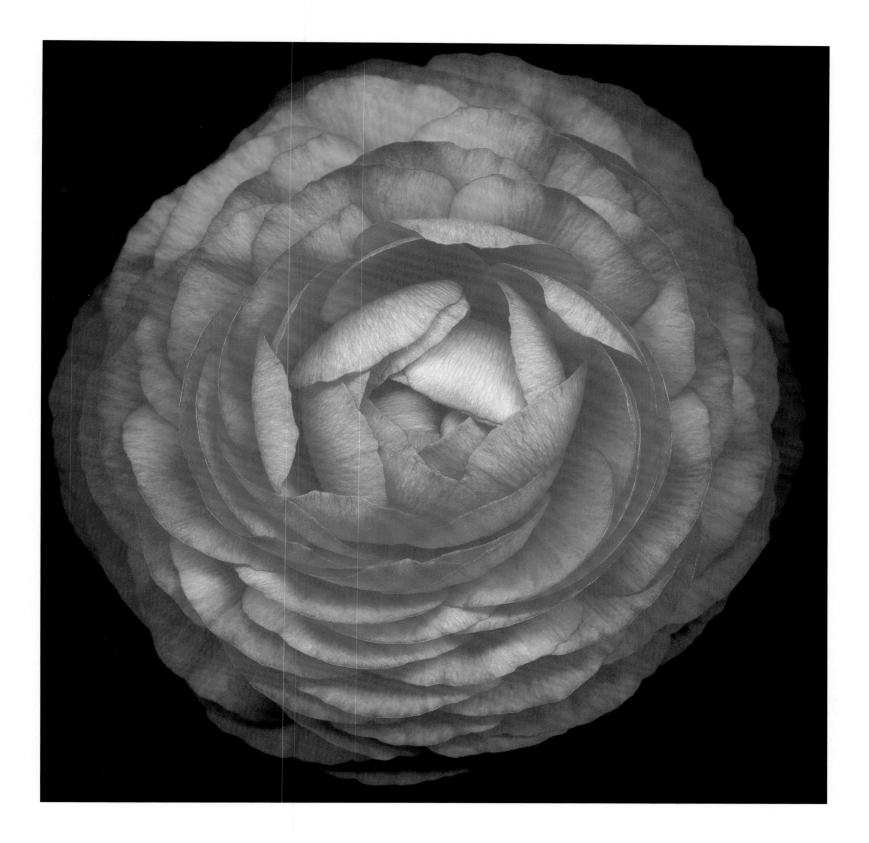

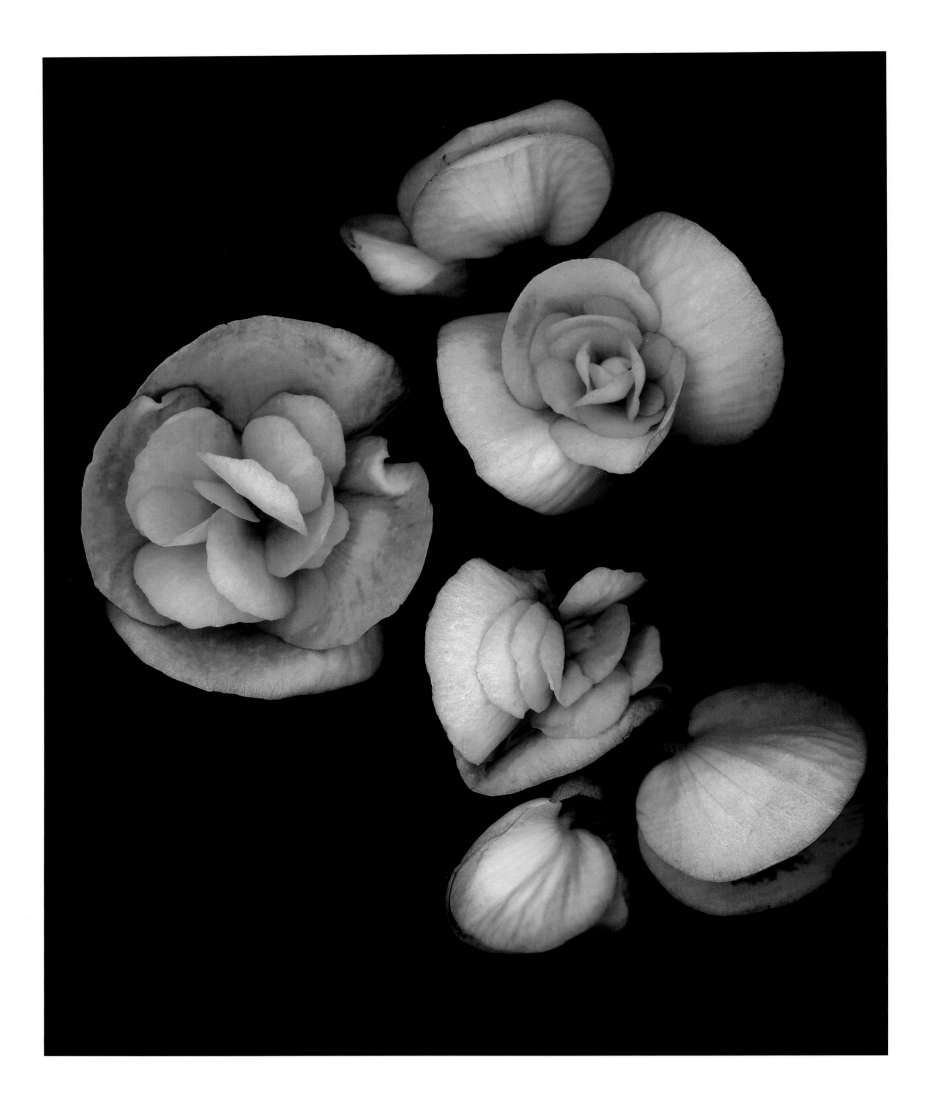

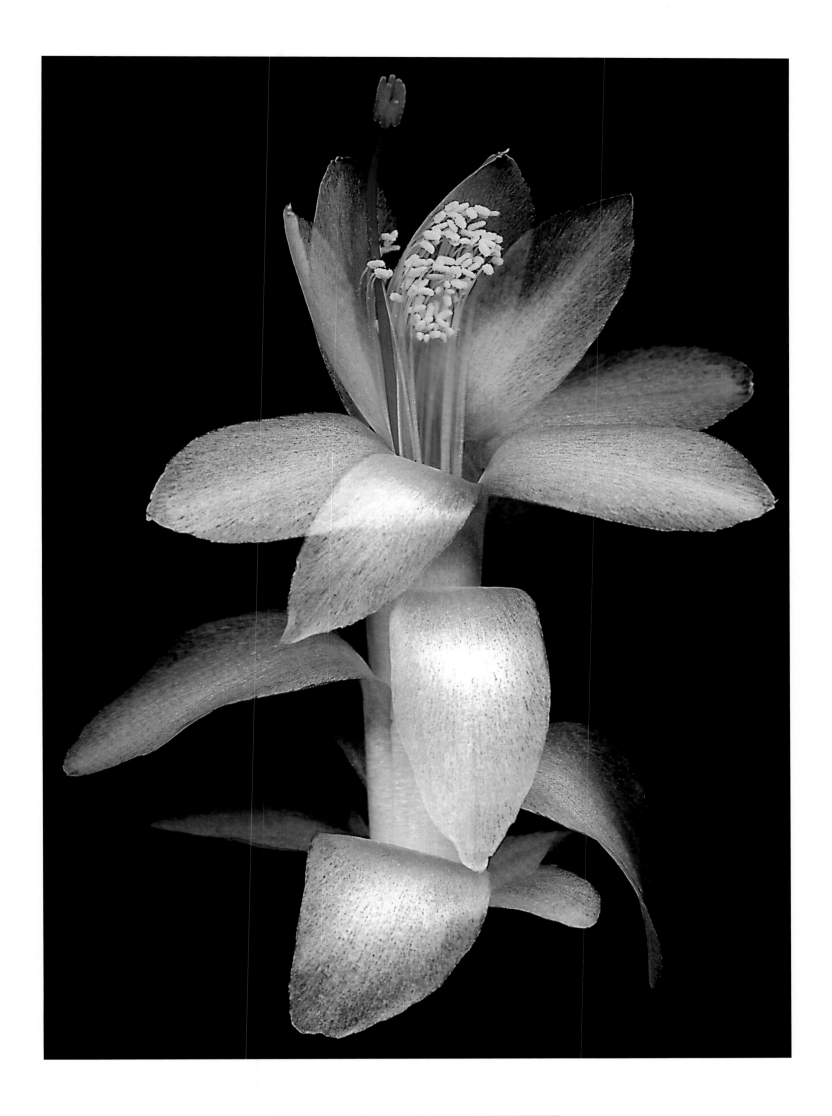

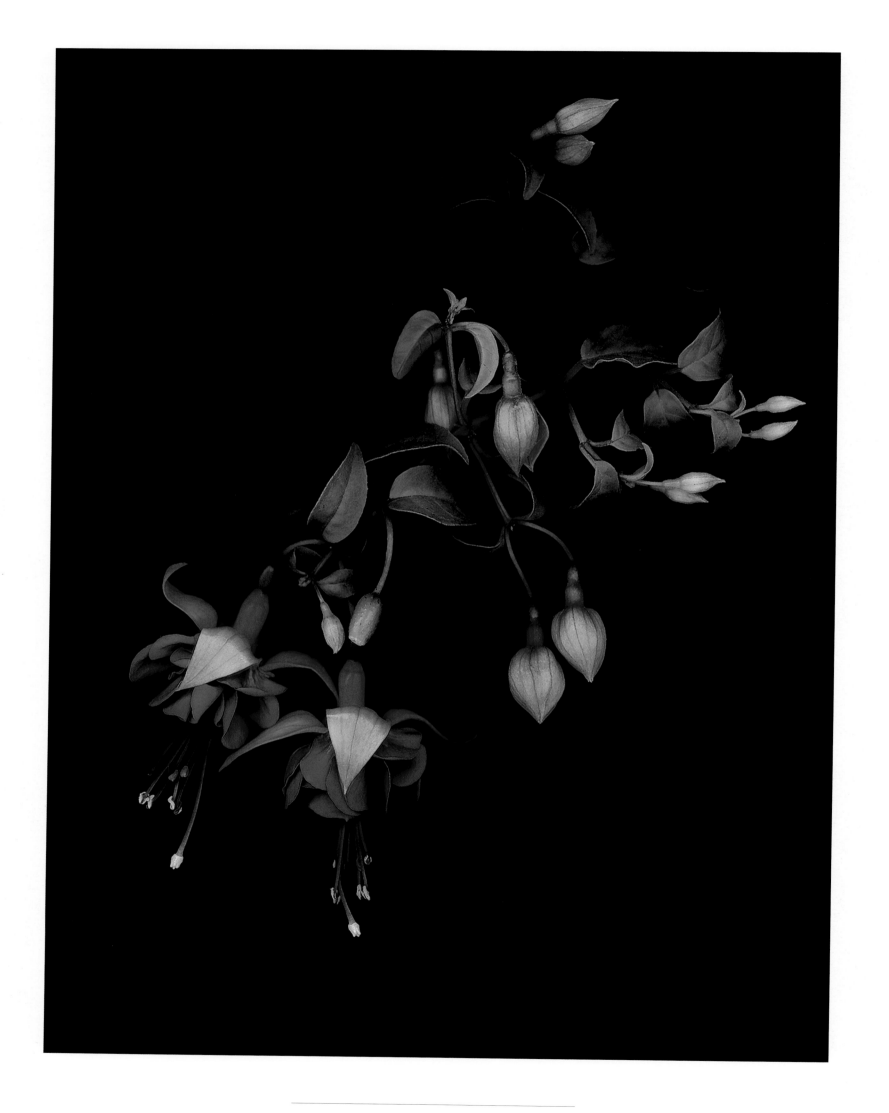

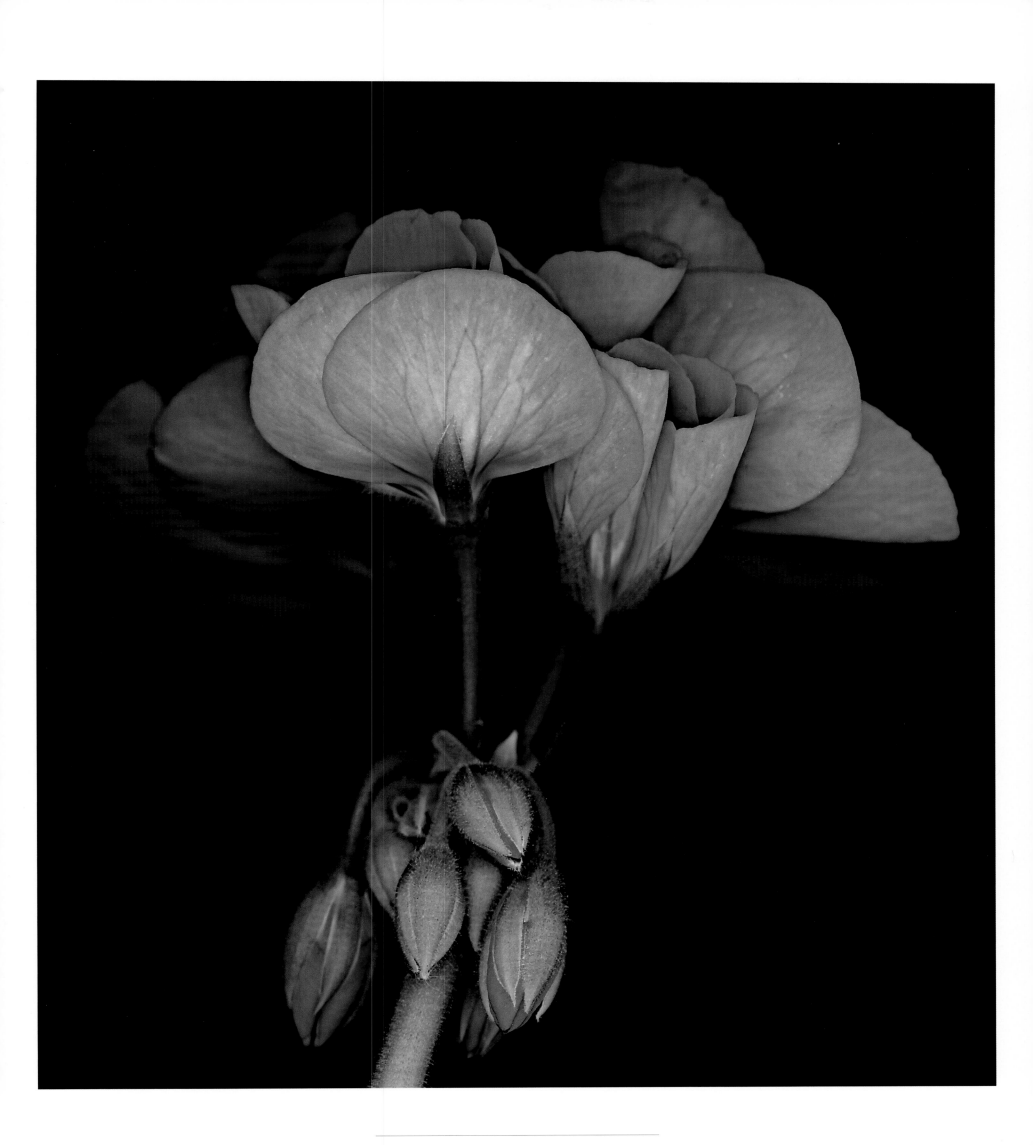

ACKNOWLEDGMENTS

One Hundred Flowers is dedicated to my wife and soul mate, Judith, whose life has touched and transformed the children of war; my daughter, Robin, whose mission has been to teach the wisdom and love of dogs; and my son, Gjon, who has used his mastery of chess to teach the game of life. It is also an appreciation of my brother and sister, Murray and Ethel, who were there to help me so many times; and a memorial to my brother and sister, Alvin and Belle.

I would like to extend my heartfelt thanks to the following individuals, without whom this book could not have been realized. The advice and encouragement of curator Leslie Nolan were invaluable. I am particularly grateful to her for bringing my photographs to Constance Sullivan who shaped and produced One Hundred Flowers, and with whom it was a privilege to work. Her mastery of bookmaking and impeccable standards were an inspiration. Katy Homans's pristine design sets the book apart. I also want to thank Carol Judy Leslie, publisher, and Karen L. Dane, associate editor, at Bulfinch Press for their enthusiastic efforts on behalf of the book.

Others who provided assistance, support, and recommendations that are greatly appreciated are: Mariette Allen, Dave Barnett, Beth Black, David Caras, Tim Daley, Emanuel, Susan Falk, Linda Ferrer, Carol Gallagher, Stephanie Hobbs, Susan Osborne, Pat Rodegast, Marie Schuman, Bill and Carol Smith, Anne Stovell, Lou Strano, Doris Straus, Brook Tinney, and Ruth Thompson.

Lastly, I want to especially acknowledge the support of Mark Radogna and Fabia Barsic of Epson America, whose printers and scanners made this project feasible.

H. F.

INDEX